HISTORICALLY
African American
LEISURE DESTINATIONS
AROUND
Washington, D.C.

PATSY MOSE FLETCHER

THE
History
PRESS

Published by The History Press
Charleston, SC
www.historypress.net

Front cover: Historic Images Collection, Washingtoniana Division, Martin
Luther King Jr. Library.
Back cover, top to bottom: Courtesy Susan P. McNeill, Robert H. McNeill Collection; Historic
Images Collection, Washingtoniana Division, Martin Luther King Jr. Library; Scurlock
Studio Records, Archives Center, National Museum of American History, Smithsonian
Institution.

First published 2015

Manufactured in the United States

ISBN 978.1.46711.867.5

Library of Congress Control Number: 2015950736

For Murphy Sr., Ric, Murph, Carl, Greg and Ron, who have found leisure.

Contents

Contents

Foreword

*P*atsy Fletcher's insightful and important work *Historically African American Leisure Destinations around Washington, D.C.* offers a panoramic view of the special tactics that African Americans have used for racial uplift. She has shown that through travel and recreation and using social, literary and music clubs; sororities; fraternities and fraternal orders; and church and youth groups, African Americans found a companion to hard work.

While W.E.B. Du Bois and Booker T. Washington often had disagreements over the nature and pace of black progress, they shared a belief in the collective purpose and duties of black people. Washington and his supporters believed that "of deeper significance if possible, than equality before the law…is equality of industry…he who earns his bread by sweat of his brow is, in our teachings, as much entitled to respect and honor as he who rules an empire and enjoys with him an equality of fraternity, friendship and recognition." Du Bois believed similarly that black people who worked hard were as deserving of a first-class education and leisure and recreation as anyone else. They deserved to spend time with their families reading, attending lectures and concerts and enjoying nature. Indeed, as he wrote, for generations African Americans had "no one with leisure to turn the bare and cheerless cabin into a home, no old folks to sit beside the fire and hand down traditions of the past: little of careless childhood into dreaming youth."

In Washington, D.C., a city as segregated and oppressive as any at the turn of the twentieth century, industrious African Americans sought to find ways to give comfort to those who daily strove to live and provide for their loved ones. They sought to create spaces and places for rest and recreation to help soothe the souls and weary bodies of black folk.

Mary Church Terrell—the founder of the National Association of Colored Women who played a major role in integrating Washington, D.C., and in supporting places for rest, recreation and leisure—put it simply in 1898: "And so lifting as we climb onward and upward we go, struggling and striving, and hoping that the buds and blossoms of our desires will burst into glorious fruition ere long." In this book, Patsy Fletcher has captured the essence of what good, hardworking, creative and industrious people do when they do good things together—of men, women and children who have lifted as they have climbed.

—Maurice Jackson

Maurice Jackson teaches Atlantic history and African American, jazz and Washington, D.C. studies at Georgetown University. He is author of the critically acclaimed book *Let This Voice Be Heard: Anthony Benezet, Father of Atlantic Abolitionism* and co-editor with Jacqueline Bacon of *African Americans and the Haitian Revolution: Select Articles and Historical Documents.* With Blair Ruble, he is co-editor of a special issue on "Jazz in D.C." in *Washington History* (April 2014). A 2009 inductee into the Washington, D.C. Hall of Fame, he is the chair of the D.C. Commission on African American Affairs.

Acknowledgements

When I was asked by The History Press to write this book, I thought, "Yikes, I can't do this." At the same time, I wanted this rich story told. So with the encouragement, assistance and just plain old generosity of many, I've got some of it told.

I can't begin to name all who helped, but here are a few: Adrena Ifill and Joy Kinard, who encouraged my inquiry almost ten years ago; and the late Donna Wells, Joellen ElBashir and Marya McQuirter, who inspired and supported my scholarship.

I am especially grateful to Kim Williams, Maya Davis, Schwanna Cockerham-Qualls, John-Peter Thompson, William Henderson, Paul Fletcher, Carolyn Sue Williams, John DeFerrari, Michele Casto, Kelly Navies and Jerry Garcia for their reassurance; Javier Barker and Michelle Jones for their sustenance and levity; Joellen ElBashir, Ida Jones, Kenvi Phillips, Lopez Matthews and Richard Jenkins of the Moorland Spingarn Research Center, Jennifer Morris (Anacostia Community Museum), Jon West-Bey (Prince George's County African American Museum and Cultural Center), Robert Hurry (Calvert Marine Museum), Kirsti Uunila (Calvert County Historic District Commission), Kay Peterson (National Museum of American History) and Leila Boyer (Calvert County Historical Society) for hassle-free archival research; Dianne Dale for making her family history available; Susan McNeill for generously sharing images taken by her father and letting me know the places of her youth; Barbara Moore, Ray and Jean Langston, Mary Uyeda, Robert Ford, Dr. Alfred O. Taylor Jr., Novell Sullivan, Howard

ACKNOWLEDGEMENTS

Chichester, Philip Winter, Mayor James Crudup Sr., Bette D. Wooden, Tanyna Saxton, Charles "Bob" Martin, Margaret Dickerson-Carter and Anastasia Johnson for willingness to share their memories; Andrew Kahrl for his impeccable scholarship; Beth Taylor for sharing her work with me; Koda Atkins-Mose, Marya McQuirter, Sandra Jowers-Barber and Banks Smither for their advice and guidance; and Pamela Beard, Deborah Mose, Om Fletcher and Tino Fletcher for their pushing; as well as my mother Sylverine Burt, Laura Wood, Kim Mose and the rest of my family, all of whom have contributed in their own way.

INTRODUCTION

*I*t was James Baldwin who said in "Sonny's Blues," "For, while the tale of how we suffer, and how we are delighted, and how we may triumph is never new, it always must be heard. There isn't any other tale to tell, it's the only light we've got in all this darkness."

So "how we are delighted" and where we were delighted are the tales of this book. Partaking of leisure through pleasure gardens, amusement parks, resorts, beach communities and camp meetings were ways in which the Washington, D.C. African American community was "delighted" during the late nineteenth to mid-twentieth centuries, the period covered in this book.

From the end of Reconstruction—that period following the Civil War until the Compromise of 1877—through the late 1950s, the putative termination of de facto segregation, Afro-Washingtonians went about the business of leisure where and when they could. As a Washington African American newspaper, the *People's Advocate*, put it in July 1880, "We are willing to put our race against any other in the matter of getting up and going on excursions. They will go, and there is no use talking about it."

In fact, leisure and recreation were such an important quality-of-life measure for black Washingtonians that when they had a voice in District government, they pushed successfully for passage of laws in 1869, 1872 and 1873 prohibiting segregation and discrimination based on color in public places including theaters, hotels, streetcars and parks. For a short period, they enjoyed the illusion of inclusion in the Washington area.

Custom, prejudice and terrorism, though, cast a pall on black attempts at leisure in public spaces enjoyed by whites. When this discrimination found support through court decisions such as the 1896 Supreme Court ruling in *Plessy v. Ferguson* that separate places based on race did not violate the Fourteenth Amendment so long as they were equal, the gate slammed shut. So where could Afro-Washingtonians go to enjoy leisure?

This book identifies several places in the Washington area that African Americans could claim as their own—safe havens where they could feel comfortable and able to relax without being subject to white rejection or mistreatment. Some places were black-owned; others were white-owned that catered to the black crowd; and a few others, some public, were open to blacks on special days.

The Washington African American newspapers and periodicals from the 1880s and thereafter were replete with references to or advertisements of summering. At the beginning of "the season," generally early May in Washington, the listing of one-day trips, picnics, excursions, summer boardinghouses and other forms of vacationing filled the society and ad sections. These listings lasted through late September, the end of the season.

During D.C.'s sweltering months, black people—mostly working as maids, seamstresses, laundresses, porters, street cleaners, chauffeurs or whitewashers—would save pennies from their meager earnings to take a little rest and relaxation away from their very modest and sometimes deplorable dwellings. Local steamboat trips, pleasure gardens, picnic parks and camp meetings were among the more affordable forms of outings. These excursions were a democratized form of leisure travel for nineteenth- and twentieth-century African Americans. Sponsored by churches, fraternal orders and other social organizations, the usually one-day affairs to picnic gardens or amusement parks were offered at reasonable rates and open to all members and, in some instances, non-members as well. Upcoming excursions might be announced in church a month or so before the event, and word would spread. Generally, all who could pay would be invited. Local picnic parks included Eureka, Green Willow and Madre's and were accessible by streetcar. Steamboat excursions, sometimes on vessels that were black-owned, took in Collingwood Beach, Notley Hall and Glymont, among others.

The train, particularly the Baltimore and Ohio (B&O) Railroad, made trips farther afield much easier. Not only did the B&O develop sites specifically for tourist travel, but it also offered special excursion rates. Excursion train cars would be added for traveling groups. Popular early area excursion

sites accessible by train included Deer Park, Maryland; Silcott Springs and Opequon, Virginia; and Harpers Ferry, West Virginia.

Camp meetings had broad appeal as they provided opportunities for African Americans to engage in leisure based on religious expression. They grew out of an old tradition when a slaveholder might provide a day off from the fields for a "quarterly meeting," usually conducted by a white preacher. Following emancipation, participation in these gatherings, generally held in rural settings, could be as short or as long as one wished or could afford.

There were also amusement parks visited by Washingtonians that were developed specifically by blacks for blacks. These were distinguished from picnic gardens or parks in that they offered a much broader array of amenities. Among them were Suburban Gardens of Deanwood in D.C. and Carr's and Sparrow's Beaches on the Western Shore of the Chesapeake Bay. Colton Point in Maryland and Silcott Springs in Virginia were examples of boarding resorts, while Highland Beach and Columbia Beach in Maryland were developed as vacation communities. Into the twentieth century, several more vacation or leisure spots were available in the region. These were generally more accessible by automobile.

Leisure travel during the period covered by this book enjoyed significant growth. One of the most influential factors was the technological advance in transportation, starting with the train. Theodore Corbett noted, "Expanding railroad transportation made it easier to travel, and railroad companies began to promote inexpensive vacation destinations that had not existed in the past." This also held true for steamers and streetcars and their increasing availability and affordability. For the African American leisure-seeker, however, there was still rampant bias in train travel, particularly in the South, including Washington. African American passengers would be relegated to segregated seating and treated rudely at the whim of the white conductor or passengers.

Later, the automobile provided easier access to vacation destinations within the United States and certainly within the Washington area. The African American who could afford a car would be freed from restrictions and indignation sometimes suffered in railway travel, although in many ways, the road was more dangerous. This need for precaution gave rise to early and mid-twentieth-century travel guides like the *Negro Motorist Green Book* (1936) or the *Travelguide* (1952), the latter of which assured "Vacation and Recreation Without Humiliation."

At the same time, there were detractors among the race who felt that African Americans, especially given the repression and discrimination

wrought by Jim Crow, ought to spend less time and money on seeking pleasure and more on racial upliftment. However, as stated in 1925 in "The Problems of the City Dweller," an *Opportunity Magazine* article by race leader Mary McLeod Bethune, herself a founder of a beach community for African Americans, "Happiness is usually a result of a perfect balancing of work-time, play-time and rest-time." That is why it was so important to people of color to have places they could claim for play-time and rest-time. Over and over again that sentiment was expressed—from the alley resident working as a laborer or laundress, to the principal of a colored school, to the department store delivery man, to the doctor at Freedmen's hospital—"A place of our own for people like us."

The topic of this book initially focused on Washington-area nineteenth-century African American leisure spaces, and the research relied heavily on newspapers of the time. The book was expanded to include early to mid-twentieth-century places, now subject to increasing but still limited scholarship with the added advantage that some of the places are extant. The book lists and describes a few of the sites that brought so much delight in such oppressive times. That African Americans took in leisure travel and even had dedicated places to visit is amazing. In fact, it has been said that for black people, pleasure is a revolutionary act in the face of pain. Black agency in creating and fostering patronage of places of their own is a rarely told tale but is one that this book hopes to address.

While they existed, Washington-area leisure destinations were responsible for providing relaxation and entertainment for thousands of local black people. Afro-Washingtonians had respite and were delighted.

Chapter 1

Chillin' While Colored

Pleasure Gardens and Picnic Parks

The Capitol Pleasure Club has reorganized and will give its first grand picnic, at Eureka Park, Anacostia. Monday, September 19th. The members of this club are employees of the United States House of Representatives and the Senate, and they extend a welcome invitation to their many friends to take a day's outing with them...Music will be furnished by Hoffman's Orchestra.
—Colored American, *1898*

Oh, the excitement of a day's outing, whether across town or down the river, in 1898—a place to go to relax. Perhaps the night before, mothers would be up late washing and ironing the clothes to be worn by the family—generally the best of their modest wardrobes. Women's fashions for the end of summer in 1898, for instance, comprised shirtwaists with leg-o'-mutton sleeves and dark, tulip-shaped skirts and smart chapeaux topping the head. Wives or mothers may have fried up some chicken, boiled some eggs or carved some ham. Readied along with slices from that special cake recipe, a picnic meal was set.

At dawn, the family would be roused to finish a few chores and then wash up, dress and grab a bite for breakfast. They would hurry to the streetcar to ride down to the wharf or across town to a pleasure garden. The steamer at the Seventh Street Wharf would be waiting, puffing and rocking slightly, ready to take on its excited, dusky passengers. The well-dressed excursioners might strut up and down the deck or crowd at the railings to wave farewell and catch a cooling breeze as the steamboat huffed down the Potomac.

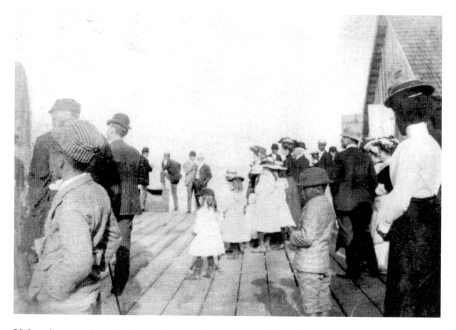

Unless the steamboat had been chartered to carry an African American excursion group, solo black travelers boarded last and rode on the lower deck. *CCM.*

A band of musicians would begin to play popular tunes of the day, their cornets or clarinets screeching into the wind.

The ticket takers at the pleasure garden or resort would be diligently collecting the presold tickets or the daily fare. Once admitted, excursioners would rush to find a place to spread a blanket and claim a spot to call home for a few hours or simply stand and look around in amazement. Almost always the grounds would hold a merry-go-round or "flying horses" to captivate the attention of the youth and carefree adults. The ubiquitous dance pavilion, staffed with the hot orchestra of the day, would call to those fancying themselves good dancers. There may also be a baseball diamond for a game between a couple of semi-pro teams or just guests. Horseshoes or quoits may call to the nattily dressed young and old men itching to demonstrate their skills and perhaps collect a few pennies surreptitiously. There were generally refreshment booths available to guests, some selling liquor, and perhaps gaming stands for a chance to win a prize.

Many pleasure gardens also were occasions for speeches and rallies, promoting a Chautauqua-like setting. Notable men and women of the day would take to the stage, generally located in the dance pavilion, and hold

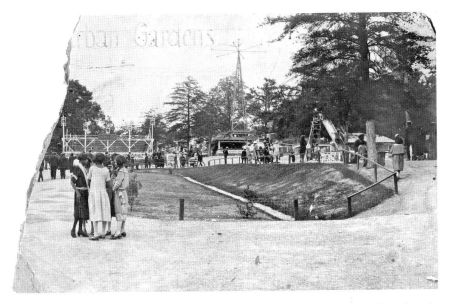

A postcard of the first-class Suburban Gardens Amusement Park, circa 1920s, the only such park for African Americans in the District. *MSRC.*

forth on the issues of the day. As elections drew close, more picnics were held to hear speeches of candidates or delegates to political conventions.

At the end of the day, the weary leisure-takers, slightly bedraggled, their formerly sprightly starched apparel now drooping and displaying patches of perspiration, would begin to make their way home. They would dredge up the strength to make one last rush of the day to catch the last streetcar, either from the wharf or from the gardens, back to their homes. For most, the next day would be a work day. Tired though they might be, they could regale co-workers or neighbors with stories of the fun and thrills of the day at the park.

Eureka Park

Eureka Park was described as a picturesque green spot just off the main street in Hillsdale. According to the *Washington Post* of June 2, 1896:

> *The panorama presented from the ground in a westerly direction is beautiful.*
> *The housetops of Washington cluster in the distance, with the Washington*
> *Monument looming up in white outlines over a cloud of smoke from the*

city's chimneys, a hazy ridge of wooded hills in the remoter background, and a steely gleam of the Eastern Branch intersecting the middle distance between the sloping grounds and the city's wharf.

The park, on less than two acres, was more of a pleasure or picnic garden, as it offered lighter amenities: swings, flying horses (the early term for merry-go-round), picnic tables, a small baseball field and a pavilion. Its additional amusements included contests and prizes, country dinners for sale and other refreshments. Park gatherings and even political rallies were often accompanied by the hottest bands in the District, so dancing was primary. Some of the more unusual activities included baby contests, pig races and ox or lamb roasts. Roasted ox, in particular, was choice eating and a gastronomic offering at many major affairs of the time.

Eureka Park probably opened in 1890. It was located on the site of the Birney School playground and parking lot and was accessible by streetcar. In fact, newspapers of 1898 and 1899 instructed potential patrons from Northwest D.C. to take the Ninth Street car and transfer at Maryland Avenue to the Pennsylvania Avenue or Fourteenth Street cars, which passed the facility. The park was entered from what is now Martin Luther King Jr. Avenue. Likely one of the earliest black-owned pleasure gardens or amusement parks in the Washington area, Eureka Park was also one of at least seven black-owned leisure gardens operating between 1880 and 1925.

Thomas M.W. Greene, a resident and owner of several lots in the Barry Farm subdivision that became known as Hillsdale, recognized the potential in the pleasure parks business. He perhaps saw the opportunity when a nearby white-owned pleasure park at Giesboro Point was closed due to fire. It had served black patrons on certain days.

Greene, a gardener, became a principal in the Eureka Park Company, which also included as officers William Thomas, a driver; Violetta Tibbs, a widow; and Annie Buckner, a domestic. William H. West, another Hillsdale resident who later worked at the Firth Sterling steel plant, served as general manager. His son was employed as the janitor for the park.

A former resident of Hillsdale stated that Eureka Park was one of "two parks that so many churches from town—from Washington—'cause then this was Anacostia—brought the Sunday School picnics and church groups and things like that." Fraternal orders and charitable and labor organizations were other groups that regularly held affairs at Eureka Park. The park was also a popular destination for Baltimoreans who came by train.

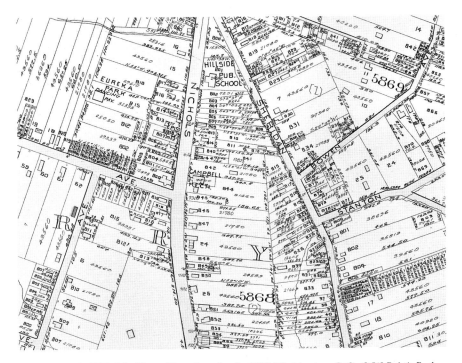

Eureka Park in Hillsdale/Barry Farm location in 1907 Washington, D.C. *G.W. Baist's Real Estate Atlas. LOC.*

Among the more unusual clubs to take excursions to Eureka Park was the newly organized Anacostia Bicycle Club, which held its first picnic there. The Needle Work Guild conducted a fundraiser to benefit indigent families. In 1910, a group calling itself the Jolly Swastika Club came out to enjoy the amusements. (The swastika was formerly a symbol for being good or for good luck.) On particularly hot days—too hot to be indoors—two or three churches would get together and hold services on the cooler and breezier grounds found at the park.

Music and dancing were important elements of the entertainment at the park. One of the most commonly featured musical groups was headed by Elzie Hoffman. Born in Washington and trained at the National Conservatory of Music in New York, Hoffman played piano, saxophone and clarinet. He is said to have introduced the saxophone to Washington. At least one of his musicians went on to play with Duke Ellington.

Given the honorary title of "Professor" or sometimes "Doctor" for his musical talent, Hoffman's day job was at the Government Printing Office. In addition, he operated a grocery store and was a civic leader in the Barry Farm/Hillsdale

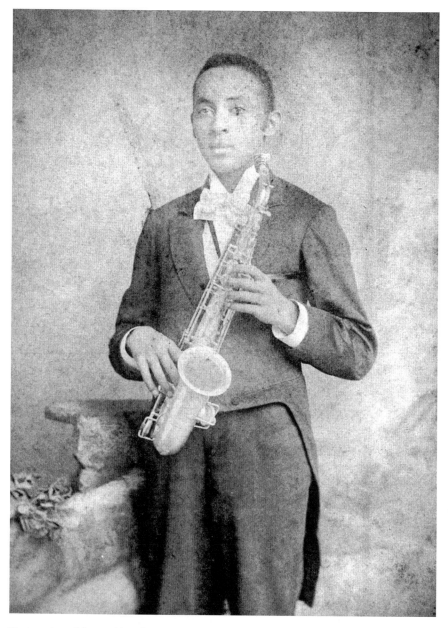

Esteemed musician and bandleader Professor Elzie Hoffman as a young man with his "axe." *Courtesy of Mrs. Ruth Hoffman Brown, ACM.*

area, having founded both the Hillsdale and Barry Farm Civic Associations. However, his band played regularly and for many different types of events, including parades, Howard University commencements, competitive cadet drills, outdoor parties and at a downtown white theater supplying music for dance scenes in films. He played saxophone for "Black Patti," the stage name for Sissieretta Jones, an early diva. In 1920, the *Washington Bee* (*Bee*) newspaper listed Professor Hoffman as one of the "Big Five" who entertained "official Washington night after night throughout the year."

Eureka Park was a frequent setting for political rallies, speeches and charitable fundraising, particularly for black Republicans during elections. Among those who gave addresses were Dr. Furman J. Shadd of Howard Medical School; Major Charles Douglass, entrepreneur and son of Frederick Douglass; Norris Wright Cuney, attorney and head of the Texas Republican Party; and J. Clay Smith, decorated Spanish-American War veteran and Elks leader.

The Blaine Invincibles Republican Club, led by Colonel Perry H. Carson, was a frequent patron. It called itself the oldest political club in the United States, and it was certainly one of the most influential in the District in its day. (The club was named for Senator James G. Blaine of Maine, who had been Speaker of the House. A candidate for president in 1884, Blaine had opposed Andrew Johnson's ending of Reconstruction and had sought his impeachment.) The Invincibles held a barbecue on June 18, 1900, for the purpose of adopting a platform and endorsing a presidential candidate after having participated in the Republican National Convention in Philadelphia. Dr. Charles Purvis; Honorable P.B.S. Pinchback, a former Louisiana governor; and Whitefield McKinley, a local businessman, were among those invited to speak. An earlier barbecue held in honor of Carson on the occasion of his election as a delegate to the 1894 National Republican Convention also drew prominent black politicians from around the country, local leaders and representatives from the twenty-two precinct clubs around the city and hundreds of others.

While Eureka Park was a source of enjoyment and relaxation for many African American patrons, not all customers were well behaved—or so the white media reported. This, in turn, led to charges that there was undue surveillance by the police, which generated unfair and exaggerated reports. When white Anacostia and Congress Heights Citizens associations agitated for closure of the park, the police actually expressed support for keeping it open. The white women of Anacostia started petition drives to close it,

Sanborn Insurance Map (1903–16) showing the locations of Eureka and Green Willow Parks in 1916. *Vol. 1. LOC.*

leading to a ruling in 1918 by the District Board of Commissioners to revoke the license for Eureka.

In 1925, the National Park and Planning Commission purchased the park for $4,000 to set up the first municipal playground east of the Anacostia River for African Americans. When the Barry Farm playground opened a year later, several community leaders, including Professor Elzie Hoffman, attended the celebratory event.

GREEN WILLOW PARK

Beginning in 1905, Green Willow Park began to receive publicity as *the* "colored" resort park operating in Hillsdale. It, too, had a dance pavilion, a merry-go-round and refreshments that included snowballs. Hoffman's Orchestra was a regular attraction, as was the Monument Orchestra, a band led by Professor Charles Hamilton that was popular with steamer excursions.

The site was in the 1100 block of Sumner Road just south of today's rental office and recreation center for Barry Farm Dwellings public housing. It was on a lot owned by Thomas Greene, who by then had pulled out of the Eureka Park venture. In a display advertisement in the *Washington Post* (*Post*) in May 1916, Greene disingenuously claimed that Green Willow had been operating on Sumner Road since 1890.

Many of the same groups that frequented Eureka Park began to visit Green Willow, an indication that Eureka Park was probably closed or had lost attraction. The park seemed especially popular with Cosmopolitan Baptist Church, the Holy Name Guild of St. Augustine Church and the renowned Amphion Glee Club. Other groups holding outings at Green Willow included the Monitor Relief Association of Naval Gun Factory and a stenographers' club, the membership of which was mainly young adults. There was even a tango contest at the park. The Elks held a picnic there for its 1910 national convention and invited boxing champion Jack Johnson to lead the grand parade. There is no evidence, however, that Johnson ever appeared.

Among speakers at Green Willow was Major Richard Sylvester, Washington's superintendent of police, who gave the keynote address for a 1916 church event. John Lankford, who became the District's first registered African American architect, also made a short speech.

Green Willow hosted a second Annual Hygenic [*sic*] Congress and Prize Baby Health Contest, in which six hundred children from three

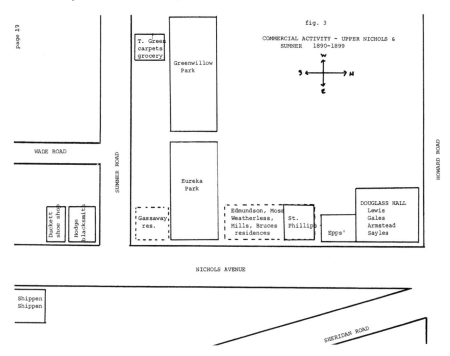

A drawing of Nichols (now Martin Luther King Jr.) Avenue and Sumner Road providing relative locations of 1890s businesses and residents. *ACM.*

months to four years of age were entered. A precursor of health fairs, there were booths with health bulletins, free examination of the babies and lectures on related topics. The most sought-after giveaways included fly swatters and fans.

Green Willow had more longevity than Eureka Park, perhaps because it may have operated as a private park available only for lease by private parties. Eureka Park seemed to have been open to all comers and private groups concurrently, as long as the admission was paid. Following the revocation of the license for Eureka Park, Green Willow's license was restricted for a period to renewal on a week-to-week basis. Groups such as the Oldest Inhabitants (colored) and the Holy Names Guild continued their annual sojourns to picnic at the park well into the 1920s.

The park was closed for part of Red Summer in 1919 when resentment toward confident black veterans spilled over into nationwide terrorism against black communities. In Washington, blacks fought back. As a result, the police on the east side of the river felt the park should be closed as a precaution. It was reopened a few days later when there were no signs of disorder in Hillsdale.

Although one of the last newspaper reports of an operational Green Willow Park was in 1927, people remembered their parents attending concerts by Professor Hoffman on Sundays and dancing there under the stars well into the 1930s. Advertisements read, "Summer nights festival—real jazz music, a country dinner and dancing begins at 7." Other residents who provided oral history for an Anacostia Community Museum exhibit recalled "attending baseball games they would have down on Fairlawn…then we had this Green Willow Park which had picnics in the daytime and dances at night."

The park closed for good sometime in the late 1930s. The property was purchased by the Alley Dwelling Authority and developed in 1942 as the Barry Farm Dwellings public housing. A portrait of Elzie Hoffman hung in the recreation center erected between the former sites of Eureka Park and Green Willow Park. It remained there—as did the memories of good times—until the recent demolition and replacement of the building. So beloved was Professor Hoffman and his contribution to the community, including the parks, that in 1976, a commemorative concert was given in his name at Virginia's Wolf Trap Farm.

MADRE'S PARK

Driving east down Rhode Island Avenue in Northeast Washington today along a community of three-story row houses and stolid apartment buildings fashioned during the early automobile era, one descends into a valley of a variety of shabby commercial structures—gas stations, convenience stores and auto repair shops. On the north side is a rise where a struggling big-box strip mall sits over the street, adjacent to a sprawling church obviously adapted from a series of large and small warehouses. This area was once a grand estate called Edgewood. It was owned by Salmon P. Chase, a noted white abolitionist who had held numerous public offices: U.S. senator, governor of Ohio, secretary of the treasury under President Lincoln and Supreme Court chief justice. When he passed away in 1873, his property passed on to his daughter, Katherine "Kate" Chase Sprague, who, beset by financial issues caused by her estranged husband and attacks on her reputation, began to sell parcels of the land to support her family.

In 1883, Moses Madre Sr. purchased roughly three acres for $825 in the Metropolis View subdivision carved out of Kate Chase's estate. There he built a home for his family of four daughters and two sons. A man of color, he and his wife, Charlotte, were from Elizabeth City, North Carolina. They most likely moved to Washington after the Civil War, settling first in the Shaw area. From the late 1860s and for most of the rest of his life, he worked as a laborer. Madre, though, as many African Americans of the time, was also entrepreneurial. Perhaps he took note of the success white leisure parks were enjoying—and the lack of similar spaces for black people—and decided to operate one on his property.

Advertising in the local black papers at the start of the season in 1891, Moses offered his park for rent for social events. He capitalized on the newly installed electric streetcar line, the Eckington and Soldier's Home, by noting that his park was located in Eckington, just a twenty-minute ride from the city. Entering a gate near the railroad tracks, a park-goer could enjoy good cool water, presumably for drinking, and a dancing pavilion. In the summers of the 1890s, D.C. people were looking for comfortable, shaded places to relax where they could partake of refreshing, clean water. Washington had many springs at that time, and Madre was fortunate to have one on his property. The park was situated off South Avenue, a street that was later absorbed into Rhode Island Avenue, in the area where the buildings of Mount Calvary Holy Church sit today.

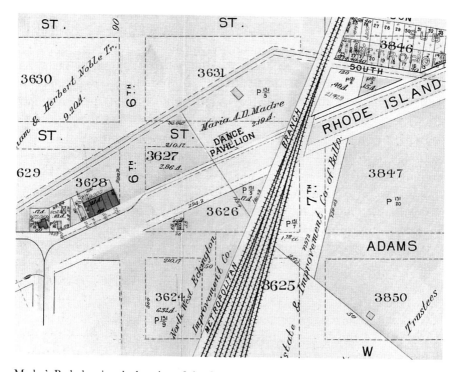

Madre's Park showing the location of the dance pavilion, 1907. Over time, the railroad chipped away at the property. *G.W. Baist's Real Estate Atlas.*

Moses Madre died in 1893, after which his daughter Marie began operating the park. Women of color in the late nineteenth century might offer lodging and meals on the premises of or adjacent to parks, but rarely were they owners of leisure gardens. Marie Madre was an exception to the rule.

Marie A.D. Madre, born in 1865, wore many hats. Educated in Washington's schools, in 1892, Marie was hired as an elementary school teacher in the D.C. Colored School system, where she would remain for most of the next forty-five years of her life. In 1897 and 1898, Marie attained law degrees—a bachelor's and a master's—from Howard University. Up to this point, she was only the third known woman of color to have graduated from Howard Law School. She was the only woman in her graduating class of thirty-one, and she was the valedictorian.

Marie Madre was the first woman elected president of the prestigious Bethel Literary and Historical Society, a position she held for several terms. A consummate club woman, she also served in the leadership of

several organizations where she shared the spotlight with other female luminaries such as Nannie Helen Burroughs, Ida B. Wells Barnett, Mary Church Terrell and Mary McLeod Bethune. The organizations included the National Association of Colored Women, the District Federation of Colored Women's Clubs, the AME Church's Temperance Department and the executive committee of the local chapter of the NAACP. Madre also headed the Virginia State Association of Daughter Elks and the District's Columbia Temple. In 1918, she married a minister who pastored several prominent churches in the area. She was thereafter referred to as Mrs. Marie Madre Marshall. Interestingly, though, in the publicity about her academic and civic accomplishments, never was it mentioned that she owned and operated the pleasure garden.

Madre began making improvements to the park and in 1902 tried to change the name to "Excelsior Pleasure Park." She enlarged the dance pavilion, added a new floor and installed electricity. Her ads claimed that Madre's had the largest and prettiest dance pavilion in town. By 1914, the park offered basketball, swings and electrical lighting for the grounds.

Madre's Park was popular with conservative groups. It was the site of numerous picnics sponsored by churches and fraternal organizations. Church groups rented Madre's annually for the Fourth of July or Labor Day. There were schoolchildren events and Sunday school outings, one featuring a pig race.

Special celebrations related to the labor movement or Republican affairs were also held there as it, too, became a venue for political gatherings and conferences of interest to Washington's people of color. In 1909, for instance, a True Reformers celebration of Labor Day that began east of the river at Eureka Park ended at Madre's Park, where several hundred people gathered to hear speeches and participate in athletic events. "Breaking news" also took place at Madre's. For example, Washington "Negroes" endorsed William Howard Taft for United States president there; and declared that General Pancho Villa was the greatest "colored" general— greater than Hannibal or L'Ouverture!

Unlike Eureka Park and Green Willow Park, there was rarely a newspaper report of unruly patrons or illicit activity at Madre's Park. There was, though, at least one incident that garnered sensational publicity. In 1913, gypsies reported that a fourteen-year-old Mexican gypsy girl, Dinah Stevens, disappeared from their camp at Madre's Park. According to the April 29 issue of the *Evening Star*, she was thought to have eloped with a twenty-six-year-old Romanian gypsy fortuneteller. The news titillated for several days

in May 1913. The couple was found two weeks later in Philadelphia, per the *Evening Star* (*Star*), whereupon the putative fiancé declared, "She will be my wife or I will die." Dinah was returned to her brother and mother at the camp at Madre's Park a couple weeks later, although her husband was detained by the police.

Within a few years, Madre's Park ceased to operate and the property was sold. Marie Madre Marshall, however, would continue her auspicious career both as an educator and as a leader in social and fraternal organizations as if the park established by her father never existed.

OTHER BLACK-OWNED PLEASURE GARDENS, 1880–1920

Brooker's Park was a short-lived pleasure garden named for its owner, William H. Brooker. It was located at Thirteenth and D Streets, SE on Capitol Hill on a site shared by the grocery store and saloon he also owned. Brooker's was more of a picnic park with a covered bandstand. Although his daughter, a budding musician, occasionally gave concerts there, the park was mostly known for hosting political rallies during the late 1890s. Several Washington-area black Republicans, including Dr. Charles Purvis and entrepreneur Robert Key, were in attendance at some of these gatherings. During one meeting in November 1897, speakers and audience members alike reacted with audible shock on being informed that John Mercer Langston, the attorney and Reconstruction politician, had passed away.

Butler's Park, owned by J. Butler, a gardener, was described as a beautiful shady grove on the Anacostia River, in spite of being plagued by mosquitoes and bordered by an unsightly pool of water. In any event, it was enjoyed by frequent Sunday school and other church groups. On July 4, 1894, it attracted a large contingent of church groups from Congress Heights and Hillsdale for a grand celebration. The *Star* reported that several church groups gathered on the Campbell AME Church grounds on what is now Martin Luther King Jr. Avenue for a flag-waving march down to Butler's Park. There they were treated to a patriotic program consisting of speeches and readings followed by "diversions peculiar to picnic parties," including "feasting" and games of all sorts. In 1904, the owner offered "bus" rides from St. Elizabeths to his park to try to increase business. However, Butler's ceased operating shortly thereafter.

The Anacostia Athletic Club practiced and played near the river and competed in leagues along the East Coast. Almore Marcus Dale is in the second row, third from the right. *Dale Family Album, ACM, gift of Diane Dale.*

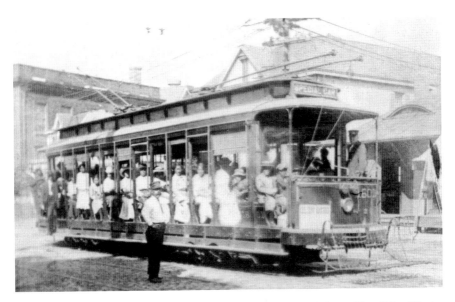

A "special" streetcar of excursioners traveling from Congress Heights to Glen Echo. Was it a special day at the amusement park just for blacks? *ACM.*

Jones Hotel sounded unpretentious in the advertisements that appear in the late 1890s in the African American newspapers. Its arboreal setting in an area that was still relatively rural would have been appealing to those looking for a quiet getaway. A May 1899 advertisement in the *Colored American* read, "A strictly first-class hostelry. Spend a pleasant day in the woods. Meals and lunches served at all hours." The owner, Moses Jones, also advertised his hotel as being near Glen Echo Park, which was located just beyond the District line in Montgomery County, Maryland, on what was Conduit Road, now MacArthur Boulevard. Glen Echo was a Chautauqua and amusement park that barred African American patrons. Most likely, Jones, like so many black owners of "resort boarding houses," accommodated African Americans who worked seasonally at white resorts. Owners frequently sought to increase their bookings and income by shorter-term rentals from summer tourists.

For a brief period, Duvall's Summer Garden operated at 2027 L Street, NW. It was opened in 1899 by John J. Duvall, who lived and ran a confectionery on the property. Advertisements in the *Bee* during the 1899 season boasted of a "large airy" pavilion, swings, cigars, ice cream and soft drinks. However, by 1903, the lot was a coal yard.

WHITE-OWNED PLEASURE GARDENS AND PUBLIC LEISURE SPACES

There were certain public parks in the late nineteenth and early twentieth centuries that permitted black visitors and some privately owned white pleasure gardens that allowed black patrons only on certain days. The privately owned would occasionally advertise in the African American newspapers and were sometimes even applauded for opening their amenities to all. But these shared spaces were rarities.

In the late 1800s, one could go to Cabin John, north of Glen Echo Park, by steamer on the C&O Canal or on land via Conduit Road on the Washington & Great Falls Electric Railway from Thirty-sixth and Prospect in Georgetown. The main features of Cabin John were the great stone aqueduct bridge, the canal and access to the Potomac River. The bridge was built during the Civil War to carry the Washington Aqueduct across the Cabin John Creek. When erected, it was the longest single-span masonry arch in the world. A drive along the canal was available, and a towpath from

Conduit Road allowed one to safely hike down to the canal and river. Black Washingtonians took advantage of the natural beauty of the site, though they were not permitted to patronize the hotel and later amusement park that operated from about 1876 until 1912. Owners of land near Cabin John went on to develop Glen Echo Park in 1891.

"A rather wide use of the public parks, Zoological Park, and Botanical Garden is made by Washington's Negro population. In these public places there is no discrimination other than the usual manifestations of race prejudice. Both races mingle freely, but are careful about maintaining their social distances," wrote William H. Jones in his 1927 study of black recreation in Washington. He also observed that on the Monday following Easter, Rock Creek Park was usually reserved by custom for African Americans. Generally, however, black use was confined to a few picnic areas.

Mary Church Terrell, famous clubwoman, educator and civil rights activist, noted in her early diaries visits to Takoma Park. She also wrote of walking from her LeDroit Park home up to the "Old Soldiers Home" to picnic and pick chestnuts on its verdant grounds. She took in Cabin John Bridge and declared that the drive in Rock Creek Park was the most beautiful.

D.C.'s Schuetzen Parks were formed in the German tradition of shooting parks where marksmanship could be displayed. One location, at First Street

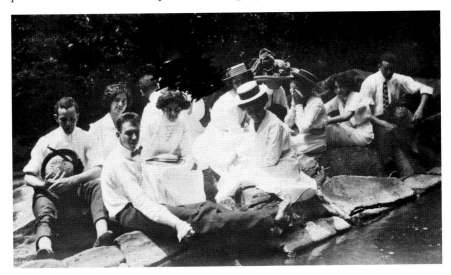

Lillian Evans (Tibbs) (second from left) enjoying Cabin John with friends before becoming world-famous opera singer Madame Evanti. *Evans-Tibbs Collection, ACM, gift of the Estate of Thurlow E. Tibbs Jr.*

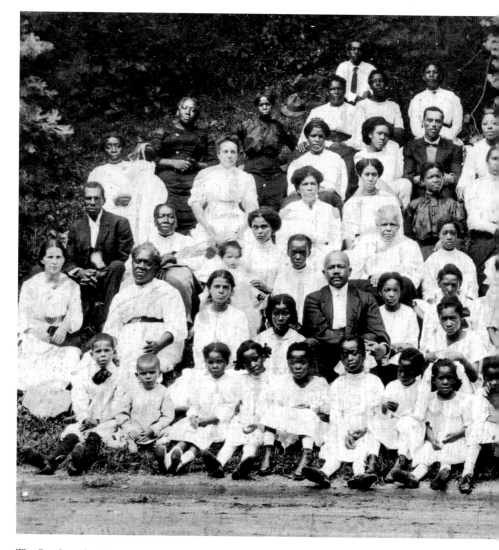

The Sunday school at Bethlehem Baptist Church in Hillsdale on an excursion to the National Zoo in 1911. *Courtesy Bethlehem Baptist Church, ACM.*

and Florida Avenue, NE, offered an array of amusements. On occasion, this park, also known as Gales' Woods, would be rented to a black group, like when it was rented to the Capital Pleasure Club in May 1883. For twenty-five cents admission, Capital Pleasure Club members could enjoy the amusements—a shooting range, air guns, a merry-go-round, croquet, swings, a bowling alley, quoits (similar to horseshoes), music and dancing

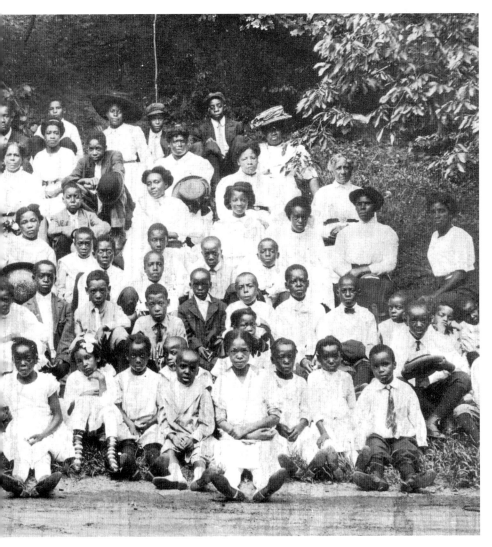

in an open-air pavilion, spring water and, of course, a beer garden—from 11:00 a.m. to midnight. The park went out of business in 1891 when new civic ordinances prohibited the sale of alcohol within a mile of the Old Soldier's Home. At the time, the most widely known Schuetzen Park was located in what is now the Park View community centered on Georgia Avenue and Kenyon Street, NW.

Palace Park on Fourteenth between T and U Streets, Van Ness Park at Seventeenth and B Streets, Bladensburg Isle in Prince George's County and Lakeview Park in Northwest D.C. were among the picnic gardens in and around the city enjoyed by African Americans. In fact, picnics could be had

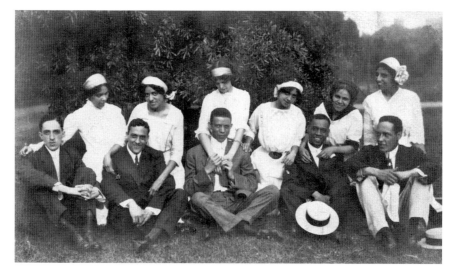

Friends and Lillian Evans (Tibbs) (second row, third from right) memorializing an undated occasion at Rock Creek Park. *Evans-Tibbs Collection, ACM, gift of the Estate of Thurlow E. Tibbs Jr.*

almost every week between May and September. "A few prominent families of Brookland, D.C., will give a basket picnic in the vicinity of Ivy City, on the 16th of August," read one announcement in 1898. Similarly, the green space of the McMillan Reservoir was a favorite retreat for people of color on the hot, sticky evenings that characterized Washington's summers.

CHAPTER 2

"LET THIS TRAIN KEEP ON RIDING"

TRAIN-RELATED RESORTS AND EXCURSIONS

*I*n her provocative discussion of the development of the blues, *Blues Legacies and Black Feminism: Gertrude "Ma" Rainey, Bessie Smith, and Billie Holiday* (1998), Angela Y. Davis notes that the theme of travel and trains is present in much of the music of the newly freed. She contends that emancipation radically transformed the lives of the formerly enslaved in three major ways: education was realizable; they could now enjoy sexual autonomy; and, most particular for this work, they were free to travel. Hence the leitmotivs of moving, freight trains, getting on board, etc. Clearly the compulsion to travel was present in the post-emancipation nineteenth century and into the decades of the twentieth century. It was encouraged by the local media and intrepid businesspersons.

The train, though, was often the scene of great humiliation for Washington blacks, especially if traveling south. Crossing into Virginia or coming east back to Washington meant being relegated to the Jim Crow car. Of course, much of this could be avoided if one were traveling in a large excursion group when, by pre-arrangement, a dedicated car had been attached or set aside.

HARPERS FERRY

The sultry summer heat of Washington sent thousands of the District's black folks to the cool rocky highlands of Harpers Ferry, West Virginia,

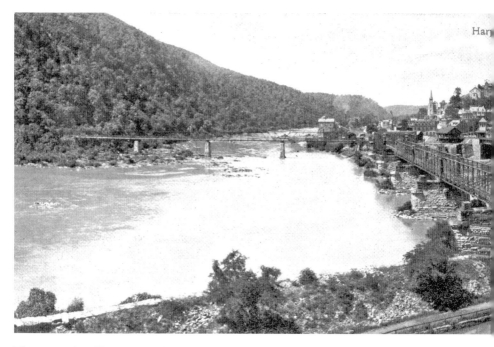

Har

The approach to Harpers Ferry from the B&O tunnel. Storer College can be seen on Camp Hill. *LOC.*

looming over the Potomac River. A two-hour ride on the Baltimore and Ohio Railroad (B&O), Harpers Ferry proved to be one of the most visited places of leisure for nineteenth-century African Americans. In various ways, it seemed ideal.

Many African Americans were drawn to the hamlet because of its significance to the emancipation struggle. Harpers Ferry was considered a spiritual place and provided an opportunity to pay homage to martyrs for the cause of freedom through John Brown's failed 1859 raid. It was thus the site of many pilgrimages and commemorative events.

Harpers Ferry also boasted a magnificent natural setting that was pleasing to those with an eye for beauty and a need to find solace in the gifts of Mother Nature. Nestled between the cliffs of two states—Virginia and Maryland—and two rivers, Harpers Ferry was a picturesque village of physical contrasts. A popular attraction was Jefferson Rock, so named after Thomas Jefferson pronounced the view from the promontory as "one of the most stupendous scenes of Nature." From the rock, one could view the tumultuous juncture of the Potomac and Shenandoah Rivers against

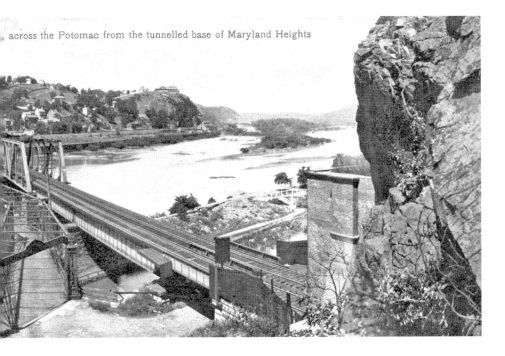
across the Potomac from the tunnelled base of Maryland Heights

the backdrop of the Blue Ridge Mountains. There was outdoor recreation such as fishing, hiking, horseback riding and carriage rides. In fact, nineteenth-century vacation accommodations at Harpers Ferry boasted of the salubrious benefits. The *People's Advocate* pronounced Harpers Ferry as the "Summer Resort" in 1877 "not because it was so advertised" but because the vacationers found its surroundings to be "conducive to both health and happiness." The advertisements appeared frequently for years in the black newspapers of the time.

When the B&O Railroad built a modern amusement park in Harpers Ferry in 1879 and made the fares from Washington affordable, the visitation rate increased exponentially. Black folks had yet another reason to take a trip to Harpers Ferry.

STORER COLLEGE

Mary Church Terrell wrote that, as a young mother, "for several summers we went to Harpers Ferry, the scene of John Brown's raid and execution. [Brown was actually hanged in Charles Town, the county

seat.] We had quarters in Storer College, a splendid school for colored youth, whose lawn was an ideal play ground [*sic*] for children." Terrell described her favorite activities as walking and climbing the nearby mountain, frequently accompanying the young daughters of other vacationing families.

Storer Normal School, later Storer College, established in 1867 to educate formerly enslaved African Americans, was run by the Free Will Baptist Home Mission and its agent, Reverend Dr. Nathan Brackett. The school was chartered in 1868 but in 1883 moved its main campus into former armory buildings contributed by the federal government and located on the hill high above the downtown. To bring in extra revenue and provide a means for students and their families to earn money and training through the hospitality business, Brackett came up with the scheme to operate tourist hotels in the buildings during the summer months.

Beginning in the 1870s, Lockwood House, a school building on Camp Hill, began taking in white summer boarders. It was managed, though, by a black couple, William Lovett and Sarah Lovett, who had moved to Harpers Ferry from Winchester, Virginia, so that their children could attend Storer. The Lovett family eventually built its own establishment, the Hill Top House, and it became Harpers Ferry's premier hotel and summer resort for white patrons.

Storer College's principal dormitory was Lincoln Hall, built on the hill with $4,000 in funding from the Freedmen's Bureau. It was a three-story frame structure that contained thirty-four double rooms to house the male students. Lincoln began to provide summer boarding for African Americans in 1877. It was operated by Storer graduate James Robinson and his wife, who developed a reputation for excellent hospitality. The number of summer roomers in 1877 was around twenty and rose to over forty in 1878. Lincoln Hall was later advertised as newly renovated and furnished, containing a large and commodious hall and a "table well supplied." Horse and carriage could be hired to view the country and places of historic interest. A room here was $4 per week (about $86 today), with special rates for families.

Myrtle Hall, the women's dormitory, opened in 1881, according to local newspaper advertisements that ran for several summers. It was described as a large three-story facility of "massive masonry at an elevation of 1200 feet above tide level surrounded by mountain scenery" and providing scenic views "overlooking the country for miles around." Its recreational activities included croquet, bathing, fishing, boating and sightseeing, all within one

The Lovett family, at Jefferson Rock, noted for their hospitality at Storer's Lockwood Hall summer boarding and later at their own restaurant, Hill Top Inn. *Author's collection.*

and a half miles of the resort. The fee the first summer at Myrtle Hall was $4.50 per week. The Hall took in over eighty boarders.

Croquet was such an important pastime in those days that the proprietor of Myrtle, Mr. William D. Wilson, took pains to describe the croquet field to the newspaper to correct any misgivings on the part of visitors over the adequacy of the facilities. The item in the *People's Advocate* read, "[The] croquet ground [is] within thirty feet of Myrtle Hall and directly overlooking this ground there are twenty-six windows. 'On account of the fences being removed and the ground enlarged,' there is at least a baker's

Myrtle Hall, seen here on a snowy day, boasted twenty-four windows from which to watch croquet games or contemplate the panoramic view. *LOC.*

dozen of trees under whose inviting shade spectators can sit and see the strokes of mallets, the velocity, collision and rebounding of balls with perfect ease and satisfaction."

Summer boarding at Storer College must have felt like the height of luxury for those who stayed there. It was close to Washington and accessible by train. Boarders were treated to delicious meals and were waited on by students eager to pass muster of their instructors. Absorbing the clean outdoors as their children roamed freely and sitting and gazing contemplatively over the countryside—all was to be had by the dusky guests and without the threat of humiliation or censure because of the color of their skin.

The newspapers reported prominent Washingtonians taking rooms on the campus during the next couple decades. Mary Church Terrell was invited to present a lecture at Storer in July 1896 for the first National League of Colored Women convention, of which she was a founder and its first president. Her topic was "The Bright Side of a Dark Subject." One wonders if she was instrumental in getting the gathering to convene at Storer based on her own pleasant experiences.

Harpers Ferry as a vacation getaway played a role in the lives of the Frederick Douglass family as well. In 1881, Douglass was invited to observe the fourteenth anniversary of Storer College and gave a memorable speech in praise of John Brown as a martyr for freedom. Proceeds from the printed speech were used to endow a professorship at Storer. A D.C. newspaper noted with a bit of irony that Douglass shared the platform with Andrew Hunter, a white state prosecutor of John Brown. Lewis, Douglass's son, was invited to speak at a later Storer commencement.

Other Douglass family members visited there as well. Frederick's granddaughter Annie Sprague Morris, who was to pass away in 1893, spent the last summer of her life in Harpers Ferry. In fact, Douglass's daughter Rosetta Sprague wrote to her father and mentioned being in Harpers Ferry in July with Annie, who had fallen ill from a difficult pregnancy and had to be attended by a doctor. Rosetta, though, found her "comfortably provided for and cheerful." Annie was joined later that summer by another member of the family, her sister Fredericka. From all accounts, Annie's health was buoyed, at least temporarily, by the invigorating atmosphere of Harpers Ferry.

Vacationing at the hilltop paradise, though, was soon to come to a close. Whether it was the sign of the times or truly a financial consideration as was proffered, the trustees determined that it could no longer support putting up black tourists for the summer. Storer as a summer resort was not profitable, and the college was losing financial support from the state. Newly established land grant colleges elsewhere in West Virginia were now receiving the bulk of state funds.

Brackett claimed to have opposed the change. However, by the summer of 1896, the Lincoln and Myrtle dormitories were closed to black boarders; Lockwood House remained open to white vacationers in spite of the fact that this endeavor was also unprofitable. The highly successful J.R. Clifton, an 1875 graduate of Storer, attorney and newspaper editor in Martinsburg, West Virginia, launched a harsh attack against Brackett and the college's trustees. Using all the tools at his disposal, most specifically his newspaper, Clifton unsuccessfully tried to reverse the obvious capitulation to the increasing Jim Crow influence. One wonders what the decision might have been had Frederick Douglass still been alive and on the board of the college.

In any event, Harpers Ferry and Storer College ceased to be a welcoming and guaranteed place to summer. White hostility, long since simmering, became more apparent. Some vacationers still came for overnight stays but boarded at the few private and black-owned houses in town. One

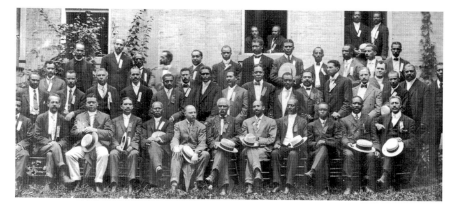

Delegates for the first public meeting of the Niagara Movement in front of Lincoln Hall on August 17, 1906. *NPS.*

boardinghouse, run by a Mrs. Sparrows, was, in actuality, a campus building that had been leased to her.

Storer College continued to permit black organizations to hold conferences or meetings on the campus on occasion. Thus, the Niagara Movement was able to hold its 2nd annual conference there from August 15 to 18, 1906. Attendees roomed in the dormitories. The commemoration of the 100th birthday of John Brown seemed a propitious and sacred moment for an organization attempting to address the racism and subjugation that permeated relations with white America. Headed by W.E.B. Du Bois with Clifford as his lieutenant, the movement, the forerunner of the National Association for the Advancement of Colored People (NAACP), brought one hundred delegates to the lofty setting of Storer College.

By this time, the fort associated with John Brown had been dismantled, taken to the World's Fair in Chicago and brought back and reassembled on the Murphy farm near the college. The Niagara delegates rose early on the morning of August 16, 1906, and walked solemnly to the farm, where they removed their shoes and socks and paid prayerful and musical homage to John Brown and the martyrs for freedom. Then they turned around and walked the half mile or so back to the campus to renew the business of how to deal with a hateful America.

Du Bois attempted to hold the succeeding year's gathering back at Storer but was denied. The already shrinking contributions to the college had reduced further following the 1906 conference. The college's donors threatened to withdraw all support if Storer opened its doors again to the likes of the radical Du Bois.

Du Bois apparently had no hard feelings, as he would write in *The Crisis* of 1912: "Those who attended the Niagara movement conference at Harper's Ferry in 1906 remember the delightful situation and excellent fare at Storer College. Harper's Ferry is one of the excursion places which many colored people make their Mecca in the summer months."

Island Park Resort and Amusement Park

Say, John, I heard the other day
From sister Phoebe Perry
The Hillsdale folk across the way
Will go to Harper's Ferry.
When do they go and on what date?
I think I can remember,
Oh, yes, I heard our preacher say
"The fifth day of September."
Of course you know I will be there
And bring my wife and daughter
If I can only raise the fare,
One dollar and a quarter.
—*Solomon Brown, undated*

Excursionists to Harpers Ferry were not necessarily interested in viewing the commemorative plaques telling the story of the John Brown raid or hiking up to Jefferson Rock for the remarkable view or even boarding for a night at Storer College. They were going to spend the day at the B&O Railroad's Island Park Resort and Amusement Park.

Island Park Resort was a B&O innovation—a way to reward its employees by furnishing them a place of leisure. It was also a marketing strategy to induce passengers to pay fares and ride its cars. The railroad company transformed the Potomac River Byrnes Island, a local picnic garden, into a first-rate amusement park accessed by a footbridge with a five-cent toll. A quick meal could be enjoyed at a lunch house, a dining tent or from various refreshment stands. As always, one could take a spin in the dancing pavilion where an orchestra of some esteem plied its magic from a bandstand. For the thrill seekers, swings, a carousel and even a Ferris wheel were available. For

the physically active, there was tennis, a skating rink and the ubiquitous sport of croquet. Later, baseball games were introduced. It was said that during the 1883 season alone, the B&O brought 100,000 people to the park. Mixed among the throngs were generally plainclothes B&O police.

Hillsdale's own Solomon Brown, a noted intellectual, politician and clerk to the first three secretaries of the Smithsonian, organized the annual event for his Southeast Washington community. He was alleged to have always announced the season with a poem. The one quoted captures the excitement of excursioning among nineteenth-century people of color.

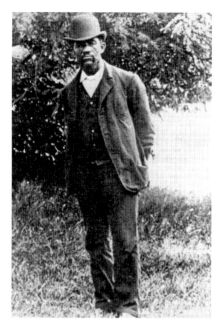

Solomon Brown, Hillsdale citizen extraordinaire, shared his love of poetry, history and technology with his community. *ACM.*

At that time, school shoes cost fifty cents and a quart of ice cream was thirty-five cents. Two dollars could buy a small boy's suit; and a dollar and fifty cents had two dozen bottles of Heurich lager delivered to your home. But for a dollar and a quarter, three could ride the train to Harpers Ferry and enjoy a resort. Thus, for Washingtonians, a one-day excursion to Island Park Resort provided an affordable opportunity to picnic and enjoy the sights and amusements. Thousands of African Americans were able to visit the picturesque hamlet through the endless excursions sponsored annually by churches, fraternal lodges and other social organizations.

Resorts and amusement parks were highly segregated. Those hosting black visitors generally had days set aside for their visits so that white and black patrons never mixed. Island Park was no exception. As an example, local newspaper the *Spirit of Jefferson* reported that on Tuesday, August 24, 1880, 800 colored excursionists from Frederick, Maryland, came, and the following day about 1,500 whites from a Catholic church in the same town visited.

The railroad offered special rates for large groups and provided them with their own cars for the trip. Sometimes as many as ten to fifteen railroad cars would be added. For example, in August 1899, Washington's Zion Baptist

Sunday school held its annual outing on a Tuesday, leaving from the station at New Jersey Avenue and C Street and traveling in eight train carloads. Many of these large group excursions were on weekdays.

Even if one were not so inclined to visit the park or even Storer College, the train ride itself to Harpers Ferry was thrill enough, especially after 1892 when a tunnel was opened. As described in the B&O literature of the time, the ride provided

> *a view so sublimely beautiful as to be everlastingly impressed on* [one's] *mind. The train passes…clinging to the side of the mountain like a creeping thing avoiding the water beneath. The mountain seems ready to topple over on the traveler looking up to ascertain its height. An impassable wall of stone appears abruptly ahead; when suddenly the train disappears into total darkness for less than a minute, then breaking into daylight with such a magical effect as to hold the traveler in speechless amazement of the scene presented—this is Harper's Ferry.*

Erosion and lack of continued investment by B&O took their toll, and Island Park was eventually closed, most certainly by 1924 when the footbridge washed away. Even as early as 1917, the local paper reported that a recent trainload of spirited young men headed to military camp was reminiscent of the days when trainloads of excursionists rolled into Island Park. One of the last reported visits was by a large contingent of black Elks from Washington who came near the end of the season in September 1915.

A final memento of the park is its bandstand, which has been restored and now sits in the town square of Harpers Ferry. There are numerous ghost stories and alleged sightings of the spectral kind. During its life, however, Island Park was responsible for bringing pleasure to scores of Washington African Americans, providing not only entertainment but also an opportunity for many to ponder history that related to their lives.

OTHER RESORTS BY TRAIN

In an August 21, 1880 *People's Advocate* article entitled "Out Doors in Summer by 'Joyce,'" a question was posed: "Do you really want to spend your summer vacation where you can rest and enjoy yourself, where you can for a time be as free and indolent, and happy as a…man may wish to be? Then

One could take the Hagerstown and Frederick Railway up to Braddock Heights. The nearby amusement park of the same name was segregated. *Author's collection.*

shun these popular resorts…and seek some sequestered nook amid rural scenes." Many black Washington leisure-seekers took the advice to heart and found respite at places in Virginia like Catlett's Station and Marshalls Cottage at Fauquier Springs, Fauquier County; and Berkeley Cottage in Lewinsville, Fairfax County. Blue Mountain House in Washington County, Maryland, apparently also offered accommodations to people of color. One group in 1895 was reported to have taken a moonlight excursion probably via the Western Maryland Railway from Blue Mountain to Waynesboro, Pennsylvania, where it attended an Academy of Music concert sponsored by the local AME church. The members of the group then "refreshed themselves at a neighboring soda fountain" and returned to the mountain.

DEER PARK

The B&O had developed other resorts at stops along its routes. Some of these stops—particularly in beautiful locales where the train would allow passengers to disembark to refresh themselves—were made into actual destinations in and of themselves. In a few choice locations, fancy hotels were developed and amenities and activities were designed to entice travelers to stay for a few days. B&O would also offer special "excursion" trains to further sweeten the deal. Deer Park, in the mountains at the far edge of Garrett County, Maryland, past Harpers Ferry, was the first of these.

From D.C.'s attractive 1851 station at New Jersey and C Streets, one could travel to the sumptuous resort hotel, opened in 1873. Deer Park was heavily promoted by the B&O and became a favorite resort for the wealthy and prominent white citizens of the Washington area. Presidents Grant and Harrison were among its guests, and William McKinley visited the establishment before he became president. It was also the site of President Grover Cleveland's 1886 honeymoon, his marriage to Frances Folsom having the distinction of being the only one to take place in the White House. Deer Park offered a swimming pool, Turkish baths, carriage riding in the crisp air and pure spring water and top-notch service and meals.

Deer Park the community, however, was also visited by Washington's people of color. It was one of a few white resorts cryptically advertised in black newspapers of the time in the form of letters to the editor. The July 31, 1880 issue of the *People's Advocate* featured a long letter signed "Mountaineer." It starts, "I judge that a word to the many readers…from this place will be very acceptable, inasmuch as there have been many contradictory reports circulated in your city about it, some calculated to prejudice the minds of many against it…As delightful summer resorts, conducive to health and pleasure, Deer Park and Oakland are far-famed."

In this instance, clarification of an open invitation to African Americans was necessary, as Deer Park was located in an area associated with Democrats, the party that opposed Reconstruction and full enfranchisement for freedmen. The letter, though, took particular pains to note that Oakland, one of the attractions of the area, was open to all visitors. Oakland was the country estate of the Democratic senator Henry Gassaway Davis of West Virginia, who was also a large landholder in the area.

The same letter contained accolades for Mrs. Coleman's boardinghouse, which provided lodging for people of color. "Mrs. Coleman's" was most

B&O excursions began from this tasteful train station until 1907 at New Jersey Avenue and C Street, NW, across from the present-day Teamsters Headquarters. *MLK.*

likely the home of Mr. and Mrs. Coleman Dandridge, residents of Oakland town, a railroad and logging settlement. Coleman, a coachman, and his wife, Caroline, listed as a "washerwoman" on the census, were with certainty the proprietors of the summer boardinghouse.

A visitor to the Dandridge house could expect to be picked up from the railroad station; boarded in a clean, quiet room; and provided hearty home cooking. For entertainment, carriage rides in the country, hiking, a visit to Oakland estate and croquet were among the activities. Washington visitors included the Grimkes, Mintons and the Moten sisters, Lucy being the principal of Miner Teacher's College at the time. Mrs. Belle Kelley and her husband, Thomas, also visited, but unfortunately for Belle, a mishap there caused her to lose a finger.

Loudoun County, Virginia

The Capital City Guard of Washington advertised in the *People's Advocate* of August 4, 1883, an excursion to Leesburg. This trip of some forty miles from the Pennsylvania Railroad station on the Washington and Ohio, later the Southern Railway line, cost fifty cents. The train departed Washington at 9:30 a.m. "to give Ladies and Children plenty of time to get to…the depot" and returned from Leesburg at 9:30 p.m. in time for all to catch the streetcars.

Loudoun County's annual September 22 celebration of the Emancipation Proclamation attracted many Washingtonians for a day of festivities and fellowship. The Loudoun County Emancipation Association had begun holding the fête in 1890. It eventually bought ten acres in Purcellville, erected a pavilion for its activities and laid a field for baseball. Referred to as Emancipation Grounds, its actual name was Lincoln Park. Emancipation celebrations featured prominent speakers, including Nannie Helen Burroughs, attorney Charles Houston and Howard University president Mordecai Johnson. Over the years, interest diminished, and in 1971, the association sold the property and dissolved.

Hillside Retreat, or Webb's Cottage, in Silcott Springs, was immensely popular. Described as "one of the prettiest groves for the amusement of the guests than any summer resort in that section of the country," the site was in Quaker Country near Round Hill at the foot of Black Oak Mountain. It offered mountain springs, lake fishing and games such as quoits and, of course, croquet. One of the attractions was the large variety of fish in its pond—over two thousand species. Another was the "hammock villa," a line of hammocks surrounding a portion of the large stone cottage. One was assigned to each guest for the duration of his or her stay.

Operating from the stone house that may have dated to the eighteenth century, John and Susan Webb were renowned for their hospitality. They may have even accommodated white patrons at certain times of the year, especially when the area was known for its mineral springs. In any case, many Afro-Washingtonians took summer respite there dating from the late 1880s until the second decade of the twentieth century. The salubrious climate of Silcott Springs led Senator Blanche Bruce and his wife, Josephine Willson Bruce, to board their son Roscoe there for several weeks in 1893 as he was recuperating from an illness. The family of minister and educator F.L. Cardozo Sr. spent time there in 1905.

Other Loudoun County places mentioned in the turn-of-the-nineteenth-century rags included Snickersville at the base of the Blue Ridge Mountains.

It was a favored destination for one-day picnic and sightseeing excursions. Hiking to Bear's Den, a popular activity, provided magnificent views of the Loudoun and Shenandoah Valleys. Given the more appealing name Bluemont in 1900, the village had the highest elevation in Loudoun County. The year 1900, though, was also when the Washington & Old Dominion Railroad's Bluemont line segregated its passenger cars to conform to a new Virginia state law.

Tokes Cottage

The *Colored American* reported in August 1898 that those visiting Opequon boarded at Tokes Cottage. This was another rural scene enjoyed by Washingtonians, one that would meet the approval of "Joyce," who advised leisure-seekers to avoid the trendy places.

A picturesque eighteenth-century village located in Frederick County near Winchester, Virginia, Opequon was one of the first white settlements in the Upper Shenandoah Valley. During the Civil War, both Union and Confederate forces used its crossroads. Later, it was a stop on the B&O Railroad.

Tokes Cottage, the mountain "home away from home," was built in the 1880s as the residence of the John and Hester families who had been enslaved on Greenwood, the major plantation in the area. The families ran it as an inn, most likely catering to whites but permitting black boarders during certain periods. Visitors could expect crisp mountain air, fresh spring water, good food, hayrides, croquet and tennis.

On July 22, 1908, Mary Church Terrell, an inveterate traveler, noted in her diary: "The food served here is excellent. The best rolls I have ever tasted. Today I took a long walk by myself and found the way to the mountain about two miles from the house and climbed to the top." During her month in Opequon, she hiked almost daily, sometimes with her two daughters and sometimes with fellow guests from Washington. She also played tennis and went horseback riding.

Tokes, amazingly, was operated by family members until 1998. The building is now part of a National Register Historic District.

Carlin Springs

A bit closer to Washington was Carlin Springs, Virginia, a leisure garden developed by the white Carlin family. Their intention was to take advantage of the fact that the Washington & Old Dominion trains stopped there for water for their steam engines. Located in Arlington County near Four Mile Run, the park touted itself as a Sunday excursion destination providing relief from the heat of Washington summers. It was leased on occasion to black organizations. In addition to its cool and picturesque setting with brooks and trees, its other amenities included a picnic area, dance and dining pavilions, an ice cream parlor, a restaurant and a bar that was closed when church groups rented the site. Like the black parks in town, political rallies were also held there.

During the 1880s, several Washington churches and fraternal groups were reported to have visited. Second Baptist Church sponsored a fundraising

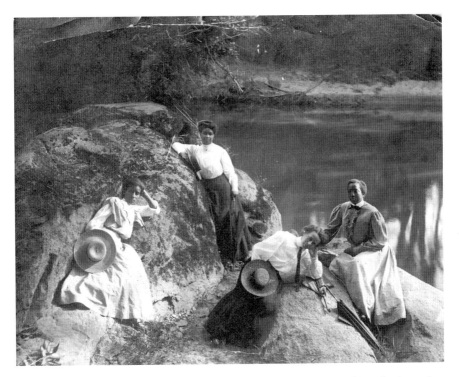

The Great Falls Amusement Park was off-limits to blacks, but Henrietta Quander (second from left) and friends could enjoy the scenery. *MSRC.*

day trip on August 15, 1880. The train fare was sixty cents round trip. The Eureka Lodge of the Masons also visited in August 1880.

Carlin Springs resort, though, was short-lived. Steamboat excursions and other parks began to siphon off its patrons. This was likely why it was offered to black groups before finally closing. In 1888, the property was sold and the buildings demolished. It was eventually subdivided for the community of Glencarlyn.

SAMUEL PROCTOR'S

Samuel Proctor's establishment was utilized primarily by those black Washingtonians "who, by reason of their business, are unable to make a prolonged stay at any of the summer resorts," wrote the *People's Advocate* on August 21, 1880. Sixteen miles from the District in Rockville, Maryland, the boardinghouse run by Proctor and his second wife, Alice Harris Proctor, was accessible by the "Western train" of the B&O Railroad. The prospective boarder would be met at the depot by a wagon for the half-mile trip to Proctor's. The large house with a wraparound porch was situated on the crest of a hill, furnishing a view of Rockville below and mountain ridges in the distance. Various trees dotted the grounds and provided shaded relief from the relentless summer sun.

The home, which Proctor had expanded, could accommodate up to thirty persons. It offered archery, croquet and access to a cool spring located on the property. Additionally, the comestibles were most likely top notch, as Samuel Proctor was a famed caterer who also ran the Senate restaurant in the Capitol from the 1860s to 1880s. At his home, genteel evening activities included cards and sometimes dancing or simply listening to a musical performance generously shared by a talented guest. Weekend boarders may have found a local minister there on a Sunday morning delivering a sermon.

Deeply involved in Republican politics, Proctor was one of several African Americans who made national news in 1872 after ignoring the advice of the former abolitionist and liberal Senator Sumner and choosing to endorse the corruption-riddled incumbent president Ulysses Grant over Horace Greeley. Greeley, though a liberal Republican, had supported the ending of Reconstruction and the absolution of Jefferson Davis rather than treating him as the criminal that he was.

Proctor's "resort" enjoyed favorable publicity, particularly from the prickly *Bee*. Proctor had averred that his enterprise was not established to make

money beyond covering his expenses but that he had opened his home to surround himself with "a class who are mutually agreeable." That "class" included relatives—the families of his brother Charles Proctor and half brother librarian Daniel Murray—and guests such as Mrs. John Mercer Langston, wife of the congressman and diplomat; Civil War hero Christian Fleetwood; and the wife of D.C. attorney Milton Holland.

Unfortunately, Proctor developed tuberculosis and had to give up the resort business. He moved back into Washington to Hillsdale and passed away in 1887.

CHAPTER 3

"ROLLIN' DOWN THE RIVER"

STEAMBOAT-RELATED AMUSEMENT PARKS AND EXCURSIONS

In August 1876, the Fifteenth Street Presbyterian Church sponsored a family trip to Glymont on the Potomac for seventy-five cents for adults and forty cents for children. "The Steamer *Mary Washington* will leave her wharf at the foot of Seventh St. promptly at 9 o'clock a.m. and 4 o'clock p.m. stopping at Alexandria both trips," read a July 22, 1876 advertisement in the *People's Advocate*. This was one of the special days set aside for black patrons. Some twenty years later, a black-owned steamboat company was able to lease the Glymont landing for regular "colored" excursions.

Summertime steamship excursions down the Potomac were extremely popular as they offered a break from the oppressive heat of Washington and its brick and asphalt settings. The boat rides and river resorts were a favored and affordable pastime from the aftermath of the Civil War through the twentieth century. Churches, fraternal organizations, labor groups and social clubs frequently sponsored trips as fundraisers or as membership perks. Individual blacks were prohibited from simply going to the ticket booth at the Seventh Street Wharf and boarding a steamship headed for a river resort unless the steamer had been booked for a "colored" excursion. Booked group trips were the only way that most people of color could visit these verdant and breezy venues as tourists.

Early steamship "resorts" were generally like the modest pleasure gardens in town—a clearing for picnics, swings and a pavilion and music for dancing—except there was water and a wharf. One such place was

The busy nineteenth-century Seventh Street Wharf in Southwest. Some black excursion boats were permitted to dock there. *LOC.*

known by several names: Giesboro Point, Tivoli Park and City View Resort. Operating at various times from about the 1870s to 1890s under one of the three names, the resort was located southwest below St. Elizabeths Hospital and proffered one of the best views of Washington.

It was a short jaunt by steamer from the Seventh Street Wharf or a scenic but longer buggy ride over the Eleventh Street Bridge, up Nichols Avenue past the asylum and down what is now Malcolm X Avenue. Leisure seekers came to the property once owned by one of D.C.'s largest slaveholders, Notley Young. The estate was used during the Civil War and housed the largest cavalry depot in the nation. The plantation house anchored the leisure park. Its days as a resort ended temporarily in 1888 when the mansion accidentally caught fire. It reopened the following year and, at least through 1891, was a stop on a steamship line.

Into the 1890s, more amenities were added to local pleasure gardens in general following the Coney Island/Luna Park model whose innovations in amusement park provisions had become instant sensations and serious revenue generators. An example was the genteel park at Marshall Hall, a former plantation on the banks of the Potomac in Maryland opposite Mount Vernon. Marshall Hall had been noted for its cool piazzas, shady trees and lovers' lanes. It offered jousting tournaments, planked shad dinners and a strict barring of "objectionable characters" (code term for "Negroes")

Giesboro Manor, a former estate owned by slaveholder Notley Young, anchored a pleasure garden. Newspapers enjoyed calling it the "Old Young" house. *LOC.*

from its park and from the steamers that serviced it. By 1895, though, it had added a Ferris wheel.

Notley Hall, another former plantation closer to Washington but also in southern Prince George's County, Maryland, had become a favorite destination. It offered a "large Dancing Pavilion" and amusements that included "Flying Horses, Shooting Gallery, Riding Tracks, Swings and Bowling Alley." It quickly opened its grounds to black patrons, first on an occasional basis and then regularly. On August 17, 1895, 1,500 to 2,000 people attended an outing at Notley Hall given by black entrepreneur Robert Key.

Travelers could take the *River Queen* from the Sixth Street Wharf to Glymont, Notley Hall or Lower Cedar Point, once called the "Coney Island of the Potomac." The old 181-foot side-wheeler was reputed to have been President Lincoln's favorite and was, in fact, the vessel he traveled on to Richmond two days before his assassination. In preparation for the 1898 season, the steamer was said to have been refurbished and was ready for "colored excursions." In June 1898, for example, a schedule of excursions on the *River Queen* was printed in the *Colored American* and listed sponsors: Key's Grand Benefit, Young Men Dramatic Club, St. Dominic Aid Society,

Metropolitan Baptist Church, Gay Hearts Social Club and Odd Fellows of Georgetown, among others. A trip conducted by the Young Men's Protective Club on June 24, 1898, was twenty-five cents round trip and fifteen cents for children. Music was to be provided by the Monumental Orchestra, which played, as well, for the church groups that visited Notley Hall.

An example of the typical schedule of an excursion by steamer was one to Lower Cedar Point on the Potomac in St. Mary's County. The vessel left the wharf at 8:30 a.m. and arrived at the resort destination at 12:30 p.m. For the next three hours, tourists could enjoy "salt-water bathing, fishing, crabbing" and a dancing pavilion where they could meet people from the surrounding area. When the whistle blew around 4:00 p.m., the steamer would depart and arrive back in Washington between 7:30 and 8:30 p.m. Israel Colored Episcopal Church took a trip down on the *River Queen* on July 14, 1898, according to the *Bee*. The *River Queen* also offered well-attended all-night or moonlight cruises to Lower Cedar Point until the local white people objected to all-black patronage.

The obvious truth behind steamboat excursions is that they were highly segregated just as other leisure sites were. Afro-Washingtonians, as blacks elsewhere, though, were hungry for places to relax and recreate freely and, in the summer in particular, ways to stay cool. The amusement business,

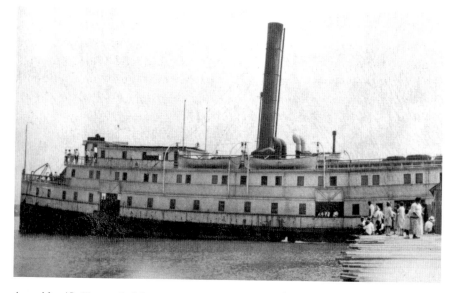

An unidentified but typical Potomac steamboat loading passengers, circa 1910. *Dale Family Album, ACM, gift of Diane Dale.*

then, coupled with real estate speculation, was one of the few ways that black entrepreneurs could make a dime and meet the demand. After all, there were several ragged steamboats left over from the Civil War and many nonworking tobacco plantations. The excursion enterprise engaged in by African Americans had the added virtue of appearing as race advancement in the face of doors being closed to the promise of full citizenship and all the rights and privileges that went along with it. As Booker T. Washington would pronounce at the formation of the National Negro Business League in 1900, "There must be for our race, as for all races an economic foundation, economic prosperity, [and] economic independence."

What was needed to run a steamboat excursion business besides the obvious—capital and a fit vessel—was a place to dock at the beginning of the trip to take on passengers, permission to dock at the destination, license to disembark at the end of the trip and respect from local authorities who trusted that one knew how to run one's business. Black entrepreneurs rarely had all the ingredients. There were, however, at least five black-run steamboat ventures in Washington.

J.W. Patterson

J.W. Patterson used churches to invest in his company, the Peoples Transportation, which, in turn, purchased the *Lady of the Lake* steamboat for an excursion and freight business from Washington to Norfolk, Virginia. Along the way, it would make tourist stops at Glymont and Colonial Beach. The latter locale was dropped due to complaints from local whites. Most of the steamers proffered bars where alcoholic beverages were sold. *Lady of the Lake* was no exception. Patterson hired a white man from one of the local Southwest D.C. gangs as his bartender, thinking this would lend some protection from sometimes rowdy patrons since the *Lady of the Lake* had white passengers and was not yet strictly in the "colored excursion" business.

However, once the excursion business began to go well for the Peoples Transportation, white shippers got together and shut Patterson out of the freight trade. According to Andrew Kahrl's detailed study, dockworkers were threatened with job loss if they handled any "colored" freight to or from the *Lady of the Lake.*

Then, whites joined the "colored" excursion business and began giving big discounts and donations to heads of black churches and organizations to pull trade from Patterson. Soon, he was barely able to meet his expenses. He

was undeniably unable to pay the promised dividends to the investors who had believed in him and given him their hard-earned dollars. When a fire destroyed the boat in February 1895, his bartender alleged that Patterson paid him to set the fire so that he could collect the insurance money. Though Patterson was charged, the court determined that the accuser was unreliable, and Patterson was acquitted in July 1895.

Meanwhile, the undaunted Patterson "came off the ropes swinging" and went back into the ring for another round of punishment. In May 1895, just past his troubles with *Lady of the Lake*, he bought the *Jane Moseley*, an ancient steamer out of Baltimore. He was able to secure a lease on Collingwood Beach, near Mount Vernon, which had been leased and developed by white captain L.J. Woolen exclusively for the "colored excursion" business. Woolen, of the steamer the *Pilot Boy*, had invested in making Collingwood a first-rate amusement park. He installed a pavilion, an early form of roller coaster, a merry-go-round, swings, boats and bathhouses. Woolen had opened for business in 1888. When Patterson took over the leisure park, he renamed it Douglass Beach in honor of America's best-known black man who had recently passed away.

Patterson's schedule quickly filled up, especially following several promotional trips. Then tragedy struck in the form of sheer cussedness. On a particular trip, the white captain of the *Jane Moseley* claimed that the waters off Douglass Beach were too shallow and the offshore pilings too deep for safe docking. As a result, passengers had to be ferried from the belching steamer sitting in the middle of the river to the beach. A few days later, according to the May 31, 1895 *Star*, the captain announced that he was refusing to make another trip to Collingwood. He then promptly called for police backup, anticipating a violent backlash from the three thousand expectant and excited excursionists from St. Augustine Church who had already paid their fare and boarded the ship. This was Decoration Day (Memorial Day), Patterson's largest booking of the season. Patterson was unable to convince his own captain to simply take the customers on a cruise down the river and back as an alternative.

When a force of about twenty police officers appeared prepared to break up a riot, they instead found resigned parishioners in their best clothes singing, dancing and picnicking on the boat. A few days later, Patterson sent the *Jane Moseley* back up to Baltimore to its "real owners," since, as the captain pointed out, Patterson had only made a down payment. Though Patterson's ensuing lawsuit was settled out of court for a fraction of what he put into his startup, he was out of the excursion business and turned to real estate.

The developers planned to offer a Chautauqua-style resort rather than the Glymont's amusement park design. The facility they were going to establish on their newly purchased eighty acres of land would be a "pleasure resort to outstrip Colonial Beach and every other resort of the white people on the Potomac." Colonial Beach, located on the Potomac and associated with the nearby birthplace of George Washington, was a first-class resort and amusement park into the mid-twentieth century but was off-limits to black tourists.

The Cobb Island cartel sought to create an all-purpose resort, according to the August 10, 1895 report in the *Afro-American*. A portion of the grounds would be allotted to excursionists and "transient pleasure seekers" who could enjoy entertainments such as the ubiquitous dance pavilion, rifle range, bowling alley and shuffleboard. This part of the park would be sectioned off from the area that would be devoted to camp meetings, teachers' institutes and other Chautauquan assemblies. The area of more intellectual and spiritual pursuit would hold an assembly hall and cottages for overnight stays.

Two years into National Steamboat Company's steamer/excursion business, the engine of the *George Leary*, already ancient when purchased, failed. Additionally, the Cobb resort project had never gotten off the ground, perhaps because the island was battered by severe storms during the same period such that in 1897 even the lighthouse was washed away. "The gales have submerged the island and the surf breaking over the life saving station washed away the cook house, oil house and boat house," causing the crew to have to abandon the island, according to the October 26, 1897 *Wilkes-Barre Record*.

Lewis Jefferson and Notley Hall/ Washington Park

Notley Hall, the plantation estate that was largely unoccupied during and following the Civil War, was sold in 1870 to a white Pennsylvania family. Upon the death in 1887 of the family patriarch, the 246-acre property was ordered sold by the Prince George's County Equity Court, which described it as "a large and substantial brick dwelling consisting of six rooms exclusive of cellar and attic, three tenant houses, stable, hay barracks and other outbuildings…adjoining the Fort Foote steamboat landing," the latter of

NATIONAL STEAMBOAT COMPANY

Some of the Peoples Transportation investors, though upset at Patterson over the *Lady of the Lake* failure, decided to make a go of it themselves. In January 1895, they formed a new company that they named the National Steamboat Company. Some of the company directors were among Washington's more prominent and stable citizens, including Robert Key, Ferdinand Lee and Daniel Webster. They purchased the *George Leary*, a 242-foot triple-decker vessel that could carry up to 1,500 passengers and took the same route as the *Lady of the Lake*. A barbecue held at Glymont to promote their business drew some 5,000 persons.

Audaciously, the National Steamboat Company announced before the end of the summer its intention to develop a resort from the ground up on Cobb Island in Charles County, Maryland. An article in the *Bee* on July 27, 1895, advertised the establishment of "A Colored Saratoga" on Cobb Island on the Potomac: "The educated and gifted members of the colored race… have schooled themselves to resignation and have not allowed themselves to think that they too could have their summer resort, their Chautauquan assemblages and their intellectual gatherings if they just made up their minds to have them."

This was a typical steamboat approach to a river resort that was most likely River View Amusement Park, 1908. *Robert G. Merrick Archives, MDSC.*

which was a propitious advantage. In 1890, the plantation was sold to a newly incorporated company, the white-owned Independent Steamboat and Barge Company (ISBC), which set out to make the site an amusement park.

After several months of floating potential investors down the river in the company's *Pilot Boy* steamboat, June 1891 saw the opening of Notley Hall, the leisure park. The *Post* predicted that Notley Hall was "certain to become one of the foremost resorts about Washington, for the natural beauties of the locality are many. Large groves and well laid out promenades exist in plenty, and with pavilion, bowling-alleys, and boating facilities the excursionists to the resort need not want for amusement."

Though advertised as the finest leisure park on the Potomac in display ads in the *Post* and the *Star*, the whites-only Notley Hall had a difficult time competing with other white resorts along the river. Following the pattern that had developed and would continue as long as there was segregation in public places, it became a resort for African Americans. The ads moved from the *Post* and *Star* to the *Bee* and *Colored American*. The ISBC formed a partnership with a black-owned and operated amusement park company in 1894. The new association was called the Notley Hall Association.

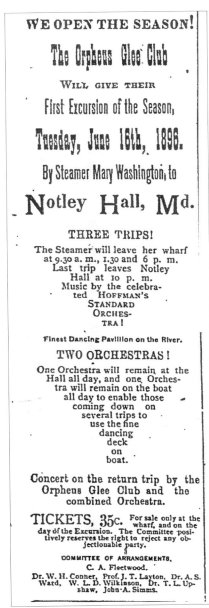

An advertisement in the *Washington Bee* for the opening of the season with a trip to Notley Hall and all its delights. *Author's collection.*

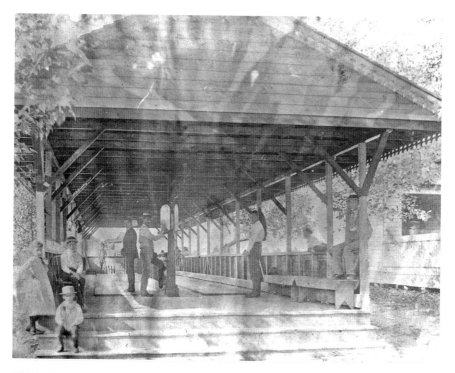

This bowling alley of the period would be similar to the one at Notley Hall/Washington Park. *Robert G. Merrick Archives, MDSA.*

Presumably, the principals included D.C. entrepreneur Lewis Jefferson. In 1896, the *Bee* advertised an excursion via the "old reliable" steamer *Mary Washington* to Notley Hall, whose dance pavilion was the finest on the river.

As of 1897, per the newspapers, the resort offered a "Bowling Alley, Riding Horses, Swings, Shooting Gallery and everything usually found at a first-class Excursion Resort." By this time, riding horses or merry-go-rounds were no longer hand pumped but operated by steam. In 1898, the property's canal was dredged to ease the landing of larger steamers, and a new wharf was built. Other attractions included the "large dancing pavilion…an excellent pony track," the collection of which was "unsurpassed by any place of amusement on the river."

As stated previously, most of the resorts or leisure gardens patronized by African Americans were also used for purposes other than play. They were often the site of speeches and rallies addressing the political and social issues of the day. They operated as a limited Chautauqua, and almost as many

people participated in these activities as in the lighter entertainment. For example, in 1903, some four hundred patrons participated in a moonlight cruise on the *River Queen* with a stop at Notley Hall to honor the local bar association and hear several speeches by prominent "colored men." Chartered by W. Calvin Chase, editor of the *Bee*, the real purpose of the cruise was to denounce Booker T. Washington and his "doctrine of meek submission." According to the *Post*'s report of the event, there was rousing anti-Washington applause and a tepid response to the mention of the once-popular president Theodore Roosevelt, who was a supporter of Washington and his unobtrusive agenda.

In 1905, Notley Hall was purchased by Lewis Jefferson, partnering with Jewish businessman Samuel Bensinger. Jefferson was respected in the community for his civic and political activism. He was also well known as a successful landholder and owner of a fertilizing business operating out of Southwest Washington. In fact, some had coined him D.C.'s first black millionaire.

Jefferson had earlier formed the Freedman's Transportation, Land and Improvement Company and had partnered with ISBC. He now organized a group of black investors to incorporate and purchase the steamship *Jane Moseley*. Jefferson had some experience with the steamer, having stowed away on it some ten years previously while still in his teens. According to the work of scholar Andrew Kahrl, it was that experience that led Jefferson to lie about his age in order to join the U.S. Navy and then travel around the world twice before eventually settling in Southwest Washington.

Although Jefferson was personally and professionally acquainted with the ownership of the *Jane Moseley* and its devious practices, he still agreed to the exceptionally high price of $20,000 and the terms of $8,000

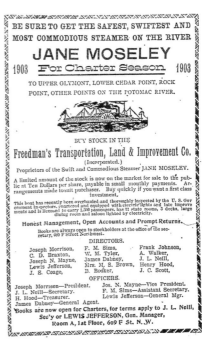

The *Colored American* advertised for investments in the *Jane Moseley* being run by Lewis Jefferson's Freedman's Transportation, Land & Improvement Company. *Author's collection.*

down and monthly payments of $2,000. The "colored excursion" business could be that profitable.

During this period, Jefferson was able to secure the lease for Somerset Beach, a resort on the Potomac in King George County, Virginia. According to newspapers, he had the backing of eighty churches in the District and Alexandria for this venture. The *Jane Moseley* had been running excursions between Washington and Colonial Beach with a stop at Somerset Beach.

Platted in 1897 to be developed into a resort town for whites rather than an amusement park, Somerset Beach lots had not sold well. A fancy hotel, a dance pavilion and a state-of-the-art wharf were built, but business continued to be slow. In March 1902, floating ice breaking up from an unusually cold winter destroyed many of the wharves up and down the river, including Somerset Beach's. Although the wharf was rebuilt (and again three years later), the few whites who resided or conducted business there began to move out. The corporation turned to the "colored" trade the same year. It courted Jefferson, bringing him down for dinner, drinks and to look over the property. It even sold a few lots to people of color. The deal was clinched.

Predictably, local whites abhorred the summer invasion of black people. The *Alexandria Gazette* reported on July 7, 1903, "People from King George county [*sic*]…are loud in their complaints against steam boat companies for landing negroes [*sic*] on Somerset Beach. They say the worst classes of Washington and Alexandria negroes [*sic*] patronize these excursions, and that steps will be taken to prevent them from landing…in the future."

The next day, the same paper quoted from a letter to the editor of a different local newspaper: "A number of the most prominent young men of the county had resolved to take the law into their own hands, and…would take steps to make landing the negroes [*sic*] either entirely impracticable or fraught with so much danger that it would not be attempted."

There was the implication that the better classes of African Americans knew their place and would likely not visit. Yet many churches like St. Luke's, clubs like Blaine Invincibles, fraternal groups like the Elks and Masons and high-toned people like Mary Church Terrell visited Somerset Beach in 1903 to enjoy the setting, the amenities and even baseball.

Jefferson made more news as president of the company that owned *Jane Moseley* when he provided a free trip to Somerset Beach to 1,500 "colored babies" and their mothers through the auspices of Southwest D.C.'s Social Settlement Centre. Cadets from Armstrong Manual Training School (as it was called then) performed police duty. According to the *Post*, Jefferson provided another free trip on June 1, 1906, for the Potomac Hospital and Training

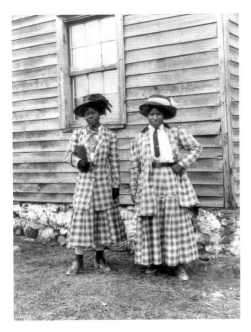

"We are rest', dressed, and looking our very best" for the early 1900s excursion! *LOC.*

School, a free dispensary located on I Street between Second and Third Streets, SW. Jefferson appeared not only to be a good businessman but also to give back to the community where he first got his start.

Jefferson's partner Bensinger also appeared to be a restless entrepreneur who dabbled in many endeavors. Late in his life, he was described as a well-known auctioneer who was also active in the Jewish community. Earlier accounts, though, showed that he was involved in horse racing and land acquisition, as well as the amusement park business. He had been arrested for cruelty to a horse, fined for working without a permit, charged with transporting gamblers to a barge in the river and involved in other minor infractions. A fire destroyed an automobile repair and storage shop that he owned, but he was fortunate enough to have insurance on the property.

These two seasoned businessmen joined forces and renamed the newly negotiated resort Washington Park, where "excursionists to the resort need not want for amusement." Some claimed that Jefferson was actually the front man for Bensinger, the silent partner. In any event, Jefferson's company now owned the two steamers that ferried patrons back and forth from Washington. He improved the grounds and offered amenities of a quality and variety that the best amusement parks provided. These included a roller coaster, a double-decker carousel, a shoot-the-chutes ride, a penny arcade, a five and ten cents theater, fortunetelling, refreshment booths, pool and billiard halls, forty acres of "Shady Woods and Dell" and, of course, a large dancing pavilion.

Roller coasters were the stuff of wild imaginations. Amusement park-goers then and today visited primarily for the roller coaster experience. Patrons of Washington Park were no different. The first one in America had opened on Coney Island on June 16, 1884. Invented by LaMarcus Thompson, it was

initially called a switchback railway and traveled approximately six miles per hour. At Coney Island, the switchback railway cost five cents to ride. The new entertainment was an instant success; by the turn of the century, there were hundreds of roller coasters around the country, raising the bar for leisure parks.

Shoot-the-chutes, an amusement innovation debuting in 1884, was basically a flat-bottomed boat that slid down an elevated ramp or inside a flume into a lagoon or large pond, skipping across the water to a stop. The ride became like the roller coasters and Ferris wheel—a must-have at turn-of-the-century amusement parks.

This shoot-the-chutes ride of the period was similar to the ride offered at Notley Hall/ Washington Park and other local parks. *LOC.*

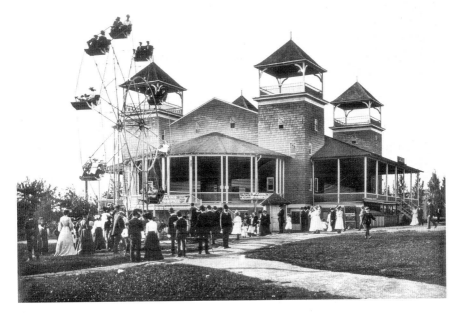

A Ferris wheel and dance pavilion typical of the period of Collingwood, Notley Hall, Glymont and other D.C.-area parks. *LOC.*

Although Washington Park officially opened in May 1908, June 26 was a truly momentous occasion. It marked the first "grand event" of the Washington Branch of the National Negro Business League, founded by Booker T. Washington. Local notables who attended included local chapter president and architect John A. Lankford; W. Sidney Pittman, another architect; and photographer Daniel Freeman. Washington Park was considered a triumph of modern black entrepreneurship and represented the fruits of several black investors. The national president, Washington, and other leaders would visit the following month as part of the national conference, which was being held in Baltimore.

Jefferson had rolled out the carpet on the twenty-sixth, running his two steamers all day at twenty-five cents a trip. The low fare and frequent runs were to "enable all of our Business and Professional men and women and their friends to spend either all or part of the day and night in a cool and enjoyable recreation, and it will be especially refreshing to all children who have been in school for the past ten months," read the display advertisement in the June 6, 1908 issue of the *Bee.*

Mary Church Terrell, ever the recorder of leisure, wrote in her diary on June 27, 1908:

> *This afternoon Berto* [Robert Terrell], *the children and I went to Washington Park with Mr. and Mrs. Alphonse Stafford and some. We were visited by Mr. Jefferson an enterprising colored business man who owns a large share in* River Queen *and* Jane Moseley *two steamboats which colored people may use going down the river. Mr. Bensinger, a Jew has put $100,000 into this park which is well equipped with everything tending to amuse the people! The children enjoyed the Merry Go Rounds* [sic] *immensely. By the way it is the finest one I have ever seen anywhere. The scenic railway and the Merry Go Round were purchased from Cabin Johns* [sic] *Bridge which has been put out of* [illegible] *business because of the prohibition law.*

From all appearances, the endeavor was wildly successful. Trips yielded hundreds of pleasure seekers spending money on board the steamers and at the park and then returning home with tales that enticed still more folks to visit. But almost from the beginning, in addition to the exorbitant prices paid for the steamers, there were a string of other challenges to the business. For example, Jefferson was barred from docking his steamer

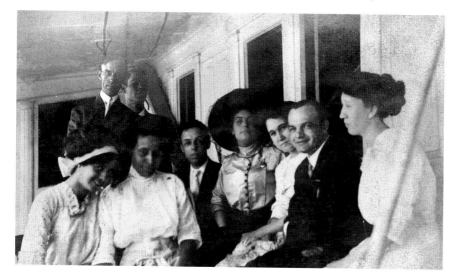

Lillian Evans (Tibbs) (far left) and company cruising on the *River Queen*, most likely headed to Notley Hall or Washington Park in the early 1900s. *Evans-Tibbs Collection, ACM, gift of the Estate of Thurlow E. Tibbs Jr.*

at the Seventh Street Wharf. He was forced to build a wharf at his own expense at O and Water Streets, near the Titanic Memorial today. The *River Queen* met with a couple accidents, causing Jefferson to have to pay for another steamer, the *Angler*.

Park-goers were for the most part church congregations, fraternal organizations and other social clubs—ordinary, law-abiding citizens seeking a respite from their hard months' labor. Yet there were altercations that sometimes resulted in assaults, which on occasion turned deadly. At least that was the way it was reported in the white newspapers. Washington Park was dubbed the pejorative "Razor Beach" (a term used for other black beaches) in a two-page "exposé" written in the *Post* magazine on August 23, 1908. The byline read:

> *Why The Police at No. 4 Get Busy*
> *WHEN THEY HEAR THE WHISTLE of the "RAZOR BEACH" BOAT*
> *A* Sunday Post *Reporter's Story of His Trip Down the Potomac on an Excursion Boat Bound for Notley Hall, the Negro Pleasure Resort, Known in Police Slang as "Razor Beach."*

The article, with great photos of some of the leisure seekers and amusements, is overshadowed by demeaning caricatures of patrons. On the other hand, though written in the tone of the day, the feature was not nearly as derogatory as the *Post*'s headlines suggested. In fact, some descriptions of the comportment of the excursioners had a tinge of reluctant respect:

> *There is a cherished tradition in southwest Washington police circles that if the bottom of that portion of the Potomac River, off the foot of N street were dragged, enough "guns" and razors, and black jacks and brass "knucks" would be recovered to stock a hardware store. There was a time, and not so long ago at that, when the return of a colored excursion boat to her wharf meant trouble for the police and plenty of work for the Emergency Hospital surgeons. But conditions among colored excursionists have improved greatly in recent years.*

Quoting an "old policeman," the author wrote further:

> *But the "Razor Beach" nowadays ain't what it used to be. Old "Razor Beach" was a resort on the Virginia side* [Collingwood], *and it was*

*well named, too. It's abandoned now. Then the colored people got to going
to Notley Hall, now Washington Park, and to other resorts on the river.
These places are as orderly now almost as the white places, but the old
name "Razor Beach" hangs to 'em in a sort slang way and that's what
we call 'em.'*

There was also faint praise for the park itself. Looking at the headline and
then reading the lengthy article—where there is also admission that "colored
excursions," especially the moonlight cruises, were the real moneymakers—
makes one question the intent of the sensational lead-in, for the article also
reads in part: "Washington Park [Notley Hall] has been conducted for the
past seven years by Louis [*sic*] Jefferson, a negro, who has for a partner a
white business man of Washington. He has made the resort the best and
largest exclusively colored pleasure resort in the United States."

As stated earlier, in spite of his successes, Jefferson also encountered issues
with the police. As early as 1901, there were accusations of unfair treatment
at the hands of the Prince George's County police. It was felt that black
excursioners were unjustly targeted for arrests. Charges as minor as talking
too loudly to more serious incidents such as gambling led to arrests, and
prisoners were taken to the county seat in Upper Marlboro some four miles
away. There they were fined and forced to find a way back to Washington. If
they could not pay, they were jailed. A committee that included the *Bee* editor
vowed to meet with county officials about this matter. The committee had
commented that ironically, under the Democrats, generally antithetical to
black interests, patrons were left alone. However, the new Republican county
leadership was set on harassing black excursioners. In any event, Washington
Park was subject to police surveillance and sometimes overzealousness.

Many other issues arose for Jefferson—methods commonly used to ruin
competitive black businesses. These included ill-founded accusations and
harassment from government. Charges of selling liquor without a license
followed by acquittal, local farmers accusing the park of dumping on
their property and seizure for an unpaid mortgage were some of the other
challenges. Interestingly, when another time Jefferson was charged with selling
liquor on board the *Angler* without a license, his attorney argued that selling
on the river was not covered by the prohibition laws. And finally, resorts like
River View, south of Mount Vernon, previously segregated, began marketing
to blacks crowds, which began to draw away Jefferson's patrons.

Washington Park caught fire under mysterious circumstances in
February 1913, and everything was destroyed. Newspapers reported that

the fire, started at about eight o'clock in the evening, could be seen for miles. Bensinger, named as the owner, said that he had not heard from the watchman. The structures were wooden, and there was no firefighting equipment on site and no assistance from Prince George's County. The flames brought a response from firemen across the river in Alexandria, but they could only stand on the shore and watch the dance pavilion and rides burn. Bensinger said the place was worth $30,000 but that it was uninsured. He suspected arson but could not name any possible suspects.

Jefferson had taken out a mortgage on the property in 1912 and within four years was forced to sell it to the holder of the note. By 1925, the wharf had washed away and the park closed.

A few years before the loss of Washington Park, in 1916, the wharf, warehouse and hotel at Somerset Beach burned. Like a cat with nine lives, Jefferson had reemerged for a brief time as the "superintendent" for the excursion line anchored by the steamer *E. Madison Hall*. This time, the steamer was owned by another black man whom the ever litigious Jefferson had to sue for his wages.

J.O. Holmes and the *E. Madison Hall*

James Ottoway Holmes owned the *E. Madison Hall* as early as 1919. He, too, had the run from Washington to Colonial Beach with a stop at the now African American excursion site River View in Maryland. The *E. Madison Hall* was previously owned by a white lumber merchant of the same name. The boat was built in Philadelphia as a private yacht for J. Pierpont Morgan. In 1917, Hall outfitted it for excursion business and chartered it in the District.

River View Park offered many of the same amusements as Washington Park and the other river playgrounds. Merry-go-rounds encased in pavilions, such as the one at River View, were considered more desirable as they offered shade from the beaming sun and cover for the sudden summer downpours.

Shortly after Holmes's purchase of the steamer, he and the vessel met with a string of unfortunate incidents. He was cited as a trustee in a suit over a debt. The steamer was to be auctioned, but fortunately, the auction was halted. Later in 1920, the company was sued over the death of a passenger who had fallen off the gangplank in Colonial Beach and drowned allegedly because there was no railing or other safety measures. And then

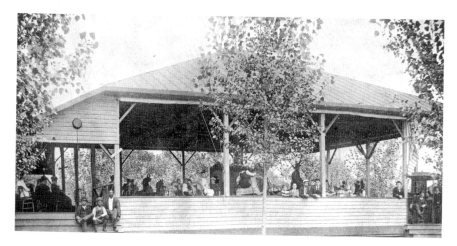

An example of a popular merry-go-round treatment, enclosed in a pavilion. This is likely River View; note the three attendants on the steps. *Robert G. Merrick Archives, MDSA.*

the *E. Madison Hall* was seized again to be auctioned off to pay creditors. Holmes must have satisfied his debts because two years later, after having spent $40,000 refurbishing the boat, it was seized again on July 5, 1922, and he was arrested for selling liquor on board. The *Afro* of July 7 reported that "a shower of bottles, many containing liquor, which were thrown overboard by excursionists ridding themselves of 'evidence,' greeted officers making the raid." Holmes was able to make the bail of $70,000, and he and the *E. Madison Hall* were released.

The sale of, the possession of and the serving of liquor seemed to be a recurring source of troubles for those in the excursion business and even for excursionists. The waning heyday of steamboat vacations coincided to a large extent with the Prohibition period (1917–34) and the Progressive Era. The newspapers of the period were full of stories of raids and arrests on the one hand and, on the other hand, assurances related to steamboat excursions that liquor would not be present. From all reports, though, liquor was alive and well and a necessary evil. Liquor-related activity was a way that enterprising black people could make money, whether bootlegging, transporting or mixing and serving. According to scholar Frederick Tilp in his rich but uneven study of the Potomac, there were a number of black bootleggers along the excursion routes. He noted that in the Occoquan Creek area alone, over twenty stills were owned by black families. However, Holmes rode out the period, and six weeks after the end of the dry years, on April 28, 1934, he applied to the Liquor Control Board for a license for his steamer.

Despite Prohibition, black folks could and did make a bit of money: as brewers, porters, servers or bar owners. *LOC.*

The issues Holmes had as a steamboat owner were more of the same he had from his years as the owner of the well-known Holmes Hotel at 333 Virginia Avenue, SW: liquor violations, thefts, prostitution and deaths. Holmes, born in 1857 in Virginia, probably into slavery, grew up in Southwest, where his father piloted a sand boat. The 1880 census shows his occupation as "huckster," a trade he parleyed into owning a restaurant, hotel, billiards club and barbershops. He was active in the Masons and served on the Coolidge inauguration committee headed by prodigious white D.C. developer Harry Wardman. Holmes was considered during this period to be the wealthiest black man in Washington. For years after his death in 1934, his granddaughter would acknowledge the anniversary of his passing with a verse in the obituary section of the newspaper.

In 1931, Holmes reported to the *Afro* that he was proud to be able to provide a steamer that was wholly manned by people of his own race and that he hoped he could find a young person to train and who would take over

the business. During his years in the excursion trade, he took Masons down to River View Park, along with churches and employee associations, among other groups. In September 1920, black Washington federal employees were given a half-day off by President Wilson to celebrate fifty-seven years of emancipation at River View via the *E. Madison Hall*. Later that month, the ever patriotic folk celebrated, under the auspices of the White Cross Labor Bureau, the 139th anniversary of the adoption of the U.S. Constitution with a fundraising trip on the steamer.

One regular customer in the 1930s was the radio evangelist Elder Lightfoot Michaux, who would lease the *E. Madison Hall* for mass baptisms. The steamer would carry congregants numbering in the thousands to a barge in shallow water. Immersion candidates would file down the gangplank onto the barge and await their turn in the water with Elder and his helpers. Sometimes camera and media people would be hovering in small rowboats to record the events. The baptisms brought good publicity for the *E. Madison Hall*.

Several of the waterside parks had been leased periodically by Washington African American churches for the same purpose: to anoint the converts in the waters of the Potomac or the Patuxent. The only other black-owned and operated steamboats in the area, the *Starlight* and the *Avalon*, out of Baltimore, also took part in the religion-oriented service. The steamers' owner and captain, George W. Brown, ferried people to his Patapsco River resort, Brown's Grove, for baptism ceremonies.

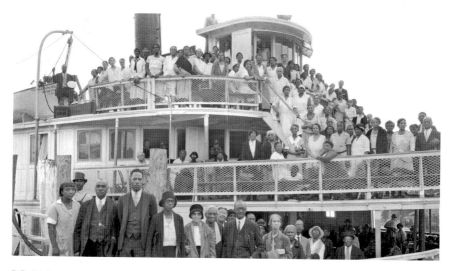

J.O. Holmes announced at the start of the 1931 season that his steamer was completely overhauled and ready for excursioners. *Scurlock Studio Records, NMAH.*

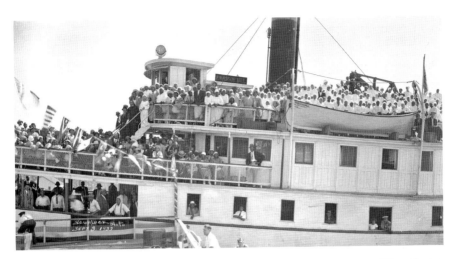

E. Madison Hall carrying passengers in 1933 to a mass baptism in the Potomac River. *Scurlock Studio Records, NMAH.*

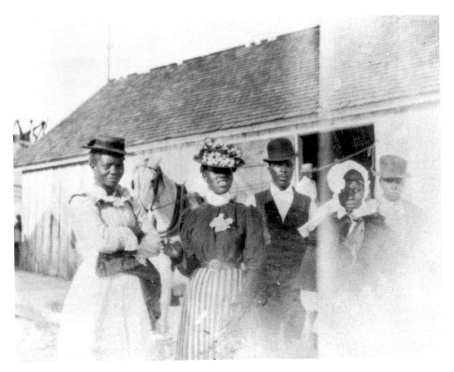

Out for a bit of leisure on the Patuxent, day-trippers await a steamer for the return home. *CMM.*

OTHER STEAMER-ORIENTED BEACHES AND RESORTS

Another beach accessible by steamer and patronized by black travelers included Mount Bethel Beach near Matthews in King George County, Virginia. The leisure garden property was purchased in 1898 by the Mount Bethel Baptist Association. The facility, a former white resort, already housed bathing quarters, recreational and boating grounds and a building for overnight sleeping. The association has used it since purchasing it for church training conferences and retreats.

Piney Point may have been another beach patronized by blacks. Weems Steamboat Company, whose D.C. offices were at the Seventh

Street Wharf, published an extensive guidebook probably in the 1890s listing the "Summer Homes and Historical Points" along its route. The guide provided a brief description of the houses or sites, the kinds of amenities that might be offered and the names and addresses of the owners or proprietors. An entry for a Piney Point location was as follows:

A Pleasant Home, commanding a charming view of the Potomac River, and only one mile from Piney Point Wharf. Comfortable Rooms and Good Table. Will accommodate a few Colored Boarders for the Summer months.

Terms Reasonable　　　　　　　*J.D. Statesman*
Piney Point,　　　　　　　*St. Mary's County, MD*

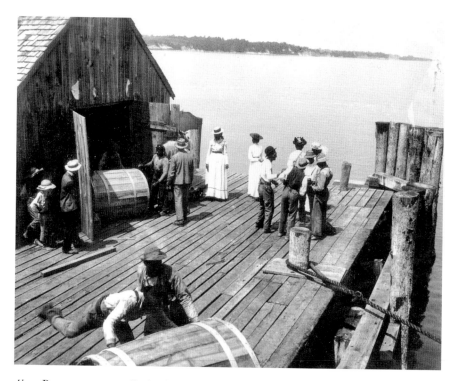

Above: Passengers at a small wharf on the Patuxent awaiting a steamer while workers ready hogsheads of tobacco for shipping. *Calvert County Department of Planning and Zoning.*

Previous pages: From a barge in, 1932, hauled by the *E. Madison Hall* into the Potomac, Elder Lightfoot Michaux would baptize his followers. *Scurlock Studio Records, NMAH.*

It turns out that Statesman was a well-respected man of color who probably grew up in the area and may have been a slave, as he was born in 1855. He was married to Ruth Fenwick, and they had at least eight children. Amazingly, from 1898 to 1900, Statesman served as the postmaster for Piney Point. Piney Point had long been a nature retreat for presidents and Washington politicians, including Teddy Roosevelt and others. Perhaps Statesman's home served as a place to board the servants of the rich and famous visiting Piney Point. In any event, by 1920, Statesman was a widower and living in Atlantic City, where, still in the tourist industry, he was the proprietor of a restaurant.

Marshall Hall Redux

In the 1950s, the resort that was formerly off-limits to people of color joined the "colored excursion" trade. The sedate Victorian-style leisure garden had begun to ramp up its offerings and install the popular rides of the period to compete with places like the local Coney Island replica upriver, Glen Echo.

The Charles County plantation site added slot machines and cocktail and snack bars. At the time, Marshall Hall was the only place outside Nevada where gambling was legal. The amusement attractions that had been installed over the years—a swimming pool, Ferris wheel, merry-go-round, railroad, roller coaster, ice-skating rink, shooting gallery and other arcades—were refurbished to appeal to the youthful. Black Washington was wild to visit Marshall Hall, which meant taking the white-owned steamers holding the franchise, like the *Robert E. Lee* and the *Southport*.

Most Afro-Washingtonians who fondly recall Sunday outings to Marshall Hall—now part of Piscataway Park operated by the National Park Service—had no idea of the history of racism it represented. They did not know that the Ladies of Mount Vernon sought to preserve the view

An aerial view of Marshall Hall, one of the most popular local amusement parks from the 1880s to the 1950s. *HSW.*

Above: Although it closed in 1978 after almost a century, Marshall Hall's last twenty years were open to these children and others who looked like them. *MLK.*

Opposite, top: Once Marshall Hall desegregated, Afro-Washingtonians of all ages flocked to take the rides and other amusements offered. *MLK.*

Opposite, bottom: Most blacks of the 1950s and '60s thought Marshall Hall had the best rides available to them and happily took the white-owned steamers to the park. *MLK.*

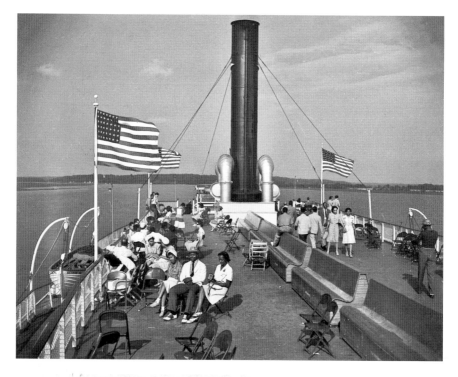

Above: Howard University sponsored trips down the Potomac in the 1940s. By this time, the last black-owned steamer company was out of business. *Scurlock Studio Records, NMAH.*

Left: A 1952 excursion contract between Gaines AME Church and the steamer *Bear Mountain* for $2,100. The church was to provide its own band. *CMM.*

across the river from Mount Vernon as it would have been when America's first president lived there. Looking out and seeing "Negroes" cavorting would have been objectionable. Some 80 years later, the Park Service did eradicate all signs that Marshall Hall had become an amusement park. The retained historically designated plantation house, over 250 years old, caught fire in 1981, and the remaining shell was later hit by a truck.

What excursions to Marshall Hall and sailing on steamships like the *Robert E. Lee* represented was African Americans taking their business to white companies. It was truly the end of Washington's black-owned steamer enterprises.

OLD POINT COMFORT AND ENVIRONS

For decades, when they had the opportunity, black Washingtonians took steamboat excursions to the Hampton Roads area. One of the biggest draws was Fortress Monroe, as it was referred to in the late 1800s, sitting on Old Point Comfort. The place where the first three enslaved men fleeing Confederate forces found shelter and were cleverly classified as "contraband of war" so they would not have to be returned held almost as much reverence as John Brown's Fort at Harpers Ferry. Old Point Comfort was also extremely popular for its waterfront; promise of cooling, refreshing ocean air; healing waters; military rituals; boating; and dancing. In 1900, its two hotels—the Hygeia and the Chamberlin, a National Historic Landmark that operates today as a retirement home—were widely acclaimed not only for the accommodations but most particularly for their cuisine.

However, in 1900 and into the mid-century, African Americans could visit the fort but not pass through the doors of the hotels unless as servants or entertainers and from a different entrance. If a black person wanted to refresh or spend the night, he or she would be welcomed at Mrs. Mary Neil's boardinghouse in nearby Phoebus. The best place, though, was the Bay Shore Hotel, the black resort hotel, which opened in 1898 between Fort Monroe and Buckroe Beach, a white resort and amusement park.

Accessible from Washington by steamer or from Richmond via the C&O Railroad, and later by automobile, the Bay Shore resort was developed by a group of administrators from Hampton College (now University). They were seeking a waterfront site for student athletics and for lodging out-of-town guests of the school. The group managed to purchase one and a half acres and constructed a four-room cottage. They started renting out rooms when

they did not have college guests. Soon church and fraternal groups out for excursions were booking stays. The hotel ownership was able to acquire six more acres and expand the lodging. By the 1920s, the Bay Shore Hotel was a seventy-room structure. Its resort had a boardwalk, pavilion and amusement rides. It cleverly advertised as providing "Sea-Baths, Sea-Food, and Sea-Air."

From its inception, though, Bay Shore Hotel and Beach also advertised itself as being located on Buckroe Beach, a location that was repeated thereafter even in the *Negro Motorists Green Book* and other black-oriented travelogues. This slight misdirection resulted in incidents of embarrassment or humiliation for white and black beach seekers. Similar to South Carolina's adjacent (black) Atlantic and (white) Myrtle Beaches, Bay Shore was separated from Buckroe by a wooden barrier built several feet into the water that would somehow keep the water from mixing. The barrier erected at Myrtle Beach was widely known as the "Colored Wall."

The Bay Shore and many other seaside resorts in the mid-Atlantic suffered severe damage during a hurricane in 1933. Up to that point, Bay Shore was quite prosperous and well run. Unfortunately, government disaster relief provided the resort only half the funds it required for necessary repairs and restoration. This led the first-class resort on a downward spiral. Bay Shore was not able to offer as many amenities and began to lose customers, which in turn reduced its income. World War II further diminished the resort's revenue, and it was never able to fully recover. The Bay Shore Hotel and resort closed in 1978 following the integration of Buckroe Beach. The property reverted back to Hampton University, which then sold the land to white developers. Buckroe, on the other hand, post-desegregation, became identified as a black beach.

With bloomer-style pants and Brownie camera in hand, these female tourists take a refreshing wade at the water's edge. *Scurlock Studio Records, NMAH.*

Chapter 4

"Gonna Lay Down My Burdens"

Spiritual and Charitable Recreation Sites

Camp Meeting: The Religious Leisure Activity

The Camp meeting era has arrived and the woods and hills are alive with
shouts of praises and songs…Almost every one who can spare or steal time
will be found there and much good is anticipated.
—People's Advocate, *August 18, 1880*

One of the most affordable and regular forms of summer leisure for African
Americans was provided by the church through camp meetings or outdoor
evangelical gatherings. The intent was to foster fervent and liberating
communion with God while in the "wilderness" of a wooded setting near
a creek. However, for many, the camp meeting also furnished a safe and
protected social outlet.

In August 1898, one could take the Chevy Chase, Maryland streetcar
from Washington to Chestnut Grove "to spend a few hours at an orderly,
well managed and pleasantly located camp meeting." Chestnut Grove was
located off Connecticut Avenue, just north of the Chevy Chase Circle. At
the time, the meeting site, as was customary, was located in a rural or semi-
rural area on a large partially wooded field and near a body of potable water.
Like other camp meeting sites, the Chestnut Grove meeting may have had
large tents set up: one for separate bathing for men and women and another
as a meal tent to cook and feed the pilgrims, generally for a price. Then there

was likely at least one large tent or makeshift shelter, frequently referred to as the tabernacle, outfitted with an altar and seats for preaching, singing and worshiping. Though many would come for a day, others who could stay longer would have brought their own tents and blankets for sleeping and relaxing, baskets of food and a change of clothes. Those coming by their own conveyances would have a section of the field to tether horses and park wagons and, later, cars.

Throughout camp meeting days and into the evenings, services would be conducted by various ministers. At many camps, the order of the day was "wash, pray, sing, prepare breakfast, pray, sing, eat," repeated in afternoons and evenings. The sermons were filled with hellfire and brimstone deliveries evoking the traditional jubilant call and response from the audience. Marching through the woods while singing hymns and gospels was frequently part of the services. This ritual signified the intent of the camp meeting: to rejoice in the wilderness replicating the experiences of the biblical children of God. Sometimes the guest ministers brought their own choirs or even brass bands. All the activities were geared toward renewal of spirit much as a stay in a secular resort sought to do.

Following the end of the Civil War, for many newly freed, the camp meeting was the setting of their first organized religious experiences. Ministers, particularly of the Methodist faith, most of whom were white and who were charged with proselytizing the darker masses, found the camp meetings appealing because of the "quick response to the summons to come out of darkness into light." The Methodist "Quarterly Meetings" were traditionally held not only for the purpose of renewing faith but also for handling church business. The "Big Quarterly" was generally held in August, as it still is in Wilmington, Delaware, where it has been declared the longest-running religious "festival" held in the United States.

Carter G. Woodson's early study of the African American church notes that following emancipation, black churches not only were places for spiritual sustenance, but they had also become places for educational, fraternal and business development. He also pointed out that "Negroes regularly attend church whether Christians or sinners [because] they have not yet accumulated wealth adequate to the construction of clubhouses, amusement parks, and theaters...[and are] barred from social centers open to whites." As the *People's Advocate* declared on August 21, 1880, about camp meeting season, "The gaiety that once decked the streets of [the city] has been transferred for time being to Asbury Grove. The young men appeared in all things calculated to attract, and the ladies in

Dressed in their finest, pilgrims head to the camp meeting in Emory Grove from the Washington Grove train stop. *Photo by Robert H. Walker, courtesy of Philip Winter.*

all things that had the power to legerdemain." For these reasons, church conventions, meetings and the like would remain popular forms of leisure well into the twentieth century.

Black Washingtonians seeking leisure through religious fellowship and devoid of worldly amusements such as alcohol and games did not have to travel as far as Martha's Vineyard, Massachusetts, or Saratoga Springs, New York, which both began as camp meetings. There were many places in the immediate vicinity, though not as jocular perhaps as those conducted in Asbury Grove, Maryland. Local camp meeting places such as Highland Grove and Chestnut Grove have essentially disappeared but at one time were the sites of more sober worshiping except when touched by the spirit.

Many camp meetings also served as fundraisers. During a two-week Chestnut Grove gathering, for instance, a special Woman's Day service devoted to the Sojourner Truth Home Association in Washington garnered a contribution totaling $6.51—almost $180.00 today. An 1880 "bush meeting" in Carlin Springs was attended by close to three hundred people and earned $200.00 for the sponsoring church.

Many celebrants looked forward to the food they would find. Dishes would be for purchase from the church families or outside vendors. Some church folk were known for pies, others for their style of fried chicken or their ham and cabbage dinners. Camp-goers had pulled out their best recipes and prepared their specialty cakes or breads. The meeting held on the grounds of Allen Chapel A.M.E. Church on Good Hope Road, Washington, was especially noted for its fare. In addition to chicken dishes, pigs' feet, oysters, watermelon, roasted corn on the cob, ice cream, ice-cold punch and other delectables were regularly offered. The variety of food available was well worth the visit for many.

Liquid refreshments were sometimes the source of much interest, warranting constant vigilance for the forbidden presence of liquor. A Good Hope Road meeting vendor or two was known to offer, surreptitiously, "fortified" tea. Camp meeting organizers tried to guard against the presence of spirits of the liquid kind but were not always successful. Spiritual sustenance at camp meetings was sometimes more literal.

The Emory Grove camp meeting, subject of a Montgomery County, Maryland study, was in many ways the prototype of the black camp meeting. The Emory community, located just south of Gaithersburg, Maryland, was set up on land purchased by newly freed families. Owners immediately erected the Emory Grove Methodist Episcopal Church and dedicated the wooded acreage adjacent to the church specifically for camp meetings. Meetings there began in 1871 but were not officially chartered by the Methodist Church until 1881.

Running generally for ten days in late July or early August, the annual Emory Grove camp would attract hundreds of people. Montgomery County was appealing because its higher elevation made a more refreshing setting than the muggy, mosquito-ridden Washington City. Before the advent of cars, buggies and wagons would be queued up to enter the ground. There would be lines of people walking the dry, dusty road from the stop on the Metropolitan Branch line of the B&O, opened in 1873 in the neighboring white camp meeting community of Washington Grove. In fact, the shortest way to Emory Grove from the train station was along Washington Grove's Broadway (now Grove) Avenue. At one point, Washington Grove, already erecting semi-permanent residences by 1897, closed its gates to outsiders, forcing Emory Grove pilgrims and residents to take the longer walk to and from the train stop.

Though the Emory Meeting lasted several days, some came for a day. *Photo by Robert H. Walker, courtesy of Philip Winter.*

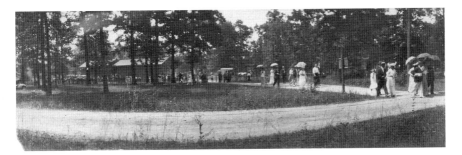

From the train station, people walked down Broadway in the middle of Washington Grove to Emory Grove. *Photo by Robert H. Walker, courtesy of Philip Winter.*

Families dressed in their best would arrive at Emory Grove with their possessions, food and sometimes even their flocks and herds of animals. They would pitch tents, where they would reside for the next few days. As time passed, some regular attendees would have been assigned trees by which they could lay down temporary roots. Later, rather than tents, "tables" would be set up at their designated tree. The tables were actually crude wooden open-sided booth-like structures with canvas roofs. These tables served dual purposes: a private space for storing personal items and sleeping in the evenings and, during the day, for preparation of food or other wares for private use or as concession stands for displays and sales. Electric wiring would be available in the twentieth century, and portable stoves would replace the open fires in the center of the tables.

Typically, the meeting would offer three services—morning, afternoon and evening—with the afternoon service of the third Sunday being the most anticipated. That service would be presided over by the most charismatic pastor who would deliver a sermon anticipated to eject the emotional or even physical burdens crouching deep within the essences of the listeners. The accompanying music would help to free the congregants and deliver them to peace. At the end of the camp meeting, the Emory Grove pilgrims would make their way home, feeling refreshed and eager for the next year's meeting.

Unlike its neighbor, the Emory Grove meeting never erected permanent meeting buildings or summer cottages for attendees. It was already a small community of African Americans, most of whom worked nearby and whose lives seemed to revolve around its church. There was, however, at least one seasonally occupied house. It was built in Emory Grove by white Washington Grove congregant Major Samuel Hamilton Walker, according

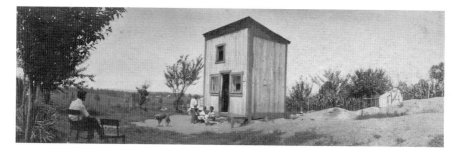

Samuel Hamilton Walker built a summer house in Emory Grove for a servant who requested one window on top so she "could look down on her neighbors!" *Photo by Robert H. Walker, courtesy of Philip Winter.*

to great-grandson Philip Winter, at the request of a black servant Walker always brought along on his retreats. Washington Grove, after all, had restrictive covenants.

There was some assessment among camp pilgrims as to which meetings were the more desirable. In describing a camp meeting held in 1896 in a grove near Port Deposit, Maryland, a D.C. visitor noted, "The Maryland camp meetings are not at all like the Virginia 'big meetings'…There is a gate fee and refreshments of all kinds are sold on the grounds…Often there are smaller tents occupied by families who literally 'camp out' for a week or two." Because of the urban nature of the city, the camp meetings of D.C. were a little different in form and format than those conducted in the more rural locales in Virginia and Maryland. More likely, one- or two-day evangelical meetings or revivals might take place in a temporary location such as at a leisure park like Green Willow or on land loaned out by a church in D.C.'s Washington County. Selby Scaggs, a white former slaveholder, allowed his farm on Benning Road to be used as a camp meeting one year when a nearby church, Jones Chapel, lost its building to fire. Nannie Helen Burroughs permitted the Seventh Day Adventists to hold a seven-day camp meeting on the high grounds of the campus of the National Training School for Women and Girls in Lincoln Heights (Deanwood), D.C.

The camp meetings, some of which began as interracial and then succumbed to Jim Crow, became increasingly interdenominational both in the leadership and in the call for participants. Additionally, many incorporated more secular activities, such as baseball, or permitted marketplace endeavors. The Good Hope camp meeting, for example, was remembered as both religious and social. The "preaching and singing and praying resounded

loudly over the neighboring hills," according to a local memoirist. There would also be an air of gaiety during those gatherings inspired by more than just the "preaching, singing and praying." It was an opportunity to wear one's best clothes, catch up with old friends or initiate or continue a courting ritual. The religious gatherings also offered working mothers, in particular, the chance to rest and worship at the same time. The meetings provided a safe space for their children to roam and perhaps be temporarily parented by others. If she could afford, she could purchase for her family the reasonably priced refreshments generally offered at the gatherings, thus giving her a day off from cooking. Perhaps like the Wilmington Big or August Quarterly, where food vendors and singing groups strolled up and down the street amidst a scene of general festiveness, there may have been storytelling and faith healing as part of the day's activities.

As a result, the appeal was broad and provided opportunities for African Americans to engage in leisure based on religious inclination. Participation in a local meeting could be as short or as long as one wished. The gatherings in rural settings permitted overnight stays, and urban settings allowed celebrants to come and go as they were able.

At the same time, these revivals had their critics who felt that the gatherings permitted too much jollity and unbridled praising. Other naysayers questioned the purpose of continuing to hold camp meetings. A Baltimore congregant was quoted in the *New York Age* in 1888, saying, "We spend more money for pic-nics [*sic*], excursions, big Sunday pic-nics, held all summer under the name of camp-meetings…than would be needed to run all our schools." The *Afro*, in August 1905, commented, "Would it not be wise for some of our ministers who are leading our people to patronize excursions and camp meetings on railroads to look a little beyond the few dollars they make out of them" to unite and use the money for higher purposes? In spite of the criticism, camp meetings continued in various formats. What was apparent was that the camp meeting was a form of leisure that many black Washingtonians enjoyed.

Camp Lichtman and Camp Pleasant

The Depression saw President Franklin Roosevelt scrambling to find ways to provide employment and stability to American families. At the same time, there were the ongoing efforts to preserve America's natural resources. A

demonstration project called the Recreation Demonstration Area (RDA) was created in part to make outdoor resources available to inner-city residents. From the 1936 report on the RDA, the following rationale was issued:

> *Washington, the nation's capital, though one of the loveliest cities in the world because of its tree-arbored streets and unusual park area, despite its variety and quantity of outdoor recreational facilities, has never had an adequate place where the lower-income families might go to rest and play, particularly in the summertime, when life in low-lying Atlantic seaboard cities is not comfortable.*

The initiative provided parents and youth exposure to life in nature away from the confines of urban settings. At the same time, it was hoped that the experience would also build self-esteem and strong character values, particularly in young people. Social service groups in Washington were to work alongside the National Park Service (NPS) to sponsor camps giving the underprivileged the chance to leave the city for a few weeks. The youth campers would have the opportunity to enjoy crafts, nature walks, swimming and other forms of leisure activities unlikely to be experienced at home. Adult campers would have the opportunity to focus on their young children, practice parenting techniques and learn about hygiene, nutrition and other life skills.

The camps of the RDAs were constructed by the young white men of the Civilian Conservation Corps and the older skilled white workers of the Works Project Administration. In May 1935, they began work on the Chopawamsic RDA, the fourth largest in the United States. The project was located in what is now Prince William Forest Park in Prince William County, Virginia, and five rustic cabin camps were built within the eleven-thousand-acre area. The following year, Chopawamsic RDA debuted as a summer camp for the children of Washington.

Each camp was designed to service up to 150 people divided into units of 30. The camp had a central kitchen and dining hall, a central shower and bathroom building, administrative and service buildings, quarters for staff and water and sewage facilities. The individual camp units consisted of tents or shelters holding 4 to 8 campers, a central lodge with an outdoor kitchen and a toilet and shower building. They operated individually under the supervision of trained counselors. Most meals were served from the central kitchen in the dining room. The overnight shelters were frame buildings and screened.

Washington-area boys getting a nature lesson at YMCA Camp Lichtman, named for the Jewish entertainment mogul and philanthropist. *Scurlock Studio Records, NMAH.*

Every summer, black youth drowned in the Washington area's unsafe waters. Here, they frolic under the watchful eyes of lifeguards. *Scurlock Studio Records, NMAH.*

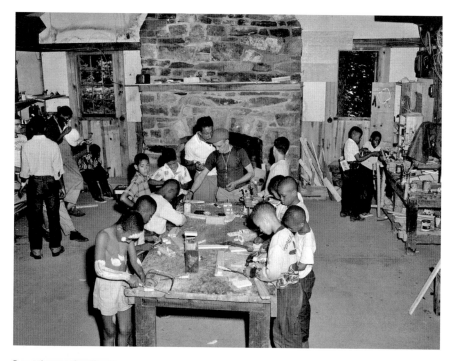

Learning crafts allowed youth to combine creativity with skills-building and resulted, hopefully, in a project to take home with pride. *Scurlock Studio Records, NMAH.*

Because of segregation, white and black youth were kept separated. Cabin Camp 1, which opened in 1936, became the home of the summer camp of Washington's Twelfth Street YMCA. Two years later, it was renamed Camp Lichtman for Abe Lichtman, a Jewish entertainment enterprises owner. Lichtman had been sponsoring the YMCA's summer camp since 1931, when it was held in the George Washington National Forest. With the tagline "The nation's finest camp for Negro youth," a session cost fourteen dollars for two weeks. The camp was also available to children from Baltimore and several urban areas of Virginia.

Novell Sullivan, who grew up in Southeast Washington, has fond memories of Camp Lichtman, which he attended most summers growing up. During his annual two weeks of swimming, hiking, crafts and outdoor life, he met boys from other parts of the Washington area.

The Family Services Association (FSA) of Washington had been running summer camps for underprivileged mothers and children since early 1906. The purposes were to preserve families by giving mothers and children time for recreation and a respite from the cares and stresses

of their often tenuous home lives. FSA, along with Associated Charities, operated two camps: Camp Goodwill for white families and Camp Pleasant for African Americans.

Camp Pleasant was first located in Tuxedo, Maryland, now a largely industrial area. In its first year, according to William H. Jones in his study of black recreation, 128 mothers and children under fourteen were served. At some point before 1909, the camp was conducted at Notley Hall and then moved to rural Fairmont Heights, Maryland, in 1910. There it remained until it was relocated to Blue Plains, D.C., in 1920. Under the direction of Dr. J.H.N. Waring, the camp became a place for instruction in healthy habits, life skills and proper child care. Then it was moved to Cabin Camp 4 in Chopawamsic. The Camp Pleasant cabins were designed for mothers and toddlers and were constructed so the young children could be supervised by mothers or counselors. In addition to the courses instituted by Dr. Waring, the camp also offered typical camping activities like crafts, nature lessons and swimming.

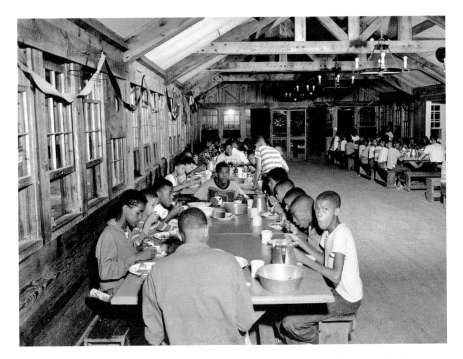

An important aspect of YMCA camp was the guaranteed three healthy meals for the two weeks of the session. *Scurlock Studio Records, NMAH.*

Chopawamsic was appropriated in 1948 to serve as a training facility for the forerunner of the Central Intelligence Agency. Renamed Prince William Forest Park, the park and associated cabins are part of NPS. Today, four of the five cabins have been placed on the National Register of Historic Places.

NATIONAL MEMORIAL TO THE PROGRESS OF THE COLORED RACE OF AMERICA

The charismatic pioneering radio evangelist whose theme song was "Happy Am I," Elder Lightfoot Solomon Michaux of the Gospel Spreading Church of God conceived of a memorial to African Americans. It would "be an inspiration to the generations to follow, to emulate the examples of their fathers, who, given their freedom became loyal citizens of the States and the Republic, with the dedication of their lives in Peace and War." The memorial would also serve as a mecca to the James River in Virginia near the place where "the first slaves landed." The installation would provide, among other loftier endeavors, "sports on water and land," education facilities, songfests, entertainment from "Stars of the Race," conventions and conferences with the most modern radio equipment for wide broadcasting.

The ever acquisitive Michaux purchased 500 acres of James River waterfront and 1,300 acres of farmland for the memorial and grounds along what became the Colonial Parkway, the highway planned to connect Jamestown, Colonial Williamsburg and the Yorktown Battlefield where America defeated the British and gained independence. He commissioned architectural drawings for a hall of fame, a monument to Booker T. Washington, a church, a radio station; a "Bethune Hostess House" and a statue depicting the progress of the race. These would be on the front side of the property, while the rear would include houses, a cooperative farm with an agricultural training center and an amusement park on the beach.

Michaux pulled together a board of some of the most prominent Afro-Washingtonians, such as Secretary of Howard University Emmett Scott; former judge James Cobb; Mary McLeod Bethune, then head of National Youth Administration; Julia West Hamilton, president of the Phyllis Wheatley YWCA; Nannie Helen Burroughs; and Jesse Mitchell of Industrial Bank. He then began the serious work of turning his dream into reality. In late 1936, he solicited and received support from the NPS of the Department of the Interior, since it managed the nearby Yorktown Historic Park and was

involved with the Colonial Williamsburg restoration. Next, in July 1937, a nationwide fundraising campaign was launched. That move turned out to be premature.

In opposition to his superiors, the superintendent of the Colonial National Historical Park wanted to confiscate the memorial land and relocate the project. He did not want Michaux's efforts seen as connected to Colonial Park, which included Yorktown, Historic Jamestown and a relationship with Colonial Williamsburg. Meanwhile, Michaux had neglected his board, and members became concerned about his financial accountability. They actually made public statements to that effect and began to resign, effectively ending the fundraising campaign.

NPS then decided that it needed the highway to connect Jamestown to Yorktown and Williamsburg. It was able to get a bill passed through Congress for the Colonial Parkway. Following a long struggle, during which the Department of the Interior attempted to simply condemn Michaux's land to take it, in 1945 it paid his price for the almost forty acres needed for the parkway to proceed. In return, Michaux was able to hold on to his remaining property, including the beachfront, as long as "no unsightly buildings" were erected on it.

Almost twenty years later, Michaux purchased an additional 625 acres in the same area, still desiring to erect a memorial to African Americans. However, he also wanted to use the land to construct housing similar to his apartment community project for middle-class African Americans in Washington, Mayfair Mansions. This new development, though, would house whites. When he died in 1968, his estate contained the remaining land for the memorial and 1,800 acres in Jamestown.

CHAPTER 5

"DON'T MESS WITH JIM"—CROW, THAT IS

TWENTIETH-CENTURY LEISURE SPACES

*H*uddie Ledbetter, more famously known as Leadbelly, wrote of 1937 Washington after he and his wife were refused housing by white landlords:

> *Home of the brave, land of the free*
> *I don't wanna be mistreated by no bourgeoisie*
> *Lord, in a bourgeois town*
> *Uhm, the bourgeois town*
> *I got the bourgeois blues*
> *Gonna spread the news all around.*

While segregation of public recreational places in Washington had long been practiced, twentieth-century Washington saw groups like the Washington Chapter of the NAACP and the local Committee Against Segregation in Recreation support black attempts at sharing leisure spaces. These efforts frequently elicited virulent reactions from whites. Sharing beaches, for instance, seemed too personal and intimate to whites, and mixing was prohibited. The battle over beaches at the Tidal Basin illustrates that point.

When reclaimed land was turned into a beach at the Tidal Basin and outfitted with a luxurious bathhouse, thousands of whites were able to find relief during the hot and humid months of Washington's summer of 1920 and thereafter. There was, however, no comparable public place for Afro-

Washingtonians. After vociferous protests by African American taxpayers and white allies, the federal government proposed placing a beach on an opposite end of the Tidal Basin. This met with clamorous outcries from whites. Alternative sites were suggested, but most, like Buzzard Point, were too dangerous and were thus objectionable to black people. Any hints of desegregated locations met with resistance from the D.C. government and certainly from the white public. The discord contributed to the defunding of the Tidal Basin beach in 1924. The Tidal Basin beach was closed, and the Jefferson Memorial was built in its place. African Americans in Washington never did get their "bathing beach."

Beaches weren't the only public leisure spaces where African Americans were unwelcome. Black female golfers were treated to physical and verbal violence when they tried to golf at the public course at East Potomac Park. White patrons and onlookers jeered at the women, called them names and threw stones at them. Black golfers received abuse even when playing on the small sandy course set aside for them at the end of the Lincoln Monument. To appease the public, in 1939 the federal government funded the establishment and construction of Langston Golf Course for black golfers on the shore of the Anacostia River.

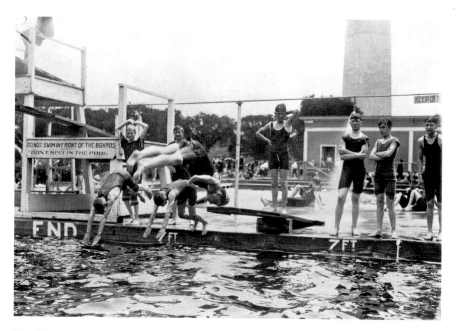

The Washington Monument in the background, youth avail themselves of the Tidal Basin's whites-only beach, closed in 1925 and removed. *MLK.*

The Anacostia Park Pool was yet another battleground. In spite of prevailing signs that Jim Crow might be losing ground, the D.C. Board of Recreation still issued an explicit regulation in 1945 strictly enforcing the division of the races at the facilities under its control. The federal government, on whose land the Anacostia pool was located, had declared that its new non-segregation policy would be applied to swimming pools. In response, over a few days, several black youths showed up to swim but were either turned away by white lifeguards who were District employees or were taunted and splashed by whites so that they could not really enjoy the pool. Hordes of white resisters appeared, and as their crowds grew, so did protective black crowds. A riot eventually broke out, resulting in injuries of blacks and arrests of blacks and whites. The pool was closed for the remainder of the summer.

Is it any wonder then that while many African Americans sought the same rights as their fellow white citizens, they also continued to seek places of their own where for a few hours they could just be?

Suburban Gardens

The "Finest Amusement Park Operated by Colored People in the World," Suburban Gardens opened on June 25, 1921, on nine acres in the semi-rural Northeast Washington hamlet of Deanwood at Fiftieth and Hayes. William H. Jones described the park: "[It is] equipped with over a mile of macadam roadway together with over twenty concessionaires, booths, and pavilions. In addition to a large dancing pavilion, there is a caterpillar, a coaster, an aero-swing, a ferris wheel, a dogem [sic], a frolic, a tumble-bug, and a fully-equipped children's playground."

The first season, Suburban Gardens was slow to attract crowds. The dance pavilion, designed by local black architect Lewis Giles, was in place, and as the summer progressed, a ticket office and café were added. Besides the pavilion, the park only offered a merry-go-round. The music, though, was provided by Russell Wooding, considered a top musician in the city. A young Duke Ellington had found work with Wooding a few years earlier before forming his own ensemble. Wooding himself went on to play in Broadway shows and appear in movies with the likes of Ethel Waters and a very young Sammy Davis Jr.

By the Fourth of July a year later, Suburban Gardens, the only amusement park within the District limits, was hopping. Having opened

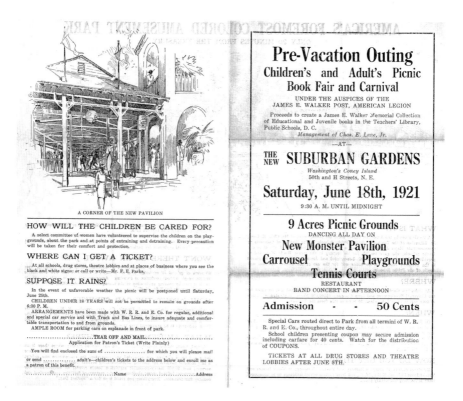

A CORNER OF THE NEW PAVILION

HOW WILL THE CHILDREN BE CARED FOR?

A select committee of women have volunteered to supervise the children on the playgrounds, about the park and at points of entraining and detraining. Every precaution will be taken for their comfort and protection.

WHERE CAN I GET A TICKET?

At all schools, drug stores, theatre lobbies and at places of business where you see the black and white signs; or call or write—Mr. F. E. Parks.

SUPPOSE IT RAINS?

In the event of unfavorable weather the picnic will be postponed until Saturday, June 25th.

CHILDREN UNDER 18 YEARS will not be permitted to remain on grounds after 6:30 P. M.

ARRANGEMENTS have been made with W. R. R. and E. Co. for regular, additional and special car service and with Truck and Bus Lines, to insure adequate and comfortable transportation to and from grounds.

AMPLE ROOM for parking cars on esplanade in front of park.

.........................TEAR OFF AND MAIL.........................
Application for Patron's Ticket (Write Plainly)

You will find enclosed the sum of for which you will please mail!

or send adult's—children's tickets to the address below and enroll me as a patron of this benefit.

................................NameAddress

Pre-Vacation Outing
Children's and Adult's Picnic
Book Fair and Carnival

UNDER THE AUSPICES OF THE
JAMES E. WALKER POST, AMERICAN LEGION

Proceeds to create a James E. Walker Memorial Collection of Educational and Juvenile books in the Teachers' Library, Public Schools, D. C.

Management of Chas. E. Lane, Jr.

—AT—

THE NEW SUBURBAN GARDENS

Washington's Coney Island
50th and H Streets, N. E.

Saturday, June 18th, 1921

9:30 A. M. UNTIL MIDNIGHT

9 Acres Picnic Grounds
DANCING ALL DAY ON
New Monster Pavilion
Carrousel Playgrounds
Tennis Courts
RESTAURANT
BAND CONCERT IN AFTERNOON

Admission - - 50 Cents

Special Cars routed direct to Park from all termini of W. R. R. and E. Co., throughout entire day.

School children presenting coupon may secure admission including carfare for 40 cents. Watch for the distribution of COUPONS.

TICKETS AT ALL DRUG STORES AND THEATRE LOBBIES AFTER JUNE 5TH.

The front and back covers of a brochure promoting an outing to "Washington's Coney Island" sponsored by an American Legion chapter. *Dr. Lee Gill Collection, MSRC.*

AMERICA'S FOREMOST COLORED AMUSEMENT PARK
ONLY 20 MINUTES FROM THE TREASURY

Inside, the brochure features a rendering of Suburban Gardens and a thoughtful orientation to the park. *Dr. Lee Gill Collection, MSRC.*

WHAT IS IT?

A Picnic given by the American Legion under the management of Mr. Chas. E. Lane, Jr., Librarian of the Teachers' Library, Public Schools, of the District of Columbia to commemorate Major James E. Walker, a former student, teacher, and official in our Public Schools, who gave his life for his country in the recent World War; and to provide funds to begin a Memorial Educational and Juvenile Collection to be placed in the Teachers' Library in his honor and for the use of the Colored teachers and pupils of our Public Schools.

WHERE?

At Suburban Gardens, a new picnic and amusement park owned and operated by the Universal Development and Loan Company ($100,000 Negro corporation)(located at 50th and H Sts., N. E., about 20 minutes from the Treasury.

WHEN?

On Saturday, June 18th, 1921. The gates will open at 9:30 in the morning and close at 12 midnight. Children under 18 years of age must leave the ground before 6:30 p. m. and children will not be admitted at night.

The outing will furnish school people the last opportunity to get together before the summer vacation, and will supply the government employees with amusement on their first half holiday.

HOW DO YOU GET THERE?

By street cars of Washington Railway and Electric Company or Motor Busses and Trucks from 15th and H Sts., N. E., and from various school buildings to be announced later in the daily and weekly press.

Take Columbia Line Cars, eastbound on H St., Northwest or Northwest operating from U. S. Treasury to District Line.

Take only cars marked "District Line," "Suburban Gardens," or "Special Car." Motor parties will find nothing but concrete, asphalt and new macadam road direct to gate. Special esplanade for parking machines.

WON'T THERE BE AN AWFUL JAM?

No, the park is located in the midst of a beautiful wooded grove extending over 65 acres of ground all of which is in the District of Columbia and will accomodate 100,000 people without confusion or crowding. Arrangements can be made for private picnic groves by making application to the management and depositing $2.00. Phone N. 10156 or write 502 T St., N. W.

HOW ABOUT THE CAR SERVICE?

All Washington Railway and Electric Co. cars crossing H St., will transfer to the Columbia Line where a special schedule will be arranged for the day. Traffic along all lines will be handled by regular and additional cars and special cars routed from renderous to be announced later through the newspapers.

WHAT AMUSEMENTS ARE THERE?

A cool, clean, refined environment in open and wooded country where there is an abundance of sunshine, shade and spring water; acre of well equipped playgrounds and safety; a new monster pavilion for dancing accommodating several thousand dancers and observers; new 20,000 merry-go-round; regulation tennis courts; an amphitheatre for motion pictures; billiard room; shooting gallery; restaurant facilities and carnival and county fair features. Everything you could wish for a "Perfect Day."

at the beginning of the Jazz Age, Suburban Gardens' dance pavilion was the scene of performances of the Charleston, the Lindy Hop and the Black Bottom, dances that were taking America and Europe by storm. It rained that day, but about 1,500 people bought tickets. Besides the dance pavilion, the musical fare and the attractions already mentioned by Jones, the park offered a Miller & Baker roller coaster, a scenic railway, a shooting gallery and a small golf course. Picnic areas and places to just sit and people-watch were also available. One could arrive at Suburban Gardens by streetcar (on the Deanwood to Chevy Chase line), by auto, by bicycle or simply on foot. Dressed in their finest, all comers expected to have a good time.

A mainstay of the typical amusement park was the roller coaster. Though there were several styles of roller coasters since the original invention by LaMarcus Thompson, Suburban Gardens' developers purchased Miller and Baker's Deep Dipper. John Miller had invented a number of coaster safety features, like the "under-friction wheels," while still maintaining the scare factor. His coasters incorporated camelback hills (multiple straight or slightly angled drops that went all the way to the ground) and large, flat turns. The park was equipped with several other state-of-the-art rides: 1920s Harry Traver inventions such as the Whip and the aforementioned Caterpillar, the Dodgem and the Tumble Bug. Providing a mix of flat rides like the Frolic and the Dodgem with elevated rides such as a Ferris wheel and roller coaster was guaranteed to satisfy all types of thrill seekers.

Suburban Gardens was developed by the Universal Development & Loan Company (UDLC), formed by some of the area's most astute race men. Among the officers and directors were M.S. Koonce, a clerk with the Department of Justice; Howard D. Woodson, a civic activist, an experienced architect and engineer and a resident of Deanwood; John H. Paynter, an author and also of Deanwood; and A.S. Pinkett, an attorney and NAACP leader. The company continued to expand and improve the amenities at the park while providing a safe and decent place for relaxation. Its white concessionaire signed a contract that he would hire only black employees for work at the park. In taking these measures, UDLC demonstrated a level of respect for its patrons and an intent to bring them "a well-equipped and high-grade amusement park."

The dance pavilion and the cavalcade of bands catered to the patron seeking a different sort of entertainment. From the beginning, some of the District's best and the nation's most famous entertainers appeared at Suburban Gardens during its almost twenty years of existence.

A riot almost ensued a few weeks after opening over a misunderstood feature act. The park advertised that the Whitman Sisters would be providing entertainment but only at intermission; this latter qualifier was missed or ignored by many. The four sisters, a phenomenal family of vaudevillians, long forgotten today, were one of the most popular acts in the country. Tap dancing geniuses, they were known especially for their clean but energetic interpretations of dances such as Ballin' the Jack, Walkin' the Dog and the Shim-Sham-Shimmy. They also produced their own shows that included a variety format of songs, dances and comedy skits, with sometimes up to thirty performers, a chorus line and jazz band and talented dancing youth, some of whom went on to have prominent careers of their own.

Hundreds showed up on August 1 for the opportunity to see the Whitman Sisters. When the act did not appear immediately, the crowd became restless. A few pranksters caused some small incident that resulted in people thinking there was a real crisis, and they began to flee. Though the park had its own special security force, the crowd's panic was more than they could handle, and the local city police were called in as backup. The *Post* sensationally reported that the police had to stop a riot, whereas the black newspapers and UDLC stated that the police simply helped to restore some order. The *Chicago Defender* in an August 13, 1921 editorial went so far as to postulate, "There are certain interests which are jealous of the success of the enterprise and would seek in every way to embarrass the promoters." In fact, the Whitman Sisters did perform during the intermission, but they later refused to commit to a return engagement.

However, under no circumstances though would UDLC want it thought that its business attracted unruly crowds. The park still had its detractors. Among them were some Deanwood residents who had to deal with the increased vehicular traffic and noise. Nannie Helen Burroughs's school was on the hill above the streetcar stop where park patrons disembarked and boarded. She frowned upon the exposure of her students to the pleasure seekers, stating in a letter of April 3, 1928: "The Suburban Gardens are located at our gate; they keep open until midnight. It is quite enough to unload thousands of people at our entrance during the four summer months...The Negro seems to be going pleasure mad." But there were few incidents such as the one that ensued over the Whitman Sisters. In fact, not only did the park provide a space for black groups, but as scholar Marya McQuirter stated in her dissertation on D.C.'s black recreation, "Suburban Gardens...was also a site for the containment of the black crowd."

In spite of these incidents, Suburban Gardens enjoyed a reputation as the "Negro Coney Island" for many years to come. Its organizers continued to attempt to address the needs of people who had few choices for safe quality entertainment and employed a few schemes to ensure attendance. Free band concerts, contests, costume pageants for children and a stilt-walking clown advertising the treats at the park were among the various gimmicks to titillate the public. When the Marvelous Melville aerial act appeared in 1926, admission to the park was ten cents, but a ride of one's choice was free.

Suburban Gardens was selected by many large white employers who wanted to give a perk to their black employees. D.C.'s Lansburgh Department Store provided annual picnics for its black employees there. Much was made of the baseball challenge between the Lansburgh porters' team and its team of chauffeurs. The *Star*'s black newspaper boys were also treated to a day at the park. Imagine their excitement!

"If there be a god…he must be white, because he witnessed all the sorrow and suffering of black people and did nothing about it," declared Clarence Darrow as recounted in the *Chicago Defender* on April 28, 1928, reporting one of the stranger events at Suburban Gardens. The famed white criminal lawyer and noted atheist was denied invitations to speak at any of the large number of churches in Washington. The NAACP, led by Howard University academic Neval Thomas, responded by giving Darrow the opportunity to give a speech at the park in its open-air pavilion. Sunday, April 22, was a dreary, drizzly day, but at least five hundred persons attended the event, which opened with a singing of "America" through which Darrow, it was noted, remained seated. The song was followed by a recitation by noted educator Mary P. Burrill of a poem, "Abou Ben Adhem," written by Leigh Hunt. In the poem, Abou awakens from a peaceful dream to find an angel in his room writing in a book of gold the names of those who love the Lord. Abou's name is not included, and he asks the angel:

"I pray thee, then,
Write me as one who loves his fellow men."

The Angel wrote, and vanished. The next night
It came again with a great wakening light,
And showed the names whom love of God had blessed,
And, lo! Ben Adhem's name led all the rest!

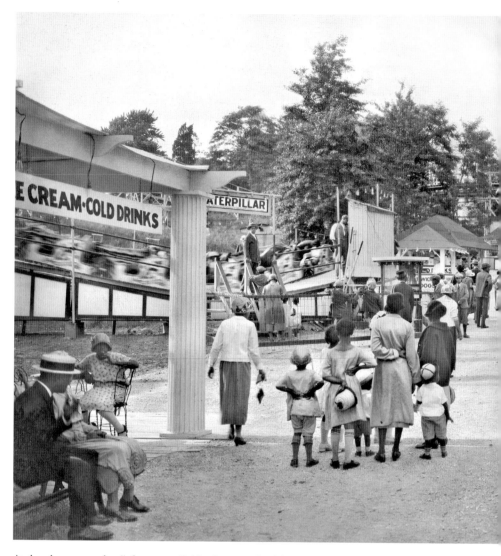

At the pleasure garden "of our own," this photograph of Suburban Gardens in the 1920s perfectly captures the amenities offered and the custom of dressing up for a day at the park. *Scurlock Studio Records, NMAH.*

Darrow then followed with a long exhortation to people of color to continue to fight for their rights as citizens. The *Defender* printed the speech in its entirety.

Not apparent from generally glowing newspaper reports or the few extant personal accounts of the amusement park were challenges to the

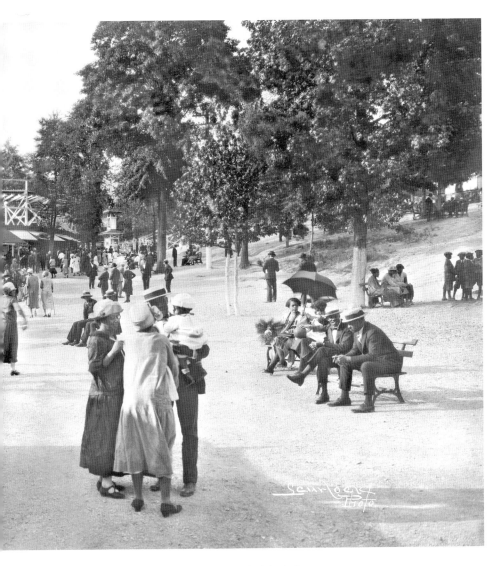

infrastructure, finances and other behind-the-scenes management concerns. Two hazardous crossings led to the entrance of the park. The responsible parties—District government and the Chesapeake Beach Railway—were unresponsive. The request for adequate street lighting, especially at the entrances to the parking areas, was similarly deferred by the city. UDLC also had to secure and maintain a private contract for water service for its water fountains while it awaited water and sewer services from the District. Ultimately, the extended sewer service to the park came in 1925, with additional improvements in 1930.

When Abe Lichtman's company purchased Suburban Gardens in 1929, he immediately began construction on a Harry Traver "crystal swimming pool" for the park. Advertisements of its 1930 opening claimed the cost was $50,000, though the building permit estimated the cost to be $12,000. Lichtman, the noted Jewish entrepreneur and philanthropist, owned a string of movie theaters on the eastern seaboard, most of which catered to black audiences. Lichtman was known for hiring black managers for his properties. In addition to his support of the YMCA summer camp, he also sponsored many public recreational park athletic teams for girls and boys. He was a good friend of Eleanor Roosevelt and supported many of her causes, including helping to furnish the National Council of Negro Women House, run by the indomitable Mary McLeod Bethune.

With the acquisition of Suburban Gardens, Lichtman invested considerably in modernizing the park. The May 16, 1931 *Afro* took the reader on a step-by-step tour of the new incarnation of the park. Upon entering the gate and a new fence line, the midway had been widened and a miniature golf course placed on the right, and on the left was the new swimming pool. At the top of the midway was a circular refreshment stand, and to its right was a Leaping Lena, a jerking old-fashioned auto ride and "The Laff in the Dark," a tamer but no less exciting fun house ride by Traver. Farther up on the left was evidence of re-sodded and landscaped grounds where one would find the Whip, concession stands and remodeled aerial swings and "Chair-o-Plane," as well as a new covered merry-go-round. At last, one arrived at the terrace to find the Thunderbolt, Tumble Bug, the Caterpillar (where sweethearts might steal kisses when shielded by the canopy), the Ferris wheel and the Fun House.

On the way back down (as Suburban Gardens was built on a slope), Lichtman created a new picnic area complete with shady trees, benches, tables and "open air kitchens" (probably barbecue grills). There was a special free area just for young children that included sandboxes, swings, seesaws and a Venetian swing ride. Dr. Alfred O. Taylor Jr. recalls his parents taking him to this section of the park while he looked wonderingly at the rides that went off the ground.

Continuing down, there were tennis courts. The pool came into view, and besides swimming, it was the scene of swimsuit and lifeguard competitions.

Below was the Crystal Palace dance pavilion, where one could swing to the most "hep" music of the day. Wallflowers could simply sit and look. The new opening of Suburban Gardens had featured Putney Dandridge but shortly thereafter showcased the irreverent Cab Calloway, the polished

Jimmie Lunceford, the dynamic Louis Armstrong and Washington's own elegant Duke Ellington, among many others. With the convenience of parking available to the park grounds, everyone who could come would be there. The venue would be jammed.

Within ten years of taking over Suburban Gardens, Lichtman closed the park, and the land was sold to develop Federal Housing Administration apartments. Today, Suburban Garden Development and Apartments stand on the site of one of the best places Washington-area African Americans ever had for pleasure and relaxation.

National Capital Country Club

Some African Americans of Washington, among the wealthiest, prominent and most influential in America, desired a facility much like a think tank that also reflected their status. Additionally, this institute would provide opportunities for recreation and leisure with like-minded people. The National Capital Country Club set out to fill that gap. The membership solicitation brochure explained:

> *The colored people of the United States are not to be denied an opportunity to keep abreast of all modern movements, hence a national organization has been created which will have a significant effect upon our social and economic life…It is highly important that such an organization provide appropriate entertainment as well as facilities for conferences and at the same time afford an opportunity for recreation and relaxation…This great need of our people has been met by the….National Capital Country Club.*

Eminences such as Emmett J. Scott (former secretary to Booker T. Washington, former special assistant to the secretary of war under President Wilson and Howard University administrator) and W.L. Houston (prominent Washington attorney and father of Charles Hamilton Houston, the law school dean, and strategist for the later groundbreaking *Brown v. Board of Education* case) were involved. Bankers, lawyers, doctors, agency and fraternal leaders and business owners were pulled together to form this auspicious leisure venue.

With grand intentions, the club opened at the end of May 1926. It was located southwest of the Contee Station of the B&O Railroad between

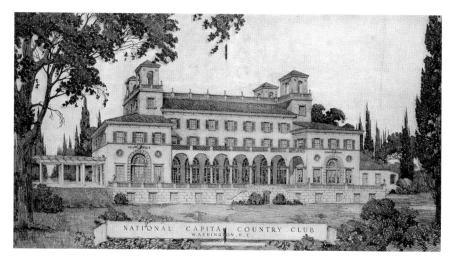

The National Capital Country Club's grand plans for its center. *Jesse E. Moorland Collection, MSRC.*

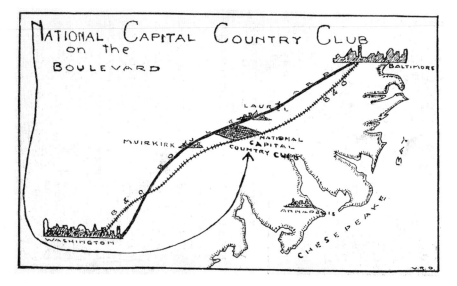

The promotional brochure of the National Capital Country Club shows its location on "The Washington-Baltimore Boulevard," or Route 1. *Jesse E. Moorland Collection, MSRC.*

Muirkirk and Laurel in Maryland in a no longer extant community named Edge Hill. Dr. Scott, president of the club, and Judge James A. Cobb, chair of the board, hosted a gala ball packed with well-wishers and visitors in town for the annual track and field meet held at Howard University. The event heralded a bright future for a first-class "place of our own."

The fancy but tasteful informational brochure included the names of the officers and governors, a veritable who's who of accomplished "colored" Washington. There were drawings of the proposed club building and conference center complete with floor plans. But for the moment operating from a standing building that looked to have been an impressive estate home, this new endeavor had repurposed it as the clubhouse, "a haven for those who appreciate the finer things of life." Sumptuous furnishings, epicurean dining for up to sixty-five and ten comfortable bedrooms, "convenient to modern baths," were to be enjoyed by members.

An entire wing had been added for dancing, small musicales or card parties. It was designed with a highly polished dance floor, a niche for a

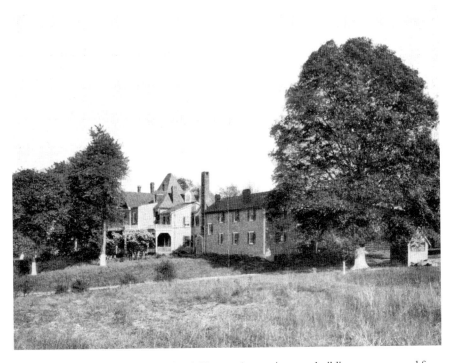

The view of the building used as the clubhouse. A stunning new building was proposed for the future. *Jesse E. Moorland Collection, MSRC.*

concert piano as well as a player piano, verandas and French windows to ensure a comfortable dancing experience. The dancing hall could host at least fifty couples. Friday evening entertainments were to be provided by various university fraternities, and Saturday night supper dances and Sunday dinners would be featured weekly.

Though not yet available by the 1926 opening, a golf course and tennis courts were assured for the near future. Similarly, billiards was to be among the amenities on the main floor in an enlarged room complete with fireplace and lounging chairs.

Membership was by invitation only. If invited, one could be admitted to this rarified enclave for an initiation fee of $20 and $15 in

An impressive invitation to join the club, embossed and with a tassel. How could one refuse? *Jesse E. Moorland Collection, MSRC.*

annual dues. A lifetime membership was also available as an alternative for $300. A surprisingly forward-thinking clause in the membership description read, in part: "A changing public attitude has finally established the principle of the equality of the sexes…And so, in keeping with modern ideas and conceptions, membership…is open to women as well as men on an absolute parity."

The following May, a nine-hole golf course was opened on the twenty-three-acre facility. The debut featured an eighteen-hole exhibition match between Harry Jackson and John Shippen. Shippen, a native Anacostian and son of a prominent minister, had been golfing since the 1890s. He was widely considered America's earliest known black professional golfer. A sixteen-year-old Shippen had placed fifth in the second U.S. Open Golf Tournament, which was held at the Shinnecock Hills Golf Course in New York in 1896. Thereafter, most golf associations altered their rules to state specifically that competing in their tournaments was by invitation only; the Professional Golfers Association specifically required that members be "Caucasian-only." A young Harry Jackson was the first champion of the newly established black golf association, UGA (United Golf Association),

formed in 1926. He triumphed over the now "old lion" to the delight of the crowds who had been treated to a rousing contest.

The year 1927 also saw the completion of tennis courts and croquet setups. For a time, the country club enjoyed significant patronage. Chic partygoers, dressed in the fashions of the day, motored from Washington seeking the pleasure and relaxation assured at this classy establishment, where they would be able to join their kind.

The Depression, though, interfered with the vision. The country club closed, and one of its members took over in 1934 and operated the establishment as a nightclub, Club Chalcedony. Among its guests was Cab Calloway, who attended a party there one night. Within four years, the property was sold.

WILMER'S PARK

The first time I saw James Brown was at Wilmer's Park and what a show he put on.

My grandfather said he saw his first professional wrestling match at Wilmer's Park.

Girl, I got to Wilmer's Park, looking fly, and there he was. The rest is history.

These are familiar refrains from black Washingtonians of a certain age. Wilmer's Park was the place to be from the 1950s to the 1970s. The crowds came by car or bus, turning off narrow Brandywine Road in rural Prince George's County to be scintillated by the sounds and sights of the latest rhythm and blues entertainers.

Starting in 1952, once paying an entrance fee at a ticket booth at the far end of the parking lot, concert-goers quickly made their way onto the grounds of Wilmer's Park. Nearby was a picnic area with a playground. On the large field ahead was the primary destination of ticket buyers: the dance hall, a two-story building with a half-cylindrical roof. Built into a hill, the dance hall was entered on one end from what was actually the second floor. The stage at the far end held all the excitement fans paid for. There were murals around the walls and ceiling fans up above that did little to cool the place down once the music started to crank up.

The former neon sign along Brandywine Road marking the entrance to the large parking lot of Wilmer's Park. *Courtesy Javier Barker.*

Arthur Wilmer was proud that his entertainment park provided a restaurant with excellent fare and a motel for patrons and visiting musicians. *Courtesy Javier Barker.*

Wilmer's also had an outdoor covered stage behind the dance hall with bleachers built into the hill, forming an amphitheater. With a large field between the stage and the bleachers, this area could accommodate much larger crowds. It was the primary venue for the later music festivals that featured go-go, reggae, rock and punk bands.

Wilmer's was developed in direct response to the Jim Crow segregation of the times. It served as a stop on the famed Chitlin' Circuit, the nickname for the mostly southern tour route for African American musical acts from the 1940s to the 1960s. Many black acts in their early years appeared at Wilmer's on their way to national fame. Chubby Checker, Otis Redding, Patti LaBelle and the Blue Bells, Fats Domino, Jimi Hendrix, Little Stevie Wonder and John Coltrane are just a few of the entertainers who thrilled Washington-area audiences.

Arthur Wilmer, a native Washingtonian, was a born entrepreneur. By the age of twenty-seven, he had purchased a restaurant on Seventh Street and turned it into a frequented supper club, renaming it Little Harlem. His place was near the Howard Theater and became an afterhours joint frequented by the theater entertainers after their shows. At Little Harlem, big-name musicians like Ella Fitzgerald, Louis Armstrong and Cab Calloway would eat a good meal, have drinks and chill out.

In 1947, Wilmer bought an old tobacco farm in Brandywine in southern Prince George's County, about twenty-two miles southeast of Washington. He planned to use the eighty acres of partially wooded and overgrown fields for hunting. But soon he was playing host on Sundays to local black baseball teams, for whom he cleared a diamond and installed bleachers. The games were a big hit and brought crowds out to take in the sporting events. Dr. Alfred Taylor said he visited many times to play baseball on Wilmer's field. Taylor was at shortstop for a couple of the local black teams, the Green Valley Black Sox and the Arlington Athletics. The field was rocky and dusty, he remarked, but that was what made black players so good—they had to play under rough conditions. Typically, Wilmer's diamond "was not manicured—that would have been a luxury," stated Taylor.

A friend of Wilmer's from the city who booked acts took a look around one Sunday and suggested that the farm would be a great place to host music shows. Wilmer got busy. He cleared more land and built the large dance hall, which literally became the stage from which new and emerging musicians could further their careers. He had the foresight to construct below the dance hall a restaurant and five apartments that served as dressing rooms. He added a fifteen-unit motel on the property so that musicians and guests

What's left of the dance hall that featured some of the greatest R&B singers of all times. The background shows the barn original to the property. *Courtesy Javier Barker.*

would have someplace comfortable to stay and not have to search for lodging or be turned away from white hotels. The meals served from the kitchen and restaurant he built were legendary. Dr. Taylor recalled that although he was at Wilmer's to play baseball, the food and music were good.

Wilmer's Park eventually contained not only the dance hall, amphitheater, motel, restaurant and a smaller stage so that there were three music venues but also a vending stand and a picnic area and playground. He also built a ranch house that served as his family's residence. There was an expansive parking lot and ticket booth. Additionally, Wilmer put in a football field to give local teams a decent and consistent place for games. All of this was presided over by the large tobacco barn, the last remnant of the past use of the land. The remaining sixty acres were wooded.

In an interview for the *Post*, Wilmer claimed that one of the first acts he booked was Ray Charles, who drew a crowd of fifteen thousand people. Wilmer's became a notch in the belt of successful entertainers during the Jim Crow period. James Brown, in his autobiography, related that after his first record, *Please, Please, Please*, came out, he and the band started touring mainly in the South. After having spent time in Richmond, he was finally booked in Washington, which opened the way for him to perform at the beaches

in Maryland and at Wilmer's Park, where he made good money. A young Marvin Gaye and the Moonglows, fresh from performing in Philadelphia, put on a show at Wilmer's in the summer of 1960 before hitting what Gaye considered the big time: the Howard Theater.

After integration, the black-only places of leisure were not as important. Wilmer, ever entrepreneurial, recast his park as a go-go music venue, attracting younger African Americans, and then as a showcase for music festivals featuring reggae and rock bands that appealed primarily to white audiences. Arthur Wilmer passed away, and his children ran the place. Soon, though, even the appearance of John Scofield, groups like Rare Essence and Black Sheep and musical festivals with names like "All Good" and "Nuclear" was not enough to keep the gates open. The park stopped operations in 2001.

Today, Wilmer's Park sits like a ghost town, a hint of the good times that once were. It is a designated historic landmark. A fraternal organization has purchased the property and plans to create a leisure park geared toward family recreation.

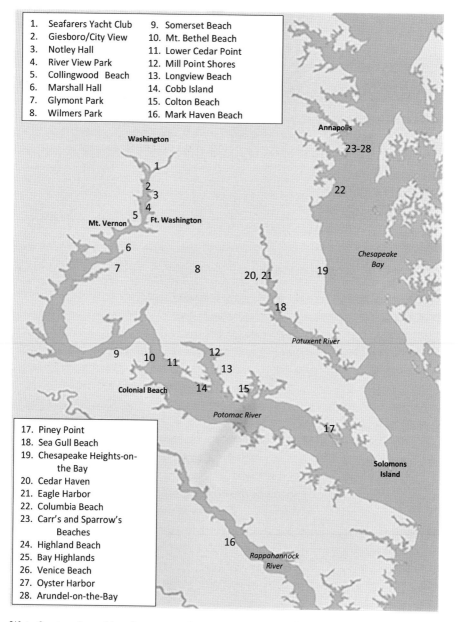

1. Seafarers Yacht Club
2. Giesboro/City View
3. Notley Hall
4. River View Park
5. Collingwood Beach
6. Marshall Hall
7. Glymont Park
8. Wilmers Park
9. Somerset Beach
10. Mt. Bethel Beach
11. Lower Cedar Point
12. Mill Point Shores
13. Longview Beach
14. Cobb Island
15. Colton Beach
16. Mark Haven Beach

17. Piney Point
18. Sea Gull Beach
19. Chesapeake Heights-on-the Bay
20. Cedar Haven
21. Eagle Harbor
22. Columbia Beach
23. Carr's and Sparrow's Beaches
24. Highland Beach
25. Bay Highlands
26. Venice Beach
27. Oyster Harbor
28. Arundel-on-the-Bay

Washington

Annapolis

23–28

22

Chesapeake Bay

Mt. Vernon Ft. Washington

Patuxent River

Colonial Beach

Potomac River

Solomons Island

Rappahannock River

Waterfront parks and beach towns on the Western Shore of the Chesapeake Bay and the Patuxent, Potomac and Rappahannock Rivers. *Author's collection.*

"SITTIN' ON THE DOCK"

BEACH COMMUNITIES AND AMUSEMENT PARKS

We should have a land of sun;
Of gorgeous sun,
And a land of fragrant water
Where the twilight is a soft bandanna handkerchief
Of rose and gold.
—Langston Hughes, 1924, Opportunity Magazine

WESTERN SHORE COMMUNITIES AND PARKS

Highland Beach

While it was never intended to be a public place where African Americans could enjoy leisure at will, Highland Beach was certainly always intended to be a place for "our people." Mary Church Terrell aptly described Highland Beach when she wrote in 1904 in the *Voice of the Negro*:

> *Some of those seen at the leading social functions during the winter spend apportion [sic] of the summer at the sea shore, in the mountains or at some quiet country resort. There is a charming spot on the Chesapeake Bay, which has been converted into a summer resort by one of the most progressive and useful colored men in Washington. Here some of the flower*

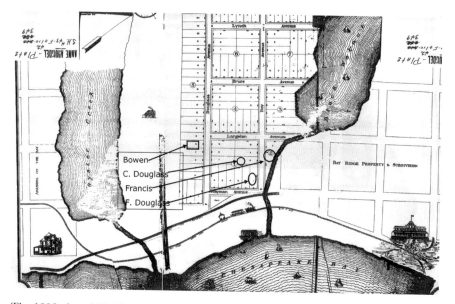

The 1893 plat of Highland Beach between Black Walnut and Oyster Creeks and the Bay; Pinchback Avenue is missing. The location of the first owners is shown. *MDSA, adapted by author.*

of the social flock of Washington and neighboring cities take their summer outing in pretty little cottages which they themselves own. Boating, fishing and crabbing are the order of the day, together with an occasional dance.

Today, it is a charming, sequestered bayside village, but in its heyday it was a haven for prominent black Washingtonians, a place of beauty where they could relax with their families and friends. In 1922, it became only the second municipality in Anne Arundel County, Maryland, as a way of protecting its interests and maintaining control of its private leisure space.

After weaving through a seeming maze of streets and an irregular collection of houses, the first sign of Highland Beach is literally a sign—a bronze plaque affixed to a stone pillar. The plaque reads, in part, "Highland Beach, incorporated 1922, Founded 1895 by Charles R. & Laura A. Douglass." Continuing at last down a roughly paved road named after a famous black person, passing unpretentious cottages of various sizes, colors and conditions, the beach is finally reached. It stretches straight out to the horizon that has a bit of fringe at the end. To the left, in the blue-gray distance, is a silhouette of a bridge.

Highland Beach, or the Beach, as it is sometimes called, grew out of the racial slight that had become the all-too-common experience of black people at the hands of white people following the failure of Reconstruction. Always wary of the undercurrents of racial prejudice and conscious of the erosion of civil rights in the late nineteenth century, people of color tended to frequent places where they were known and accepted. Yet in 1892, a restaurant at Bay Ridge, the B&O resort south of Annapolis on the Chesapeake Bay, refused to serve Charles Douglass and his wife, Laura Haley. One imagines that Charles, an accomplished man in his own right but also the son of the most celebrated black man in the world, was particularly stung. The oft-told story continues that the rebuff sent him and his wife walking away from the ornate building. They crossed a bridge over a creek and onto a property with a breathtaking view of the Bay and the distant Eastern Shore, where his father was born. The couple came upon a black farmer named Brashears. The three began to talk, and by the end of the conversation, Charles had discovered that Brashears not only owned the property bordering Bay Ridge but also that he was weary of farming and wanted to sell the land.

A year later, on April 10, 1893, the property—forty acres between Black Walnut and Oyster Creeks and fronted by the Chesapeake Bay— was transferred to Charles's son Joseph for the sum of $1,000. Joseph, a professional violinist, was a favorite of his grandfather Frederick who paid the money for the purchase. The tract had 1,250 feet of bayfront and was accessible by the Bay Ridge train. Charles subdivided the land into 131 lots, mostly 50 by 150 feet. He created avenues and named them after prominent black men, setting a trend that other black-developed beach resorts would follow. He wrote to his father on May 15, 1893, telling him of the new venture and the improvements he had made to the property. He said that he could sell enough lots that year to realize a profit and make good on the investment. He decided that because "the land at that point is higher than either side of me on the Beach," the new settlement would be called Highland Beach. The intent was to develop a place where his kind of people could enjoy leisure without the intrusion or harassment of whites.

Immediately upon purchase, Charles began building his home and managing construction of outbuildings. As a result, the family spent many hours at the property. Charles's youngest son, Haley, who would become Highland Beach's first mayor, wrote his grandfather in August 1893: "I go out fishing and crabbing almost every day. I have learned to swim well and I can swim over a hundred yards without stopping to

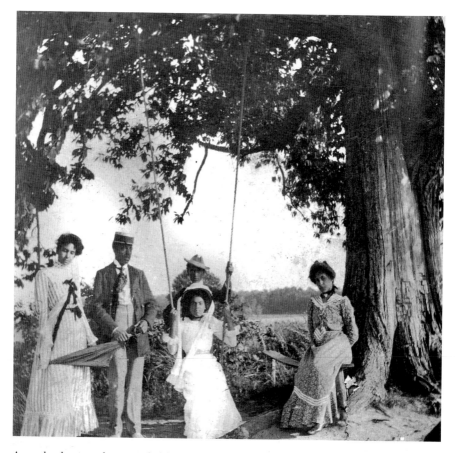

An early photographer recorded family and guests of Highland Beach relaxing and having fun, whether singing, swinging or just taking in a cooling breeze. *Gregoria Fraser Goins Collection, MSRC.*

rest." Charles's summer cottage, completed in May 1894, was the first one built in Highland Beach. The *Bee* announced on June 30, 1894, that his "beautiful residence" with a broad veranda and large airy rooms was to be the site of a private picnic on the Fourth of July and that it would be "one of the grandest affairs ever given."

Frederick Douglass oversaw the construction of his own house on the lot at the corner of Wayman and Bay Avenues. He particularly wanted a room from which he could look out across the Bay to see his origins and contemplate his life. He called his home Twin Oaks but died in February 1895 before it was ready for occupancy. His son Lewis and grandson Joseph

and their families would occupy the house over time.

By 1895, there were at least two other houses, bathhouses and a boat dock in the hamlet. The beach spread along the cool azure waters of the Bay like an unfurled fan and was crossed by train tracks. In spite of a depression in 1893, twenty-three lots had been sold to at least six buyers before 1900. At the end of 1895, the "second season" at Highland Beach, Charles's venture, the "first undertaking of the kind by our people," was pronounced a success "beyond expectation" by the *Bee*. Described as the "owner and manager of this first and only seaside resort owned and controlled by a colored man in America," Douglass celebrated with a lawn party on the "commodious grounds" of his house. Friends from the Washington area and beyond were invited and entertained by the Annapolis Mandolin and Guitar Club, assisted by son Joseph. Progressive and useful, indeed!

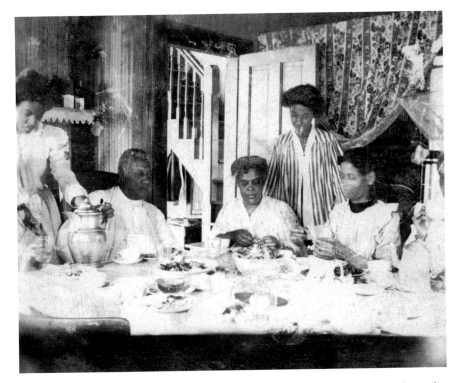

"Crab picking" and eating, a regional tradition practiced at the Charles Douglass (second from left) summer cottage. The structure would collapse decades later. *Gregoria Fraser Goins Collection, MSRC.*

Mary Church Terrell was among the first lot purchasers. She paid $350 for her property. According to her autobiography:

> *Major Charles Douglass…invited us to Highland Beach…to look at a tract of land he had bought on Chesapeake Bay. He intended to convert it into a summer resort for our group, he said, and he wanted us to buy a lot there…I was delighted with the place and decided to use the money I had earned by substituting in the high school…to buy the lot. The Honorable Frederick Douglass selected a corner lot, facing Chesapeake Bay, and asked us to take the one next to his. Our neighbor on the left, therefore, was Mr. Douglass, and on the right a short distance away Paul Dunbar bought a lot.*

Aside from Mrs. Terrell and the Douglass family, other early purchasers included Dr. John R. Francis and George T. Bowen. A prominent member of Washington's "colored" society, Dr. Francis, who attended to Senator Blanche Bruce in his final days, initially served on the staff of the Freedmen's Hospital. He subsequently directed a sanitarium in Washington for black and white patients. His wife, Betty, was one of a group of women who pushed successfully to establish kindergarten programs in the black public schools of Washington. For a total of $300, they purchased two small lots in 1895. These lots were smaller than most of the lots but formed a triangle along the stream that fed the lush Black Walnut Creek. The

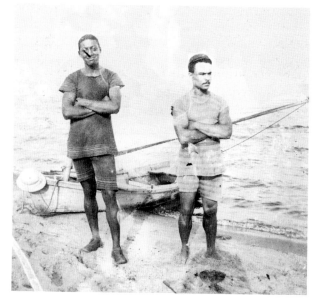

Frederick Douglass's grandson Haley, future mayor of Highland Beach, and Milton Francis at the Beach in 1899. *Gregoria Fraser Goins Collection, MSRC.*

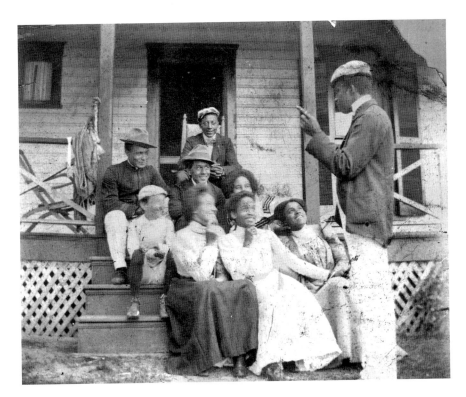

Betty Francis Henderson wrote of Highland, "Here, the problems of segregation…seemed far away or nonexistent. Here was an oasis in a parched environment." *Gregoria Fraser Goins Collection, MSRC.*

narrowest point of the triangular-shaped tract faced the Bay. Their lots were across the street from the Frederick Douglass lot. According to the Francis descendant, Betty Francis Henderson, Douglass initially picked those two lots but changed his mind, fearing that the stream might pose a danger to his grandchildren. Dr. and Mrs. Francis, who had picked the lot across the street, offered to trade with him. Their cottage was most likely the third home to go up at the Beach.

George Bowen was the son of an enslaved waterman who had commanded a sloop back and forth from southern Maryland to Baltimore. George had served in the navy during the Civil War as a mess boy. He parlayed that experience into becoming a steward for the prestigious Athenaeum Club in Baltimore and other equally prominent clubs. Charles Douglass asked Bowen specifically to invest in order that

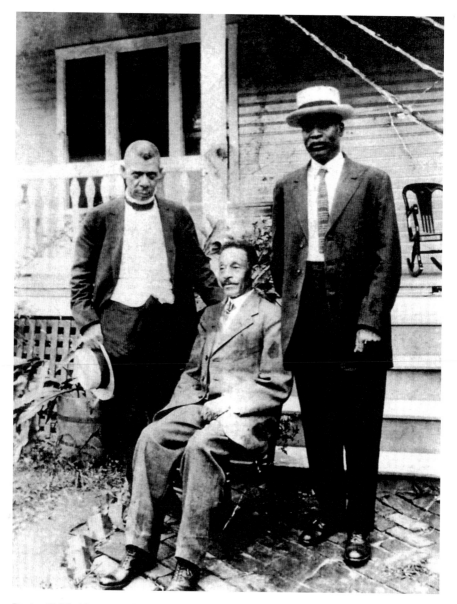

Booker T. Washington and educator Kelly Miller were among the many distinguished persons who visited Highland Beach, boarding at George Bowen's, renowned for his hospitality. *Author's collection.*

he might build and run a guesthouse. Indeed, Bowen's, facing Langston Avenue rather than the Bay, became a popular place for prominent visitors to the Beach. Bowen paid $325 for his lot in 1895 but did not complete construction of his establishment until 1902. The nine-room cottage with a large wraparound porch saw many notable lodgers over its first decade, including Booker T. Washington; Senator-elect P.B.S. Pinchback of Louisiana and his son, Toomer; Senator George White of North Carolina; Judge Mifflin Gibbs; author Charles Chestnutt; and poet Paul Laurence Dunbar.

Following the establishment of Highland Beach, the *Bee* and *Colored American* regularly mentioned doings at the Beach. Friends of the owners were thrilled to be invited. They could take a steamer down the Bay or the train from Washington to Annapolis and then transfer to the Baltimore and Annapolis Short Line, which went to Bay Ridge and Thomas Point, the lighthouse in the Bay, with a stop in between at Highland Beach. Taking an excursion to the Beach was the rage among a certain set.

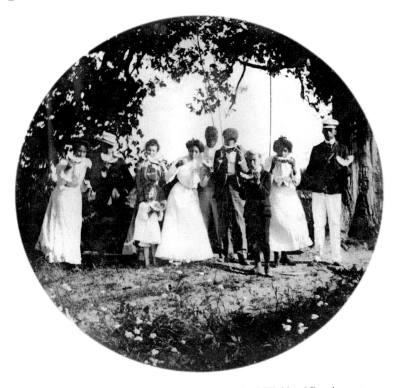

What would fun at the beach be without watermelon? Highland Beach guests are showing how it is done, even dressed up. *Gregoria Fraser Goins Collection, MSRC.*

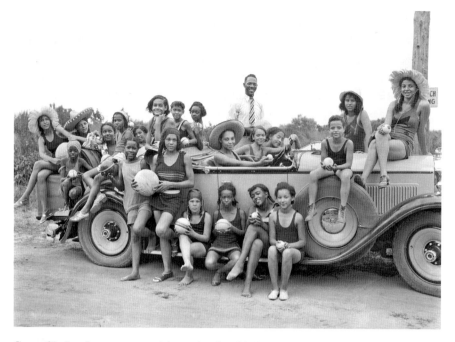

Camp Clarissa Scott was a special occasion for girls (and a boy) from Washington's Wheatley YWCA. Beach resident Addison Scurlock snapped the 1930 campers. *Scurlock Studio Records, NMAH.*

Early buyers took their time building permanent cottages, so summers saw family and friends camping in tents—"roughing it" in rollicking fun. There was no electricity until the 1920s, cooking was done on wood-burning stoves and most lots and cottages had outhouses. Mosquitoes were a major problem, so there was heavy netting at night when folks went to sleep. One could take rooms and meals at Bowen's Guest House, which later became Annozene's Tea Room, both known for outstanding cuisine. Later, Ware's Hotel took the place of Bowen's and then was replaced by Wahl's Guest House. Eventually, most of the lots were filled with comfortable homes.

Owner and resident Dr. Jesse Moorland was active in the YMCAs and YWCAs and so encouraged summer camps for city youth at the Beach. Camp Clarissa Scott was named in honor of the talented daughter of Emmett Scott, who had distinguished herself in her short life as a poet, a teacher at Dunbar High School and a respected social worker. The camp, established in 1931, was situated in the woods above the Beach in what is now Bay Highlands. The camp facilities consisted of a one-story dormitory and activity center. According to Ray Langston of the Highland Beach

Historical Society, the campers walked down each day to the beach for fun in the water. Otherwise, the Beach was generally off-limits to anyone not a guest of an owner. Violations could lead to a ten-dollar fine.

Among the activities residents and their guests engaged in were fishing, bathing, boating, hunting, croquet and tennis. Later, a pavilion was erected and people played cards, danced and put on plays. Each summer, residents would greet one another and catch up on their off-season lives, although many socialized with one another in the city. While other black beaches began having beauty contests in the 1930s, it was never done at Highland Beach. According to Langston, "All the girls were beautiful, and to pick one would hurt someone's feelings. Instead, we had debutante balls." There was a period, too, when many of the young men—including Frederick Gregory, who would become the nation's first black astronaut—engaged in power boat racing. As they got older, some outgrew the thrills and had other things on their mind.

Time at the Beach spurred all sorts of creative notions. These boys have pieced together a tree raft of sorts for fun in the water. *Courtesy Susan P. McNeill, HSW.*

Once, the beach at Highland extended for yards. Summer residents and their guests speak years later of the idyllic atmosphere and the freedom they felt. *Courtesy Susan P. McNeill, RMC.*

The astute residents of the Beach, to maintain what they had, moved to incorporate so that the increasingly stabilized community would have greater control over planning, zoning and taxation. In doing so, it was the first black resort community in the nation to become a town. With the incorporation came a ruling body and a formal set of rules. Among those were prohibitions against commercial endeavors other than the sale of property. Ware's Hotel ran afoul of the local law when it persisted in advertising in the black newspapers soliciting patrons from the general public. After falling victim to arson, it was rebuilt in 1931, physically straddling the line between Highland Beach and Venice Beach. The management changed, as did the name. At the end of the 1930s, it became Wahl's Guest House and served guests of residents until the 1970s.

Charles Douglass passed away in 1920 and willed his unsold lots to his sons Haley and Joseph. His house, largely unoccupied after this time, started to deteriorate and eventually collapsed in the 1940s. Frederick Douglass's home Twin Oaks served for a number of years as the town's post office. Then it, too, was abandoned. After years of neglect, the Frederick Douglass cottage was restored by a white couple and placed on the National Register of Historic Places. Twin Oaks now serves as the community's museum and welcomes visitors. Though the train and steamers are gone and most of the waterfront has eroded, the Beach is now more of a year-round community.

Frederick Douglass never enjoyed his completed house. Now home of the Highland Beach Historical Collection and Museum, the top floor provides a view of Douglass's birthplace. *Courtesy Deborah Mose.*

It has seen generations of first families of Washington's black society relax and enjoy leisure.

The success and stability of Highland Beach has also inspired development of neighboring communities to serve African Americans seeking private beachfront retreats. Both black and white entrepreneurs seized the opportunities.

Venice Beach was founded by Highland Beach resident O.T. Taylor. He paid the taxes on a strip of land still held by Brashears descendants and purchased the property in 1922. The bayfront land was situated between Highland Beach and Oyster Creek. It contained an old cabin Brashears used as a place for watermen to shuck oysters and clams for sale. Once Taylor assumed ownership, he had the land subdivided and named the narrow swath with one road Venice Beach. He sold lots to friends and others known to him. The first cottage was built the same year.

Two of the residents of Venice Beach were Gregoria Fraser Goins and her husband, John. They called their summer retreat John's Gift. Gregoria

was a musician and music teacher while John owned a printing company on U Street. Gregoria's mother, Sarah Loguen Fraser, the fourth known black female medical doctor in the country, was also sister to Amelia Loguen Douglass, wife of Lewis.

Venice Beach still conducts the Watermelon Sailboat Regatta each year, an event and now tradition that dates to the 1940s. It is a big affair where many people claim spots generally on Highland Beach for the day to watch the sailboat races.

Oyster Harbor was the result of white developers seeing the potential in providing vacation homes for middle- and upper-class blacks. The land that became Oyster Harbor was across Oyster Creek from Venice Beach but had no real bay frontage. In order to provide bay access, the developers "bulkheaded and dredged" an entryway to the Bay. This action altered Oyster Creek from a shallow meandering creek to a straight waterway of four to six feet deep. The development was then marketed heavily to black Washingtonians, and within the first three years of the subdivision (1950–53), according to Andrew Kahrl, the eighty-eight lots over fourteen blocks were sold to 147 individuals and couples. Some long-standing residents of

Gregoria Goins, a musician, with her husband, John, a printing company owner, and two unidentified women in Washington. The Goinses' summer home was in Venice Beach. *Gregoria Fraser Goins Collection, MSRC.*

1930 cottages in Venice Beach (top) and Highland Beach (bottom). In the bottom right, right to left, are the homes of the Sheriff (now Jarvis), Lewis and Holmes families. *Gregoria Fraser Goins Collection, MSRC.*

A day on the Bay was one of the pleasures of visiting the Beach. *Gregoria Fraser Goins Collection, MSRC.*

the area lamented, though, the ill effects on the local ecology, including the accelerated erosion of the shoreline. Oyster Harbor today has black and white residents.

Bay Highlands was subdivided and lots were sold in 1925 by a white minister who also marketed the new community to African Americans. Bay Highlands sits between the town of Highland Beach and the main road to the Beach. It has no waterfront of its own but controls the access into and out of Highland Beach. This has been a recurring source of challenges. Bay Highlands is a mixed community today.

Arundel-on-the-Bay was first developed as a white beach community. When the tide of black waterfront seekers began to approach, Arundel-on-the-Bay owners sought to protect their enclave in 1949 by dissolving their town charter and switching to a private homeowners' association. Alas, they moved a little too slowly, as the ruling in the case *Shelley v. Kraemer* had just come out stating that racial restrictive covenants in housing and real estate were unenforceable. This 1948 Supreme Court decision eventually had an impact all over the country, but in Washington, communities changed almost overnight. When one of the white residents of Arundel-on-the-Bay got into a dispute with his neighbors and sold his house to a black family, the remaining white owners scattered like birds startled from a tree. Blacks with means moved in. Once on "their" beach, they were just as protective of "their space" as the whites who had just left or, for that matter, as their nearby historically black sister community.

Carr's and Sparrow's Beaches

To protect his flock from being exposed to weekend beer drinking at Sparrow's Beach and all that went with it, Reverend George Brent would schedule a trip on the first Monday in July. This usually marked the end of vacation Bible school and the date of the annual church picnic. Brent—a beloved pastor of Deanwood's largest church, First Baptist Church of Deanwood, designed by black architect Romulus Archer—would charter at least two buses and extend the invitation to anyone in the neighborhood who wanted to go. According to Deanwood native Barbara Moore, one bus would be for the children of the church and the other for community members who were not necessarily parishioners of First Baptist Church. Brent organized merchants in the tightknit village to donate goods needed for the fun day at the beach, and the women of the church would cook up the food so that

everyone attending would have something to eat. Such was the delight around the annual trip that some businesses even closed up so that the owners could also take a day at the beach. "It was the wonder years," sighed Moore.

Carr's and Sparrow's—you almost never heard one mentioned without the other. They were, in fact, two different but adjacent beaches that were owned by two sisters and open to the public for a fee.

Located on a peninsula south of Annapolis known as Annapolis Neck, the land had been purchased in 1902 by Frederick Carr, a man who had been born into slavery. After decades of working as a waiter and cook at the Naval Academy in Annapolis, Carr moved his wife and children to settle on the 180-acre farm on the shores of the Chesapeake Bay. Within a few years of farming, to supplement their produce-sales income, the Carrs made their property available for group picnics and summer boarders. By 1909, Carr's Farm was known to Washingtonians as a place to take a day at the beach. The shrewd elder Carr also took legal precautions to ensure that the land stayed in the family. His steps would prevent future claims to his family's property by white developers.

By the 1920s, many black Washingtonians owned automobiles. William H. Jones claimed that of the 1,000 black households surveyed, 627 families owned or were buying a car. This provided them the means to traverse the rough and irregular roads that led to the Bay, where they could spend the day or days on beachfront property such as Carr's. Possessing an automobile, to a limited extent, also allowed black leisure seekers the means to forgo renting a room on the road or at a resort; they could camp out. Eventually, the roads improved, car ownership increased and access to Carr's and Sparrow's and its amenities became easy and regular.

Frederick Carr's daughter Minnie Dickerson began offering overnight accommodations at a boardinghouse she and her husband built on the farm. In 1916, the *Afro* named some of the notables who spent time at Dickerson's Mount Pleasant Cottage, where crabbing, fishing and, of course, "bathing" were offered, along with delicious home-cooked meals. Following a visit in August 1931, *Afro* columnist Lula Jones Garrett conveyed the kind of quiet pleasure many African American excursioners sought: "Just the perfect spot for one of those lazy-day not-to-be-bothered rests. After several injudicious attempts to buck the sea nettles, this child was perfectly content to prop her twelfth vertebra against a tree and watch the rest of the swimmers try the water or deepen their tans on the beach."

Meantime, the whites-only Annapolis Roads Club had been opened just a quarter of a mile or so from the Carrs' property with grand plans

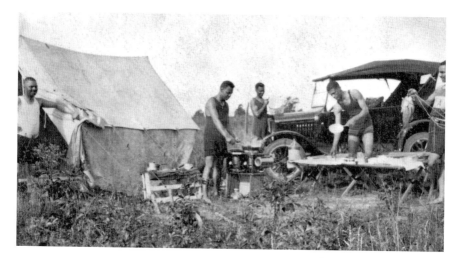

Afro-Washingtonians packed their cars and headed to rustic camp meetings or black-owned beaches or riverfronts and set up camp. *Dale Family Album, ACM, gift of Diane Dale.*

for expansion on lands yet to be acquired. The owners and promoters persistently sought not only to buy the holdings of Carr and his family but also to remove them from such proximity. When Frederick Carr passed away in 1928 around the age of eighty, his heirs were forced to go all the way to the Maryland Supreme Court to uphold their father's intentions for his affairs. Once the matter was settled, the surviving family members set out to continue the financial legacy. Daughters Florence and Elizabeth were able to purchase the shares of the property from surviving siblings who had established lives in other places. The sisters, in turn, developed their beachfronts into "Negro" playgrounds that survived, physically, well into the 1960s and mentally and emotionally in the minds of former patrons to this day.

According to Philip L. Brown in *The Other Annapolis*:

> *In the 1930s Carr's and Sparrow's beaches…opened to provide protected bathing for swimmers…Sparrow's Beach catered mainly to families and church groups interested in bathing and picnicking. Carr's Beach catered to the younger group interested more in the entertainment provided by famous bands and popular entertainers.*

Florence Sparrow put her acres to use more as a resort than simply picnic and beach grounds. She built cabins for overnight visits and began

to have events to attract families, social clubs, fraternal organizations and church congregations. She invested in some of the latest amusement park rides and built a playground and baseball field. She put in picnic tables, beach chairs and umbrellas and food stands and began hosting activities, such as beauty contests, that would attract large crowds. Along with new amenities, on Sunday afternoons, Florence featured entertainers such as Charlie Parker. Billie Holiday appeared there in the 1930s in one of her earliest concerts, accompanied by Count Basie. Patrons were thrilled to know that here was a place for them. As Dr. Taylor stated matter-of-factly, "There was no place else to go."

Carr's, formally named Carr's View Beach, opened during the 1930 season under the management of Elizabeth Carr Smith. According to John P. Coleman in his work on amusement parks in Maryland, Elizabeth initially sought to provide safe places for black youth to frolic in the water since they were prohibited from enjoying the more protected beaches open to whites. Every summer season during the period of segregation, a significant number of black swimmers drowned. This was due in great measure to the fact that places where they could swim were unsafe. At Sandy Point Beach in Annapolis, for example, blacks were admitted but relegated to the worst and most dangerous section. In response, Carr Smith offered weekly swimming and lifesaving classes through the Red Cross.

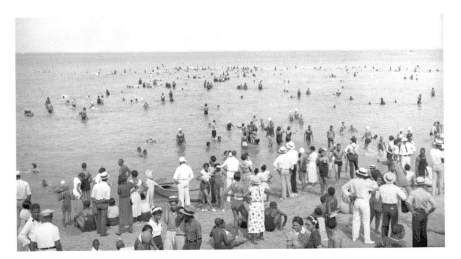

Sparrow's Beach on a typical summer day. If you couldn't get in the water, you could stand on its edge and catch a breeze and a view. *Courtesy Susan P. McNeill, RMC.*

139

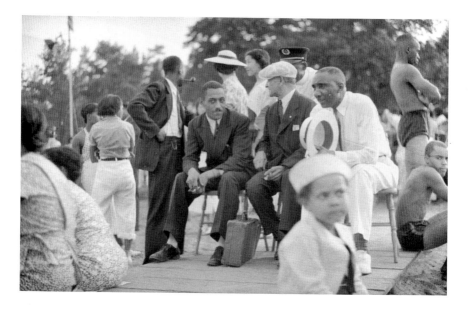

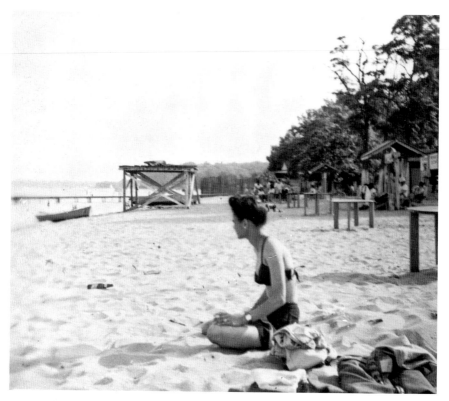

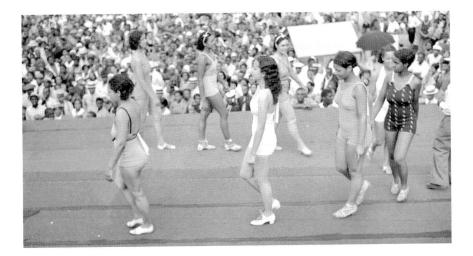

Above: One way that Sparrow's attracted patronage was through its beauty contests. Other black beach parks followed suit and held their own. *Courtesy Susan P. McNeill, RMC.*

Right: And the winner is… The black newspapers generally carried photographs of newly crowned queens, providing publicity to the beaches. *Courtesy Susan P. McNeill, RMC.*

Opposite, top: By the 1940s, Sparrow's catered primarily to overnighters or to excursioners in large groups—from church, fraternal, labor and social organizations. *Courtesy Susan P. McNeill, RMC.*

Opposite, bottom: While most images show Carr's and Sparrow's Beaches filled with throngs of leisure-seekers, one could sometimes sit quietly, contemplating the beauty of the Bay. *Courtesy Susan P. McNeill, RMC.*

She, too, began to hold specialty events to increase the numbers of patrons. For example, there was an annual Catholic Day that attracted busloads of Catholics from the Washington area. Gaming booths, refreshment stands and dancing were also added. Like many places of entertainment in Maryland at the time, slot machines were available. When rides were introduced, Washingtonians flocked to Carr's to enjoy the Ferris wheel, swings and carousel, as well as boat rides on the Bay.

The flush economy after World War II meant that many blacks had the means to indulge in "R&R." Carr's became distinguished from its sister beach as it became a major stop on the Chitlin' Circuit for black artists. The who's who of rhythm and blues and jazz, especially those starting out, had a stint at Carr's or Carl's, as many mistakenly referred to it.

Elizabeth Carr Smith passed away in 1948, and her son Frederick Smith and his wife, Grace, inherited her twenty-six acres. He partnered with Baltimore numbers magnate William Adams, who was trying to develop a black beach community nearby that he had named Elktonia. Smith and Adams formed the Carr's Beach Amusement Company. With guidance from Baltimore promoter Rufus Mitchell, Carr's became a premier entertainment venue. Top-notch acts were brought in. Later, the company formed a partnership with a Jewish-owned Annapolis radio station, WANN, founded in 1947. It had become one of the first to offer black-oriented programming. D.C.'s own Hal Jackson, a native of the Capitol View neighborhood who became one of the better-known radio hosts in the nation, was an early disc jockey at the station. However, it was the later radio host mentored by Jackson, Charles "Hoppy" Adams, a former cab driver, who caused Carr's popularity to soar. Considered an R&B deejay, Adams talked about the upcoming concerts on the radio and then served as the electric master of ceremony of Carr's concerts, many of which were broadcast from the pavilion. Audiences were almost as thrilled to see him in person as they were the artists about to appear on stage.

A weekend day at Carr's or Sparrow's would begin with beachgoers arriving early in the day to secure a place on the grounds. Then everyone would be off to swim, eat, drink, sun and take in some of the rides and other amusements. As a youth, Dr. Taylor's family would drive to Sparrow's from the Washington area in his father's '39 Pontiac. Accompanying them would be Mother's picnic basket filled with her famous fried chicken and potato salad, along with fruit and Kool-Aid in a thermos. During the day of relaxation, the Taylors would meet family members who frequently rented a cottage on Sparrow's Beach for the week. Like many families, the Taylors would pack up and leave as the sun was setting.

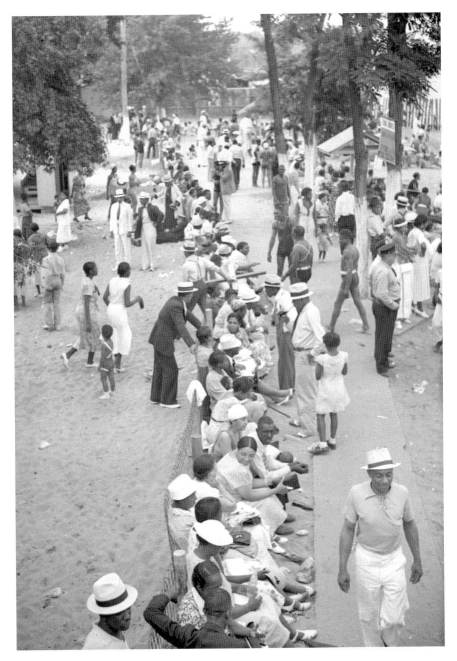

Many visitors came to the twin beaches simply to sit and people-watch. For some, that was the best amusement park activity. *Courtesy Susan P. McNeill, RMC.*

Left: At Carr's, as "the sun goes down," the stars come out. James Brown, one of the brightest, made the rounds in his early career. *Author's collection.*

Below: Hoppy Adams, a WANN-Radio disc jockey, was as popular as many of the performers whose shows he emceed in the 1940s in Carr's Pavilion. *Scurlock Studio Records, NMAH.*

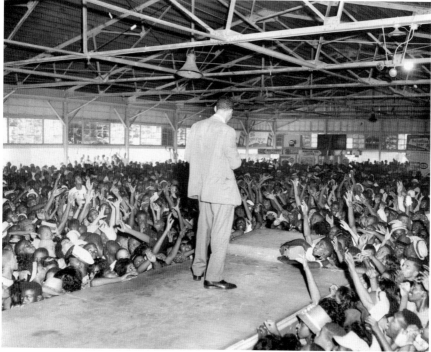

A family camped out at Carr's Beach in 1942. Many came early and found or created shade and places to hang wet towels after a dip. *Thomas Baden Jr. Collection, MDSA.*

Other patrons were waiting for the sun to go down. That is when the real entertainment would begin: dancing to the live music of some of the most famous black artists. Among the acts that appeared at Carr's were Little Richard, Sarah Vaughn, the Drifters, Jackie Wilson, Otis Redding, Billie Holiday, the Shirelles and James Brown, who was one of the most popular. As Novell Sullivan put it, "He would tear the place up." Local drummer Howard Chichester, who was into jazz from an early age, recalls that on one occasion when his family was leaving Carr's a bit later than usual, he learned that the night's performer was to be Red Prysock, the saxophonist and brother of crooner Arthur Prysock. He remembers how much he wished that he could stay and see the show.

Most entertainers on tour had to deal with pretty wretched digs, as racial discrimination excluded them from most decent accommodations. But at Carr's, they could rest and relax on the beach and stay in the quieter and well-kept cabins on Sparrow's Beach. Carr's also became popular as a training camp for boxers preparing for prizefights. After Joe Louis worked out before adoring fans for a few weeks in August 1951 in

An economical but "special" treat for patrons of Carr's shows was a poster featuring artists whether or not they had gigged at that venue. *Author's collection.*

advance of a match in Baltimore, several other pugilists began to use the facility as well.

With all these exciting acts, though, came the crowds, the traffic and the noise. Hundreds of cars lined Bay Ridge Road trying to get to the action at the beaches. On summer weekends, buses left at 10:30

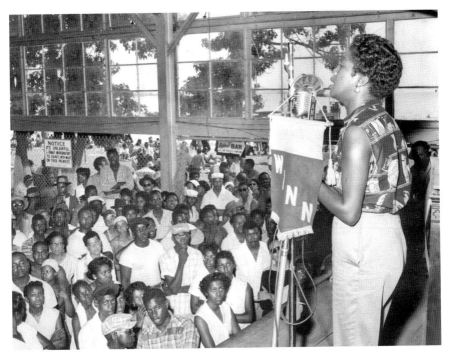

Above: A very young Sarah Vaughn mesmerizes the Carr's crowd. She was one of a number of jazz-identified musicians who performed here through the Chitlin' Circuit. *Scurlock Studio Records, NMAH.*

Below: A view of an audience awaiting entertainment at Sparrow's. Note the horizon is absent the Bay Bridge; it had not yet been built. *Courtesy Susan P. McNeill, RMC.*

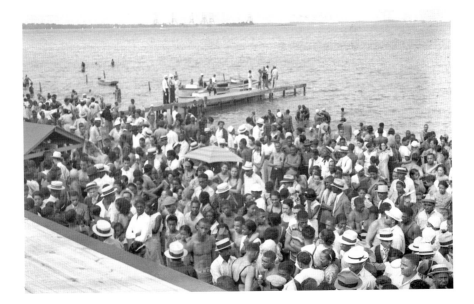

ANNUAL OUTING

The **NATIONAL** *Plastic Products Company*

Bay Ridge & Carr's Beach

SATURDAY, AUGUST 13, 1949

A flyer by the National Plastics Products Company advertising the company-sponsored outing for its employees—guess which workers went to Carr's? *Courtesy CMM.*

We're Off . . . With a toot and a whistle and a blowing of horns our gaily be-decked parade is off for a day of fun. More National folks than ever before turned out for this year's outings and the good old weather-man smiled on us again.

Did you say fun? Brother we had it; with swimming, softball, rides, contests and plenty of good eats and drinks for all.

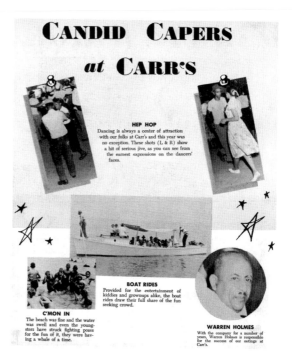

This was the page depicting National Plastics Products Company's "colored" employees having a good time on the company dime. *Courtesy CMM.*

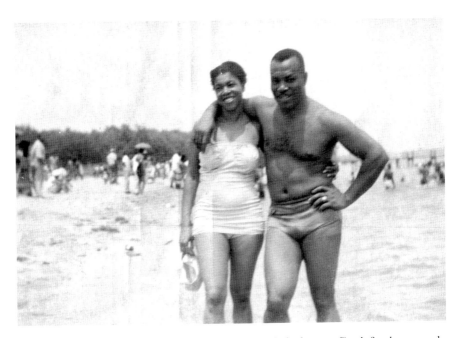

Percival and Katharine Bryan, Hillsdale residents, regularly drove to Carr's for the sun and entertainment, even following a bout of police harassment. *Percival Bryan Collection, ACM, gift of Rose Dyke.*

a.m. from Tenth and U Streets for Sparrow's, returning at 6:30 p.m. Buses chartered by organizations and churches, like those coming from Deanwood, rolled in, most going to Sparrow's, which was in the business of renting to large groups.

Carr's eventually established its own security force to cut down on incidents, at least on the grounds of the resort. It wanted to reassure law-abiding patrons that they were safe visiting Carr's, its neighbors that illegal activity was not occurring and the police that it could handle violators without the presence of white law enforcement. The force was led by George Phelps, who would become Anne Arundel County's first black deputy sheriff.

The Carr's security was kept busy. Novell Sullivan tells the story of sneaking into Carr's as a teenager. He and his friends would leave their Garfield, D.C. neighborhood by car headed to Carr's for a concert. Once they got close to the beach resort, to keep from having to pay the entrance fee, he would get in the trunk. The car would be driven onto the grounds and parked. When the coast was clear, he would emerge from the trunk and proceed to enjoy the sights and sounds. Security, though, was always on the lookout

for fare dodgers and other trouble makers. Among those like Sullivan were others who tried to sneak around the barriers in the water fencing off Carr's Beach. According to both Sullivan and Chichester, there were also holes in the fence on land that separated Carr's from Sparrow's, and people were always sneaking back and forth. Then there were those bringing in their own booze and still others who imbibed too much and lost decorum.

Little of this mattered; people went because there weren't many other places open to them. The music lovers wanted to dance and see musicians perform. Those a bit more sophisticated—or simply star-struck—wanted to make the scene after the shows for a chance to rub shoulders with the entertainers and their entourage at Club Bengazi on the site. Named for the U Street institution, it was later redecorated and renamed the Tahitian Port Lounge.

The 1950s to 1960s were the heydays of Carr's. Crowds numbered in the thousands. But after Jim Crow was nominally brought down, patrons

Against the backdrop of Carr's amusement park, these young women pose beside Hoppy Adams's promotional car and perhaps hope to meet a celebrity. *Scurlock Studio Records, NMAH.*

realized that Carr's and Sparrow's Beaches were a bit shabby and that newly available beaches and clubs had more to offer. The opening of the Bay Bridge in 1952, followed by the availability of the entire beach at Sandy Point and other places of leisure, gradually led to the loss of business for Carr's and Sparrow's and the eventual sale of the land. As Novell Sullivan put it, "All of a sudden, we could go to Ocean City or Atlantic City or even the islands; we no longer had to go to Carr's." Struggling to hold on and remain relevant, Carr's last concert in its open-air pavilion was in 1973 featuring Frank Zappa and the Mothers of Invention for five dollars. It was an event that attracted over eight thousand people. Today, the former family land is the site of high-end condominiums and a sewage treatment plant. But in its day, Carr's and Sparrow's Beaches were the stuff of legends.

Columbia Beach

Whenever one starts talking about the pleasures of Highland Beach, invariably a long-term D.C. resident will bring up Columbia Beach. Sitting in Shady Side, Maryland, to the south of the black beach towns, the cozy Columbia Beach community is between Flag Pond Creek and the Chesapeake Bay on a cove in a peninsula. The beachfront hamlet was started in about 1940 "by African American citizens seeking a place where they might enjoy the beauty and relaxation provided on the shore of the Chesapeake Bay, unhindered by the rampant racial segregation that characterized the nation in the 1940s." A white Washington developer purchased eighty-eight beachfront acres in 1939 and subdivided the property into 359 lots. Marketed to professionals of color, the lots sold quickly.

Washingtonians began building modest cottages in the 1940s in this "Gem of the Bay." Although it is now mostly an integrated and year-round community, early visitors spoke of driving the forty or so miles from the District starting in June to the beachside homes they either owned or rented to stretch out for the summer. Here they would sun, splash in the tide, fish, play cards and just unwind on the main beach that at one time stretched for many yards into the Bay.

On Sundays during the summer, there was church service. Initially, it was held on the lawn of Alphonso "Al" Jones, the first commodore of the Columbia Beach Boat Club. He had a Hammond organ that he would bring out, and each worshipper would bring his or her own "pew." Services are now conducted in a little chapel in the community. The street that had been

Columbia Beach, the only gated black beach community on the shore, lost a good bit of its beachfront through erosion but still retains its charm. *Courtesy Javier Barker.*

named for "Peg Leg" Bates, a famous black entertainer, was renamed Al Jones Drive for the early community leader.

The parents of Bette D. Wooden purchased three lots in 1947 and built a small house. She spent almost every summer of her youth there. She recalls that there were no grocery stores nearby, so families would have to bring in most of the food and supplies needed for their stays. After hours of romping on the "little beach," a smaller beachfront around the cove, she and her friends would go from house to house, playing records and dancing.

Among the early owners and regular vacationers were Cortez Peters of the business school fame; George Ferguson, a prominent D.C. architect; Bishop Smallwood Williams, founder of Bibleway Church; and a sister of Jackie "Moms" Mabley, the famed comedian. In fact, whenever the kids would see a Rolls-Royce in the community, they would get excited because they knew "Moms" was visiting.

At many black beach communities, boating was an important pastime. This was particularly true for Columbia Beach, where almost everyone owned a boat. Beginning in 1945, boating regattas were held annually in the cove fronting the community. Rowing races were its early attractions. From the late 1950s, though, regattas featuring powerboats (along with the coronation of the regatta queen) became *de rigueur*. This trend lasted into the late 1970s but was in its heyday in the 1960s at Columbia Beach. Columbia Beach families like the Triverses were regular regatta organizers

and participants, with patriarch George, a rowing champion, joining two of his sons in racing speedboats and hydroplanes. Teddy Nelson and Frederick Gregory, a Highland Beach vacationer, were other avid racers and winners of several Columbia Beach Regatta trophies.

Queens of the regatta were selected by Columbia Beach Boat Club members and were chosen from among the teenage daughters of families of residents. Howard Chichester remarked that the young women at Columbia Beach were some of the best looking he had ever seen. The families of the new queen and her court assumed the costs of the coronation ceremony, which took place the weekend prior to the regatta. The following weekend, the queen and her court would preside over the races and all the ritual that went with them. The first queen was Marvee Brown, who was crowned in 1947. Ten years later, Wooden became queen of the regatta.

The Trivers sons, Reggie and Brian, were later members of the Speedmasters Club formed in 1970 by Clarence "Stix" Archer. Speedmasters became the first black club to participate in the American Power Boat Association (APBA) races run by the previously all-white Southern Maryland

The cottage of Bishop Smallwood Williams of Bible Way Churches was once one of the largest at Columbia Beach. Now the hamlet has many suburban-sized houses. *Courtesy Javier Barker.*

Boat Club. The races at Columbia, though, were considered "wildcat" and were open to anyone, including whites, who wanted to compete. The Trivers brothers, who frequently placed in the races, were encouraged by Thomas Butler, another member of the Columbia Beach community and part of D.C.'s Seafarers Yacht Club. Butler was a reputed numbers dealer who was financially able to indulge his passion of speedboating.

Columbia Beach, a gated community with streets named after black luminaries like Booker Washington and Oscar DePriest thrives today, its famed regattas, queens and sandy beaches part of the past. Though proud of their history, residents are concerned today with erosion and water runoff.

PATUXENT RIVER COMMUNITIES AND PARKS

Eagle Harbor

In 1925, a white businessman purchased a farm south of Trueman Point on the Patuxent River with the idea of creating a resort community for African Americans. He had the land surveyed and platted and began to advertise in the black newspapers. Eagle Harbor was to be a "high class summer colony for better people." The lots went for fifty dollars or less, and if one did not have a car to ride out to look them over, a bus was furnished from U Street to transport prospective buyers the thirty miles out from Washington.

Eagle Harbor delivered on its promises of a hotel, merry-go-round, bathhouses and tearoom. There was also a park for picnicking and gazing across the river expanse to the opposite bank. New residents and visitors could also partake of the standard waterfront fare: swimming, crabbing, fishing and boating. Churches used the beach for baptisms. Many Washingtonians motored down to enjoy the peaceful, unpretentious setting on the banks of the sky-blue waterway that once was busy with tobacco- and oyster-related steamers and other vessels.

The wharf, Trueman Point Landing, had been an official tobacco inspection warehouse for decades. As a result, the road between Trueman Point and Washington was one of Prince George's earliest and most well traveled. It made for an easy drive from the Washington area.

John T. Stewart Sr. of D.C.'s Stewart Funeral Homes was among the first buyers and bought several lots that he, in turn, developed. Stewart eventually

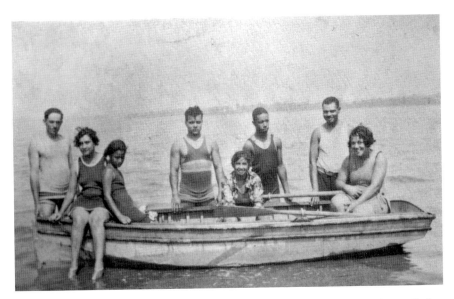

The sweltering humidity had Afro-Washingtonians seeking relief in Eagle Harbor or Cedar Haven because of the easy thirty-mile drive on the well-traveled road. *Dale Family Album, ACM, gift of Diane Dale.*

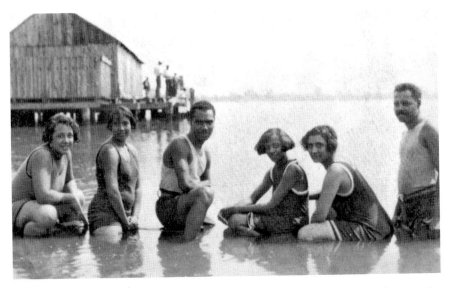

The de-licensed tobacco warehouse at Trueman's Point seemed ideal for a vacation paradise for African Americans. Beginning in 1925, lots for sale were heavily advertised. *Dale Family Album, ACM, gift of Diane Dale.*

became a leader in Eagle Harbor and served as the first chair of the Eagle Harbor Citizens Association. The association began to make or push for improvements such as roads, jetties and a town hall. Stewart was said to have been a financial backer for the development of the town.

Within ten years of the establishment of the vacation colony, its summer settlers had followed the example of Highland Beach and incorporated as a town. The *Maryland Gazetteer* noted that in 1940, Eagle Harbor's population as an incorporated town was a whopping two. (Arundel-on-the-Bay's population was eight, and Highland Beach's was nine.) The town, though, was dotted with small cottages, along with small hotels for overnight guests. In spite of its relatively slow and modest development, the owners in the new settlement had built a pier to add to its attraction.

Today, the view from the "Paradise on the Patuxent," as it was originally marketed, includes the spewing stacks of the Chalk Point Generating Station, a coal-fired power plant downstream. The swimming waters are silted and have a quicksand pull, rendering them dangerous and off-limits. In spite of these detractions, a certain charm still prevails, and the draw to Eagle Harbor persists. According to Mayor James Crudup, there are about sixty

Eagle Harbor, an incorporated town in Prince George's County since 1929, is still primarily a beach community with modest cottages. *Courtesy of Deborah Mose.*

A view from Eagle Harbor's beach today is of the coal-fired Chalk Point Generating Station that put an end to the harbor's promotion as a place for swimming and crabbing. *Courtesy of Deborah Mose.*

permanent year-round residents now but hundreds of vacant lot property owners. Most town activity, he says, "occurs in the summer months, and many folks spend days and weekends in their cottages."

Cedar Haven

Just north of Eagle Harbor, on the other side of Trueman Point Road, Maryland Development Company intended to outdo the Eagle Harbor development. Cedar Haven's promotional materials presented soothing, hard-to-resist pleas: "It is a wonderful place for children far from the dangers of city streets. They have abundant wide spaces to roam and play in, to learn the mysteries of nature, to fish, to swim, to crab, and to boat. Even the boulevards, avenues, and streets teach them the names of their country's great men and women, inspiring them to emulate their notable lives." It was true—the streets had names like Bethune Avenue, Crispus Attucks Boulevard and Coleridge-Taylor Street.

The cottage structures tended to be either Sears kit houses or to emulate a kit design. The first three houses, which served as the Cedar Haven model

houses, were of the Sojourn, White Cedars and Bellana Sears Bungalow designs. Guests without homes could stay at the Cedar Haven Hotel, also a Bungalow-style structure overlooking the water. The hotel offered a dance hall and noted kitchen. The community's bathhouse could accommodate eighty guests and was staffed by trained attendants. It also had a screened lounge overlooking the river.

Although streets were laid out, some were never fully extended or paved. However, by 1931, 172 lots had been deeded and another 101 sold. Robert Robinson purchased a lot in 1927 at the corner of Richard Allen Street and Banneker Boulevard but didn't put up a structure. Almost thirty years later,

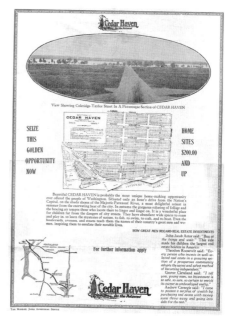

Cedar Haven promoted its "shady shores" and "bracing air." As a child, Howard Chichester found the rural village to be all that it promised in this advertisement. *UMSC.*

Robinson's son-in-law Arthur Chichester built a house on the lot by working painstakingly on weekends and sometimes weeks over a couple of summers. He constructed a kit house purchased in 1955 for $3,695 from D.C.'s "oldest and finest" builders supply store, Barber & Ross, located on Rhode Island Avenue. Arthur's brothers, some of whom were skilled craftsmen, helped put up the house.

Though Arthur was traveling to the beach to work on the cottage, his children who accompanied him thought of the family trips as "going to the country." Son Howard Chichester recalls spending his days roaming the woods with summer friends from Eagle Harbor or swimming in the river. Crabbing was another pastime, yielding Maryland blue crabs at least double the size of the crabs available today.

A fond memory of Howard's sister Tanyna Chichester Saxton was picking blackberries along the roads. The blackberries, she recalled, were huge. She and her brothers and sisters would be able to fill large containers with blackberries, which they would then cart to their mother. Using the largest speckled enamelware or graniteware Dutch oven made, Belle Robinson

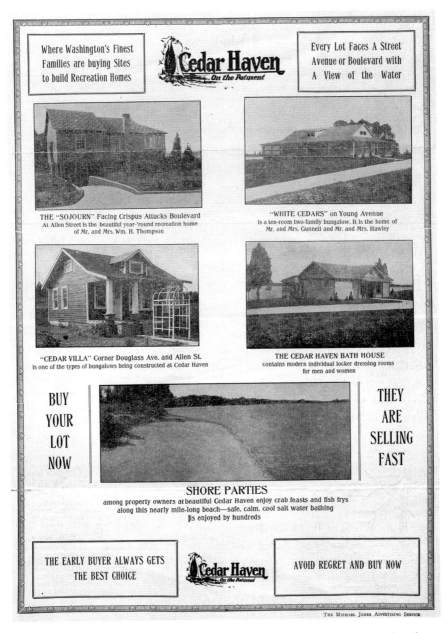

Today, there are fewer than forty homes in this riverside retreat. One reason may have been related to inflated tax assessments in the 1950s. *UMSC.*

Chichester would bake a scrumptious blackberry cobbler, and there would still be berries left over.

Howard Chichester moved to Cedar Haven as an adult so that he could stable his horses. Until a few years ago when he left, much of the land was still wooded, and like Eagle Harbor, the community was still small and rural. In 2008, there were only thirty-four houses in Cedar Haven.

Both Cedar Haven and Eagle Harbor are on the Maryland Inventory of Historic Properties and the National Register of Historic Places for their significance as early African American resort communities. They offer a glimpse of the dreams of black leisure seekers.

Sea Gull Beach

Sea Gull Beach resort was located on the lower end of the Patuxent River in Calvert County at the foot of a country road traversing flat farmland. Today, the narrow road is paved and the beach refined, surrounded by verdant manicured grassy lawns punctuated by a few modern manor houses, some of them gated. In the early days, the road was dusty and potholed, lined on each side with narrow gullies that led to a field where one parked and strolled through the weedy expanses to the waterfront.

In May 1955, when Jewish businessman Joseph Goldstein of Prince Frederick announced that he was developing his property at Brinkley Point as a resort, his theme was "Enjoy the Best, Relax and Rest at Sea Gulls Nest." The area was already known as one of the best beaches along the Patuxent, with its white sands and fresh-water swimming. Goldstein had opened a restaurant featuring seafood fresh from the river and promised a motel. The resort possessed a 250-foot pier dock, boat rentals, fishing, crabbing, umbrella-ed picnic tables and tree-shaded grounds, barbecue pits and a playground.

Sea Gull Beach was an occasional stop on the Chitlin' Circuit hosting the R&B stars of the day. A white Calvert County resident stated that as a teenager, though she was a fan of many of the musicians, there was no way that she was going to be able to visit Sea Gull Beach; her parents would have forbidden her.

A black enterprise in Washington had been managing the beach for a couple years and threw beach parties and dances featuring national and local entertainment. In 1957, it formed the Sea Gull Retreat Country Club to develop "a summer resort, with year-round facilities." The

Above: The scene at Sea Gull Beach at dusk no longer resembles the late 1950s, with adoring fans of R&B stars performing in the former waterside music venue. *Author's collection*.

Left: A souvenir from a show at Sea Gull. The black promoter was unsuccessful in establishing a members-only club on the premises. *CCHS*.

161

president, Welker Underdown, a prominent entrepreneur and manager of Washington's Dunbar Hotel, proposed a membership resort near Sea Gull Beach that would "give members…beach entertainment for themselves, and their families" and advantages of a country club. The club was to have a dance pavilion and modern cottages for rent or sale. At least one shareholder pulled out when he heard that the new endeavor was touting a goal of "the more the merrier." John Duncan, D.C.'s recorder of deeds in 1957, said that he was opposed to "mass appeal."

Although the country club idea may have faltered, Sea Gull continued to provide entertainment and expand the amenities offered. Drag racing, camping, pony rides and horseback riding were among them. One summer, the beach was part of the annual East Coast Gypsy Tour and featured a show called "Flying Missiles & Throttle Twisters." The Gypsy Tours were motorcycle rallies. D.C.'s unique vocalist Billy Stewart provided the music. In another event, one of the last for Sea Gull Beach, the Soul Searchers performed for a fundraiser to benefit Washington-area youth centers. In 1970, the Soul Searchers were considered one of the best Top 40 dance bands in the area. Within a few years, their leader, Chuck Brown, initiated the go-go music movement.

POTOMAC RIVER COMMUNITIES AND PARKS

Colton Point

Jutting into the Potomac River from one of the many peninsulas lining the coast was another sleepy little hamlet in St. Mary's County, Maryland: Colton Point. It was once a white resort community. In 1913, sixteen acres situated on Alsir Cove at St. Patrick's Creek were sold for $1,600 to African American couple John E. Golden and Mary V. Golden of Washington, D.C. John, who had served in the U.S. Navy, worked as a train porter; Mary was a seamstress.

Like the Carrs, the Goldens started out simply hosting picnics in their creek-side yard and having overnight guests in their home on the property. Also like the Carr family, the entrepreneurial spirit took hold, and within two years, the Goldens had erected a hotel for summer boarding, aptly named Golden's Hotel. Situated with water to the east and north, Golden's was a two-story frame structure with a screened porch across the front and south

Colton Point was quite popular with a certain crowd—maybe the more settled, sedate, professional folk looking for an out-of-town bridge party. *Courtesy Susan P. McNeill, RMC.*

Golden's Hotel at Colton Point was a beautiful refuge from urban Washington. These photos by renowned photographer Robert H. McNeill may have been used for marketing. *Courtesy Susan P. McNeill, RMC.*

sides. An attached kitchen was at the rear. Golden's then offered lodging overnight, for a week or up to a month.

Within a few years, Golden's included guest cottages in addition to the hotel. Its advertisements stated that the resort offered thirty-six rooms and seven cottages. Together, they could host up to one hundred guests. With the addition of its dance hall and a barroom pavilion built over the water, the resort could, and did, sometimes handle up to three hundred overnighters and day-trippers combined.

Golden's Hotel promised in its advertisements modern facilities, bathing and outdoor sports and dancing every Saturday night. The cuisine comprised fresh vegetables and seafood. In 1932, the resort charged two dollars for the day or twelve dollars for the week, with an additional seventy-five cents per night for lodging.

A sedate overnight stay for a group of female guests of Mary Golden's adult daughter, Josephine Morton, was described as follows: "Upon arrival guests were served coffee and water. Bridge was played at night, prizes being awarded…At midnight a plate dinner was served. Guests were later assigned to cottages for the night. After breakfast the next morning the guests were taken boat riding on Chesapeake bay."

Like most beach resorts, there was a pavilion for dancing and other events. Dancing at Golden's occurred on Saturday nights, with music by a local band. *Courtesy Susan P. McNeill, RMC.*

The Goldens built small cottages for the overflow or for those who wanted just a bit more privacy than offered by the hotel at Colton. *Courtesy Susan P. McNeill, RMC.*

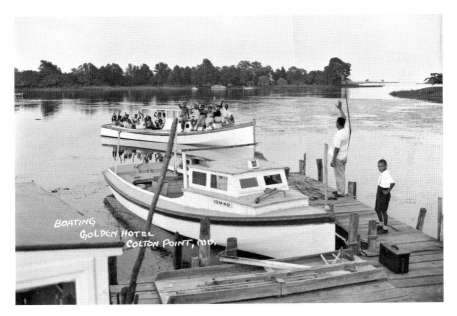

A Colton Point attraction was a boat ride down St. Patrick's Creek to the Potomac to view St. Clement's Island, Maryland's birthplace. *Courtesy Susan P. McNeill, RMC.*

Many of the guests were professional men and women and their spouses. Most motored down, others boated in and bus service was also available. Professional and fraternal organizations such as the Terrell Law Club, the Washington Bar Association, a reunion of the Howard Medical School class of 1924, Association of Former Internes of Freedmen's Hospital, Barrister's Wives Club and Sigma Delta Tau (a legal fraternity) were among the lofty groups that patronized Golden's and its Colton resort.

The patrons would spend their time crabbing, fishing, taking boat rides or lounging aboard yachts of guests basking in the sun. Playing cards or just taking cocktails with the swinging sounds of a small combo such as the Rivers Chambers Duo were other favorite ways to relax. Baseball games were extremely popular and were played on a field on Golden's property. Onlookers took seats on the sidelines to root for their favorite team and perhaps extend some of the rivalry later over a game of bridge. There was hiking nearby and a view of St. Clement's Island, where the *Ark* and the *Dove* landed, bringing Leonard Calvert to claim Maryland for the king of England. The highlight for many, though, was dancing under the stars.

Resorts like Golden's at Colton were important for "certain people," to coin a phrase of E. Franklin Frazier, a noted sociologist who made his home in Washington. They offered rest and relaxation without the busyness of the crowds of Sparrow's, for example. There were a few precautions to be taken in the area. For instance, the hotel warned guests about walking into town, advising them that if they wanted to stroll to do so going north along Maryland Route 242 rather than south toward Colton Point. However, it was evident that Golden's was able to make guests feel secure and free to be themselves. A certain decorum was expected and maintained.

Eyeing the success of Golden's, in 1942 another African American, Ewell L. Conway, purchased two acres just north on St. Patrick's Creek, where he, too, built a hotel, the Shirley K. It was later referred to as the Colton Country Club. Nearby, in the late '50s and early '60s, Betty Dickerson hosted groups who came by chartered bus from Washington to spend midnight to 6:00 a.m. on the beach overlooking St. Clements. She provided a midnight dinner that included crabs, ham, crab cakes, sliced tomatoes and iced tea and also offered dancing to a band in a dance pavilion.

John Golden died suddenly in January 1932, leaving Mary Golden a widow. When she passed away in 1945, she left the property to their only child, Josephine Morton. Upon Josephine's death eight years later, the property was willed to Calvary Protestant Episcopal Church in Washington. At the time, the hotel property consisted of four acres of improved land, six

acres of cleared land, the hotel, the pavilion, five cabins, two houses, three sheds, an icehouse and a boat. The value of the bequeathed main buildings was placed at $7,800. Josephine intended that the revenue generated by the hotel be placed in a fund for the education of young black men in the Episcopal ministry. The fund was named the Mary V. and John E. and Josephine Golden Morton Fund.

In 1956, the church sold the property to Harry Graves and Mildred Graves, who renamed the resort the Graves Hotel. Advertisements for the hotel touted it as a destination for the "Discriminating Vacationist." The property was sold in 1968, whereupon it became known as the Lew-Dan Hotel after its new owners. However, it was not long before its doors closed, and by 1974, it was no longer operating. The hotel still stands, albeit in deteriorated condition. Fortunately, the resort's place in history has been recognized and placed on the Maryland Historic Sites Inventory.

Longview Beach

A resort community on the Wicomico River off the Potomac in St. Mary's County near Bushwood is Longview Beach Club. It began as as a weekend or summer resort enclave for professional blacks of Washington. According to Susan McNeil, who spent summers there as a child, it was like the Highland Beach of St. Mary's County.

Developed in the 1950s by the same white developer of Oyster Harbor, William Schlusemeyer, the settlement is nicknamed the Seventh District for the electoral district where it is found. The community begins high above the shoreline off a main road and slopes rather steeply down to the water. The modest homes sit on large lots, and many have breathtaking views of the river. In 2001, a homeowners' association was formed, the Longview Beach Club, and the name is posted at the entrance off Maryland Route 238 into the settlement.

Though fishing and boating were the primary outdoor activities that drew guests to the resort, the center for activities was the Bramley Inn, a restaurant and lodge renovated from the old plantation manor of the same name. Slot machines were a big draw, noted Howard Chichester. His mother, Belle Chichester, frequently visited for the penny and nickel slots. Longview also received much publicity for its beauty contests.

Viola Murphy Gardner and George Gardner purchased a Longview lot in 1958. He had served in the U.S. Navy, and when he retired, they settled

Longview Beach was most often reported for results of its annual beauty contests. The heart of the community centered on the Bramley Inn. *Courtesy Susan P. McNeill, RMC.*

in Washington, where they worked as civil servants in a number of high-ranking positions. After retiring again in the 1970s, they moved out to Longview and purchased the Bramley Inn. In addition to the renovations to the inn and added amenities, they opened six cottages on the grounds to rent to overnight or weekly guests. Although the doyenne—as McNeil refers to Viola Gardner—passed away in 2010 at age ninety-three, the inn, under new ownership, is open on weekends and, favoring the adult crowd, features music, dancing and delicious crab cakes and cocktails. Longview still attracts folks looking for a bit of relaxation and gracious hospitality.

Mill Point Shores

Not far from Longview Beach, taking a left off Route 238 heading west, the road ends at Mill Point Shores. The vacation community established in 1951 is situated in a point at the confluence of Chaptico Bay with the Wicomico River. Its one and a half miles of shoreline are spiked with jutting piers. Some of its streets bear the names of people important to African Americans such as Carver and Roosevelt.

Mill Point Shores was heavily advertised in the *Evening Star* and the *Post* in the spring and summer of the early 1950s. Described as forty-three miles from Washington, the development was "For Colored Families who appreciate the finer things in life" or those with "discriminating taste." A clubhouse had been built, and there were extra-large lots awaiting buyers. The marketing worked as, in its heyday, Mill Point Shores had almost four hundred homes.

For a time, in addition to its appeal for African Americans seeking the peace of a pastoral waterfront community, Mill Point Shores hosted a jazz festival featuring some of the top area musicians. Today, it is sparsely populated, and several of the cottages have been abandoned and are severely deteriorated. At one time, though, Mill Point Shores was mentioned in the same breath as Columbia Beach or Highland Beach.

Other Twentieth-Century Waterfront Places of Leisure

The discussion of nineteenth-century places of leisure paid homage to the African Americans who persisted in seeking spaces and enclaves of relaxation in spite of the realities of being black in Jim Crow America. There were many more and better-known twentieth-century pleasure sites similarly developed in response to rigorously enforced racial restrictions. With white leisure sites such as Long Beach on the Western Shore of Chesapeake Bay openly advertising in 1941 that "the privacy of your family and their protection is assured by proper racial and building restrictions in this highest type community," black people continued to seek places of their own. Some had different ideas of leisure, and some were grand ideas. Here are a few more.

Mark-Haven Beach

Going back a few years, if one decided to break up a 180-mile auto trip from Washington to Hampton Crossroads, for example, one could take a certain shaded country lane toward the Rappahannock River near the halfway point, off Highway 17 in Essex County near Center Cross. There at the end would be Mark-Haven Beach, a little compound providing bucolic

riverside accommodations for the African American traveler. It offered a breezy, healthful retreat from the grime and noise of the metropolis.

Established first in 1937 as the Triangle Inn, a combined restaurant and entertainment center, the operation owned by R.A. Markham was expanded ten years later. He purchased 160 acres of the property of former steamer-oriented Jackson Beach, a white resort, and later added another 100 acres. He and his wife, Gertrude Johnson, developed a comfortable but unpretentious resort complete with an eighteen-room lodge offering air conditioning (in the late 1930s) in some rooms. The commodious lobby even sported a television. The delicious home-style meals served in the dining room often utilized vegetables and fruit grown on the property and fish and seafood taken from the river. There were family-friendly cottages available for rent and endless recreation possibilities. These included fishing and crabbing off the pier, swimming, table games, hiking, dancing and fish fries and barbecues. The view from the beach was filled with a constant stream of marine traffic that even included a few steamers harkening back to early days when Jackson Beach was a stop for unloading and loading excursionists.

As experienced by its predecessor, Mark-Haven's business changed and was no longer profitable. For Jackson Beach, steamship excursions dried up in large part due to mobility brought by automobiles. For Mark-Haven Beach, the desegregation of white leisure places brought more choices to African Americans. Thus, Mark-Haven closed in 1970, and the Markhams went into housing development.

Holly Knoll

When he retired from serving as president of Tuskegee Institute from 1915 to 1935, Robert Russa Moton bought this property in Capohosic on the York River in Gloucester County, Virginia, near the home of his birth. Moton had had a stellar career marked by the transformation of Tuskegee into a fully accredited university and the founding of the National Urban League, among other achievements.

Holly Knoll, the house, on an acre of land on the riverfront, functioned from 1935 as Moton's residence for the last five years of his life. He built a log cabin on the property that was a replica of the cabin in which he was born.

From the beginning of Moton's residency, per his intention, Holly Knoll also served as a conference center/think tank with boarding and recreational facilities able to host up to fifty people. Since establishment of the center,

Robert Russa Moton became the second principal of Tuskegee Institute. He retired to Holly Knoll and made his new home a policy institute. *Evans-Tibbs Collection, ACM, gift of the Estate of Thurlow E. Tibbs Jr.*

an administration and support building, a dormitory, a tennis court and a swimming pool have been added. A pier in the river accommodates fishing, boating and swimming.

Known also as the Robert Russa Moton House, the building is a National Historic Landmark. In earlier years, it was an invitation-only retreat primarily, but not exclusively, for African American intelligentsia and leadership and their families. The retreat gave participants, while in a leisure setting, the opportunity to consider questions of the day such as education issues, civil rights strategy, relations with Africa and generally how to improve the lives of people of color.

Today, Holly Knoll is the Gloucester Institute. Its mission is to provide "an intellectually safe environment where ideas can be discussed and transformed into practical solutions that produce results, and a site to train and nurture emerging leaders."

Seafarers Yacht Club—Anacostia River

Headed north on a rough road along the western shore of the Anacostia River is an assortment of low buildings on the right, some industrial and others marked as boat clubs. Railroad tracks parallel the road from slightly above on the left, and a bicycle path crosses overhead, as does the Sousa Bridge, casting shadows. Trees and bushes loom in some spots, and the sun bursts through in others, all the while offering peeks at the ribbon of water and the hills across the river. Finally at the road's end on the right, a sign reads, "Seafarers Yacht Club." The gate to the chain-link fence sits open, and between outbuildings and equipment, several piers tethering boats of various sizes are sighted. Front and center is the boat Bob Martin built. To the right, a small covered picnic area heralds the

entrance to the one-story white frame building with bowed windows that is the clubhouse.

Lewis Green, a Washington woodwork and vocational arts teacher, built the boat of his dreams in the 1940s following a pattern in a magazine. It was a forty-nine-foot cruiser with a Buick motor that he named *Geraldine* for his daughter. When he was denied moorage at any of the boat clubs in the District, he started a club and sought space for it from the U.S. Department of the Interior, which controlled the waterfront. After being repeatedly turned down by the government, he appealed to a friend of his, Mary McLeod Bethune—a member of President Franklin Roosevelt's "Kitchen Cabinet"—and her friend Eleanor Roosevelt. Interior reversed its position and granted the club a lease.

The site was mostly marshland and muddy water. That did not deter Green and his followers. There, the 1945 Green's Boat Club, later renamed the Seafarers Yacht Club, established as the first known African American boat club in the United States, found a home. Members got busy cleaning up the property, building docks and a small clubhouse, defying efforts to make them go away. Black people now had a place to moor their boats, relax waterside and begin their tradition of the Friday night fish fry.

Seafarers Yacht Club still reserves a place of honor for the cruiser of Charles "Bob" Martin, the club's second commodore. *Author's collection.*

Over the years, the club has had its challenges. The annual renegotiation of its lease, first with the federal government and later with the District government, lent a degree of instability, frightening away some members. The silting waters of the Anacostia made it increasingly difficult for grander boats to dock, and the ambiance of rumbling trains and the shadow of an overhead bridge did not fit the image sought by some aspiring yachtsmen. A group split off and established Seafarers of Annapolis, which took an active role in the black regattas of the Bay.

D.C. Mariners had formed in the interim under the helm of indefatigable Charles "Bob" Martin, who had built his own boat following in the path of his mentor, Green. Having no place to settle, in 1965, D.C. Mariners were absorbed into the Seafarers at the request of Green, who was planning to retire from the now waning club in danger of closing altogether. Under Martin's leadership, Seafarers began to revive. He and his son built a larger clubhouse, recruited new members and took on a slightly different role.

There was a constant need to clean up the riverfront and promote water safety due to the hazards of the site. Thus, Seafarers initiated an annual river cleanup. It was later partnered by the nearby white District Boat Club. These early efforts have spurred widespread interest and action in making the Anacostia River clean and navigable. In addition, the river cleanups have grown into a major annual community event.

Seafarers has also been deeply committed to providing regular boating safety classes. Other public service programs include holiday turkey giveaways to needy families and sponsorship of a Boy Scout troop. According to Martin, one of its most gratifying projects used to be giving free boat rides to people who had never taken one. Waiting riders would line up across the river, ironically near the swimming pool that had been closed to them a few years prior. Rising fuel costs, though, ended this rewarding project. Under Martin's helm, the program of "giving back" is what has sustained the club. The service aspect appeals to many of its members.

Though the other boat clubs along the Anacostia River are now integrated, some even with black commodores, Seafarers still offers its brand of comfort and relaxation. The clubhouse is inviting and displays some of its history on the walls. Today's members can enjoy playing pool, dancing or simply gazing out across the water in the relative quiet now that the train traffic is less frequent. Martin's self-constructed boat assumes an honorary perch, bobbing with the tide as if nodding approval of the club's creation and continued existence.

Chesapeake Heights-on-the-Bay

Chesapeake Heights-on-the-Bay, a beautifully planned community for the shores of Calvert County, was advertised as providing "the kind of homes that appeal to leading professional men, business men, diplomats and all others appreciative of fine living. [It] is a perfect home site for anyone of large understanding who wants to live at peace with his neighbors." Had it succeeded, it no doubt would have become a settled beach/resort village much like Highland Beach or Columbia Beach.

Albert I. Cassell, a black Washington architect and developer, owned 480 acres of beachfront and wooded highlands and proposed a daring project in 1959. He had many large successful projects in the metropolitan area under his belt, including Mayfair Mansions, several buildings on the Howard University campus, buildings on Morgan State University campus and the James Creek public housing development.

The Chesapeake Heights proposal, near Prince Frederick and just north of Dares Beach, centered around three-fifths of a mile of waterfront. It promised a private beach, a pier, boat moorage and a boardwalk. Off the beach, an adult pool, a children's pool, a community center, a shopping center with ample parking and a motel were planned. Cassell offered choices among four home models ranging from three bedrooms with one bath to four bedrooms with two and a half baths, each with a carport. The prices ranged from $18,190 to $21,500. Promoted as an "international community," it was suitable for year-round living.

Ground was broken in 1960, and much of the infrastructure was completed. The appraisers had nothing but accolades for the project, noting that it made "excellent use of natural advantages of land" and that "a very good balance has been arrived at in the allocation and placement of home sites, recreational, commercial and educational facilities." Cassell put up his own money and was able to secure some federal funding. Several lots/homes had been sold early, including one to Cyril Bow, a local African American architect and a frequent collaborator of Cassell.

This was actually the second project Cassell proposed for this land, located almost fifty miles from Washington, where he lived and worked. In 1935, he attempted a Public Works Administration project that would have been a self-contained, self-sustaining community "primarily for colored persons." The development would have included homes and revenue-generating amenities such as a theater, casino, hotel, pier and power plant. Most importantly, a rug factory would be created at which residents would

be gainfully employed, earning an income and contributing to the local tax base rather than being "on the dole," as so many Americans were at the time. He involved fellow architects such as Louis Fry, Cyril Bow and Ralph Vaughn, as well as white professionals, in both the planning and design. The surviving pre-computer-aided design (CAD) drawings and renderings, on file at the Calvert County Historical Society, are exquisite.

The proposed utopia-like community "primarily for colored persons," named Calvert Town, would be similar to a federal relief project in the area that was funded—Greenbelt, developed for whites. The *Baltimore Sun* called Cassell's project a "subsistence homestead" plan. Though Cassell had the support of then secretary of the interior Harold Ickes, some politicians on the national and local level thought it smacked of socialism. Others had objections to spending public money for blacks when many white people were also suffering under the Depression. After two years, when it became apparent that the funding was not forthcoming, the Calvert Town project died. Despite this setback, Cassell continued to have a successful career, adding to his portfolio of triumphs.

Chesapeake Heights-on-the-Bay also met a painful death. The bank declared that Cassell and his almost 250 investors defaulted on their loan and sued successfully for $800,000. An honorable man, Cassell struggled but managed to repay each of his investors. He died four years later, in 1969, broke with but his good name and works still intact. Remnants of the meticulously platted development still exist, as does the proposed main street, Cassell Boulevard.

Throughout this period of carving out spaces specifically for the black leisure-seeker, many patrons and providers had no idea that there would ever be a change—that black people would be free to go where they liked. People had taken what they had and made the most of it. "Their own places" brought African Americans tremendous pleasure and feelings of freedom within the confines of a "colored" excursion or "Negro" amusement park or resort.

However, there were always others who sought the end of exclusion based on race, including many who enjoyed those places of their own. They wanted enforcement of their rights as citizens to enjoy leisure at any and all public recreational places, and they fought hard to achieve it.

Yet once the legal end of segregation came, many of the special parks and resorts were abandoned and deserted. Former customers faded away, and owners went into debt. African Americans flocked to the places previously denied them only to find that those places, too, eventually closed.

The street grid and some street names are all that remain of the vision of master architect Albert Cassell to develop a bayside community. *Author's collection.*

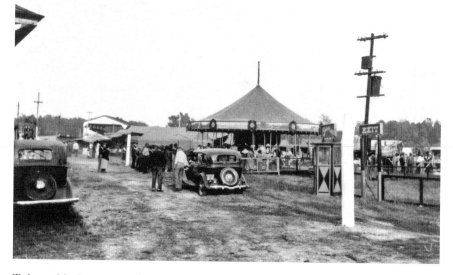

To have visited a segregated amusement park or pleasure garden and been at ease is a cherished memory for many blacks today. *Charles Hamilton Houston Collection, MSRC.*

The closure of black (and whites-only) amusement parks and resorts has been seen as tragic by some. Memories of Carr's and Sparrow's or Glen Echo of the past invariably evoke feelings of nostalgia for many. Yet these were segregated places, and the abolishment of forced segregation in recreational places was a victory, a sign of progress.

There were costs, however. African American entrepreneurs continue to face challenges experienced by their predecessors—inability to attract investment, low credit extension, unequal enforcement of government regulations and harassment of patrons, among other issues.

176

After significant strife, area blacks could enjoy Glen Echo. Integration, though, spelled the end for many black places of leisure and white amusement parks. *MLK.*

But blacks and whites (and other racial and ethnic groups, for that matter) enjoy recreation together today in Washington-area places like Six Flags, Kings Dominion and Colonial Williamsburg. They are able to swim together at Sandy Point, Colonial Beach and Dares Beach. However, what happens in these settings when there appears to be more blacks than whites and over a sustained period of time? Or when they are loud? Or when they want a different kind of music played? Is it cultural or just disorderly? As stated by Anastasia Johnson, a former patron of a few of the black resorts in the area, "Integration had an impact…even down to how we played."

Conflicting emotions and reactions and unresolved race issues still exist but cannot cloud the heroic efforts and bold dreams of African Americans to create enclaves, spaces and moments of leisure. This book has told the story of the triumphs—of how we were delighted!

Abbreviations Used
in Photo Credits and Sources

ACM Anacostia Community Museum Archives, Smithsonian Institution
CCHS Calvert County Historical Society
CMM Calvert Marine Museum, Solomons, Maryland
FCHS Frederick County Historical Society
HSW Historical Society of Washington, D.C.
LOC Library of Congress
MDSA Collection of the Maryland State Archives
MLK Historic Image Collection, Washingtoniana Division, Martin Luther King Jr. Library
MSRC Moorland Spingarn Research Center, Manuscript Division, Howard University
NMAH Archives Center, National Museum of American History, Smithsonian Institution
NPS National Park Service
PGCAAM Prince George's County African American Museum
RMC Robert H. McNeill Collection
TBL Thomas Balch Library
UMSC University of Maryland Special Collections

SELECTED SOURCES

Introduction

"Annual Report of the Public Printer." Washington, D.C.: Government Printing Office, 1899, 1900.

Baldwin, James. "Sonny's Blues" (1957). In *Going to Meet the Man*. New York: Vintage International, 1995.

Brooklyn Eagle. "The Colored Brother Becomes an Offensive Coon." July 20, 1885.

Colored American. July 9, 1898; August 6, 1898; September 17, 1898.

Corbett, Theodore. *The Making of American Resorts: Saratoga Springs, Ballston Spa and Lake George*. Princeton, NJ: Rutgers University Press, 2001.

The Crisis. "Vacation Days." August 1912, 186–88.

Gatewood, Willard B. *Aristocrats of Color: The Black Elite, 1880–1920*. Bloomington: Indiana University Press, 1990.

Griffin, Farah J., and Cheryl J. Fish, eds. *A Stranger in the Village: Two Centuries of African-American Travel Writing*. Boston: Beacon Press, 1998.

People's Advocate. July 31, 1880. Quoted from the *AA Presbyterian*.

Chapter 1

Colored American. August 20, 1898; September 17, 1898.

Morning Times. August 15, 1897, advertisement.

People's Advocate. July 24, 1880; May 26, 1883, advertisement.

Proctor, John Clagett. "Schuetzen Park Was a Famous Resort." *Sunday Star*, June 1, 1930.

Terrell, Mary Church Manuscript Collection, LOC.

Washington Bee. "Boxing at W.H. Brooker's Park." August 25, 1895.

———. "Grand Opening." May 6, 1899.

———. "LOOK! LOOK!" August 4, 1883.

———. "A Summer Resort." April 29, 1893.

Washington, D.C. Recorder of Deeds, D.C. Archives.

Washington, D.C. Wills and Probate, D.C. Archives.

Washington Post. "Maryland Republicans Will Rejoice." November 14, 1897.

———. "Representative Colored Enterprises." May 9, 1915.

Chapter 2

Book of the Royal Blue. Vol. 1, no.1. Baltimore, MD: Passenger Department of the Baltimore & Ohio Railroad, October 1897. Baltimore & Ohio Railroad Museum and Archives, Baltimore, MD.

Burke, Dawne Raine. *An American Phoenix: A History of Storer College from Slavery to Desegregation, 1865–1955.* Pittsburgh, PA: Geyer Printing, 2006.

Christian, Charles M. *Black Saga: The African American Experience, A Chronology.* Washington, D.C.: Counterpoint, 1999.

Cooper, Mark Anthony, Sr., ed. *Dear Father: A Collection of Letters to Frederick Douglass from His Children, 1859–1894.* Philadelphia: Fulmore Press, 1990.

"Cultural Landscape Report: Lower Town, Harpers Ferry National Historical Park." Department of the Interior, National Park Service, Harpers Ferry National Historical Park, National Capital Region, 1993.

Daniel, A. Mercer. "The Lovetts of Harpers Ferry, West Virginia." *Negro History Bulletin* 32 (February 1969).

Everett. "An Evening Stroll at Harper's Ferry." *People's Advocate,* July 16, 1881.

Glencarlyn Citizens Assocation. *Glencarlyn Remembered: The First 100 Years.* "Carlin Springs." glencarlyn.org/GlencarlynRemembered/Glencarlyn_Remembered_First_100_Years_v2.pdf.

Gozdzik, Gloria. "A Historic Resource Study for Storer College for Harpers Ferry, West Virginia." Morgantown, 2002.

Hardesty, H.H. "Map of Loudoun Co. Virginia." 1883. TBL.

Harpers Ferry NHP File: Niagara Movement Meetings 1905–1909.

Harwood, Herbert H., Jr. *Rails to the Blue Ridge: The Washington & Old Dominion Railroad, 1847–1963.* Falls Church, VA: Pioneer American Society, 1969.

"Hilltop House Hotel." www.hilltophousehotel.com/images/hilltop_house_brochure[1].pdf.

Hutchinson, Louise Daniel, and Gail Sylvia Lowe. *"Kind Regards of S.G. Brown": Selected Poems of Solomon G. Brown.* Washington, D.C.: Smithsonian Institution Press, 1983.

Kahrl, Andrew W. "The Political Work of Leisure: Class, Recreation, and African American Commemoration at Harpers Ferry, West Virginia, 1881–1931." *Journal of Social History* 42, no. 1 (Fall 2008).

People's Advocate. May 21, 1881; August 17, 1880; August 4, 1883.

———. "Mr. Solomon Brown Brought a Large Excursion Here Friday." September 25, 1883.

Spirit of Jefferson (Charles Town, WV), June 15, 1886; July 19, 1887; July 17, 1888; August 24, 1889; August 24, 1889.

Terrell, Mary Church. *A Colored Woman in a White World.* Washington, D.C.: National Association of Colored Women's Clubs, 1968.

Thompson, Elaine, guest curator. "'Let Our Rejoicing Rise': Emancipation Day in Loudoun County, Loudoun County Emancipation Association 1890–1970." Leesburg, VA: Loudoun Museum, 1998.

U.S. Federal Census, 1870–1920, Washington, D.C.

———. 1900, Garrett County, MD.

Washington Bee. Advertisement, "Summer Boarders," July 9, 1910.

————. August 5, 1905.

————. "Loudoun, VA Social Notes." August 29, 1896.

Woodson, Carter G. "Early Negro Education in West Virginia." 1921. www.wvculture.org/history/africanamericans/woodsoncarter02.html.

Zartman, Dr. I William. "Opequon Historic District." National Register of Historic Places Registration Form, 2002.

Chapter 3

Afro-American. "The Steamer *E. Madison Hall* Is Now Ready." May 16, 1931.

Coleman, Robert. *The First Colored Professional, Clerical and Business Directory of Baltimore City, 1st Annual Edition, 1913–1914.* Baltimore, MD: Coleman Print, 1913.

Colored American. April 16, 1898; June 11, 1898; June 18, 1898; June 25, 1898; May 23, 1903.

Cudahy, Brian J. *Twilight on the Bay: The Excursion Boat Empire of B.B. Wills.* Centerville, MD: Tidewater Publishers, 1998.

Evening Star. "Colored Men Organize." June 22, 1908.

————. "Honor Memory of Douglass." August 24, 1908.

Kahrl, Andrew. *The Land Was Ours: African American Beaches from Jim Crow to the Sunbelt South.* Cambridge, MA, 2012.

Mount Bethel Baptist Association. www.mtbba.org.

Pearl, Susan G. "Admirathoria/Upper Notley Hall." State Historic Sites Inventory Form, Maryland Historical Trust. 1996.

People's Advocate. "Excursion to Glymont." September 8, 1883;

Sunday Star. "The Rambler Writes of the Glymont Neighborhood." September 3, 1916.

Tilp, Frederick. *This Was Potomac River.* N.p., 1978.

Ultimate Roller Coaster. www.ultimaterollercoaster.com.

Washington Bee. "Frederick Douglass Day! To Be Celebrated at Washington Park, Monday, August 24th." August 15, 1908.

————. "Grand Outing." June 6, 1908.

————. "July 4th Excursion." June 30, 1894.

————. "National Steamboat Company." August 24, 1895.

————. "A Pioneer Steamboatman." June 18, 1898.

Washington Post. "Acquitted of Illegal Liquor Sale." October 22, 1908.

————. "Booker Not Their Ideal." September 16, 1903.

————. "A Historic House Gone: The Old Young Mansion at Giesboro Point." September 4, 1888.

————. "Mrs. J.C. Bensinger Dies." June 29, 1922.

————. "A Permit Needed to Stop a Leak." October 24, 1893.

————. "To Celebrate September 2." August 6, 192.

————. "Washington Park Burns." February 3, 1913.

Chapter 4

Afro-American. "Camp Meetings in Full Blast: People Do Not Go for the Good of the Meeting but to See Friends." August 27, 1904.

————. "Camp Meetings of Adventists Opens June 15: Services Set for Burroughs Training School Campus." June 17, 1939.

———. "Michaux Heads $20,000,000 Drive for Va. Memorial." March 20, 1937.

———. "'Sweat, Noise and Stink' in Camp Meetings." October 8, 1927.

———. "What Are They Going to Do About It?" July 31, 1909.

Atlanta Daily World. "Elder Michaux, Radio's 'Happy Am I' Evangelist, Says Jamestown, Va Cradle of Negro Slavery in America." August 29, 1936.

Baldwin, Lewis V. "Festivity and Celebration: A Profile of Wilmington's Big Quarterly." *Delaware History* 19 (Fall–Spring 1981): 197–206.

Chicago Defender. "Explains Memorial to Race Colonists: Michaux Tells About Building at Jamestown." July 31, 1937.

Colored American. September 3, 1898.

Cromwell, Adelaide M. *Unveiled Voices Unvarnished Memories: The Cromwell Family in Slavery and Segregation, 1692–1972.* Columbia: University of Missouri Press, 2007.

Edwards, Philip. Telephone interview, May 21, 2015.

"Emory Grove: A Black Community of Yesteryear." *The Montgomery County Story.* Vol. 31, no. 1, February 1988. Montgomery Historical Society.

Evening Critic. "Old-Fashioned Camp Meeting." June 25, 1882.

Hopkins, G.M. *Atlas of Montgomery County, Maryland, 1879.* Baltimore, MD: Garamond/Pridemark Press, 1975.

Lampl, Elizabeth Jo, with Clare Lise Kelly. "'A Harvest in the Open for Saving Souls': The Camp Meetings of Montgomery County." Prepared for the Maryland Historical Trust, 2004. Reprinted Maryland–National Capital Park and Planning Commission, 2012.

McIntosh, Phyllis. "The Corps of Conservation." *National Parks* (September–October 2001): 23–27.

Montgomery, William E. *Under Their Own Vine and Fig Tree: The African-American Church in the South, 1865–1900.* Baton Rouge: Louisiana State University Press, 1993.

National Park Service. "Prince William Forest, 1936–1948 Summer Camps." www.nps.gov/prwi/learn/historyculture/summer-camps.htm.

People's Advocate. August 21, 1880.

———. "These Excursions," September 3, 1881.

"Reflections and Impressions by William E. Smoot." Ella Pearis Collection, ACM.

Winter, Philip, and Gloria Winter. E-mails to the author, June 17, 2015.

Woodson, Carter G. *The History of the Negro Church.* Washington, D.C.: Associated Publishers, 1921.

Chapter 5

Afro-American. "Country Club Open." May 21, 1927.

Blupete. "Abou Ben Adhem." www.blupete.com/Literature/Poetry/HuntAbouBenAdhem.htm.

Columbia Beach Citizens Improvement Association. "Columbia Beach History." cbcia.org.

Fletcher, Tinofireyi. "Reflections on Community, Opportunity, and Changing Fairways: The Wake Robin Golf Club." Unpublished paper presented at University of the District of Columbia, 2007.

John Shippen Memorial Golf Foundation. "John Shippen Biography." johnshippen.net/john-shippen-biography.html.

Jones, William H. *Recreation and Amusement Among Negroes in Washington, D.C.: A Sociological Analysis of the Negro in an Urban Environment.* Washington, D.C.: Howard University Press, 1927.

Katen, Brian. "Parks Apart: African American Recreation Landscapes in Virginia." In *Public Nature: Scenery, History, and Park Design*, ed. Ethan Carr, Shaun Eyring and Richard Guy Wilson. Charlottesville: University of Virginia Press, 2013.

Lyric Find. "The Bourgeois Blues." www.lyricfind.com.

Meyer, Eugene L. "Maryland Life: From Count Basie to Heavy Metal." *Washington Post*, January 5, 1989.

Moore, Charles, ed. "The Improvement of the Park System of the District of Columbia: I. Report of the Senate Committee on the District of Columbia. II. Report of the Park Commission." Washington, D.C.: Government Printing Office, 1902.

Patterson, Stacy. "Wilmer's Park." Maryland Historical Trust Maryland Inventory of Historic Properties Form. 2008.

Washington Post. "New Colored Course Is Formally Opened." July 24, 1927.

———. "New Country Club Opens at Edge Hill." June 1, 1926.

———. "Six Negroes Booed Out of Anacostia Pool." June 27, 1949.

———. "Swimmers Protest Tidal Basin Bathing Beach Abandonment." February 27, 1925.

Webb, Lillian Ashcraft. *About My Father's Business: The Life of Elder Michaux*. Westport, CT: Greenwood Press, 1981.

Wolcott, Victoria W. *Race, Riot, and Roller Coasters: The Struggle over Segregated Recreation in America*. Philadelphia: University of Pennsylvania, 2012.

Chapter 6

Afro-American. "Columbia Beach Holds Its Annual Queen's Coronation." July 20, 1985.

———. "Sea Gull Beach Initiates New Idea in Country Clubs." October 12, 1957.

———. "22 D.C. School Clubmen Disport at Colton's on the Potomac." June 8, 1932.

Black World/Negro Digest. "Conversations with Africa at Capahosic." July 1967, 93–95.

Brown, Philip L. *The Other Annapolis: 1900–1950*, Annapolis, MD: Annapolis Publishing Company, 1994.

"Cedar Haven Community Description." www.mncppcapps.org/planning/HistoricCommunitiesSurvey/CommunityDocumentations/87B-039%20Cedar%20Haven/87B-039_Cedar%20Haven%20Community%20Description.pdf.

Cox, Pearlie. "Pearlie's Prattle." *Afro-American*, August 2, 1952.

Dermody, Ann. "It Was a Club of Their Own." *BoatU.S. Magazine*, March 2009, 26–31.

"Eagle Harbor Community Description." www.mncppcapps.org/planning/HistoricCommunitiesSurvey/CommunityDocumentations/87B-038%20Eagle%20Harbor/87B-038_Eagle%20Harbor%20Community%20Description.pdf.

Garrett, Lula Jones. "Gadabout-ing." *Afro-American*, August 8, 1931.

Henderson, Edwin. "Trend Toward Water Sports Noteworthy, Writer Discovers on Vacation Jaunt." *Afro-American*, September 18, 1948.

House and Home Magazine. "Mark Haven Beach." www.thehouseandhomemagazine.com/Articles/Issue15JulyAugust2010/MarkHaven.

Hughes, Elizabeth. "Golden Hotel." State Historic Sites Inventory Form, Maryland Historical Trust. 1996.

McKithan, Cecil. "Holly Knoll—R.R. Moton Home." National Register of Historic Places Inventory Nomination Form. 1981.

Nelson, Jack E., Raymond L. Langston and Margo Dean Pinson. *Highland Beach on the Chesapeake Bay: Maryland's First African American Incorporated Town*. Virginia Beach, VA: Donning Company Publishers, 2008.

Southern Maryland Newspapers Online. "Seventh District Landmark Making Comeback." July 18, 2012.

Terrell, Mary Church, Papers, MSRC.

Selected Sources

Washington Post. "Lewis T. Green, Teacher in D.C." August 30, 1976.

Widdefield, Ann. *Passing Through Shady Side.* Bloomington, IN: AuthorHouse, 2013.

Manuscript Collections

"Anacostia Story" Exhibit Files, ACM.

Black History Committee Oral History Project, TBL.

Cedar Haven File, UMSC.

Dale Family Papers, ACM.

Dr. Lee Gill Collection, MSRC.

Eagle Harbor and Cedar Haven Files, PGCAAM.

Ella Pearis Howard Collection, ACM.

Evans Tibbs Papers, ACM.

"Evolution of a Community" Exhibit Records, ACM.

Mary Church Terrell Papers, 1851–1962, Manuscript Division, LOC.

Percival Bryan Collection, ACM.

Interviews by the Author

Howard G. Chichester, July 2 and July 15, 2015.

James Crudup Sr. by e-mail, July 1, 2, 2015.

Margaret Dickerson-Carter, August 29, 2015.

Anastasia Johnson, July 15, 2015.

Raymond Langston, June 2, 2015.

Charles "Bob" Martin, July 17, 2015.

Susan P. McNeill, March 14, 2015, and by e-mail.

Barbara Moore, May 15 and July 10, 2015.

Tanyna Chichester Saxton, July 29, 2015.

Novell Sullivan, June 25, 2015.

Dr. Alfred O. Taylor Jr., July 2, 2015.

Mary Uyeda, tour/interview, May 16, 2015.

Philip and Gloria Winter, by e-mail, June 16 and 17, 2015.

Bette D. Wooden, August 10, 2015.

Unpublished Papers

Fletcher, Patsy M. "Chillin' While Colored: Nineteenth Century African American Places of Leisure." Unpublished paper, presented at Washington Historical Studies Conference, Washington, D.C., 2008.

McQuirter, Marya Annette. "Claiming the City: African American, Urbanization, and Leisure in Washington, D.C., 1902–1957." PhD dissertation, University of Michigan, 2000.

Taylor, Elizabeth Dowling. "Samuel Proctor." Unpublished notes, 2015.

Selected Sources

Other

Baist, G.W. *Baist's Real Estate Atlas of Surveys of Washington, District of Columbia*. Philadelphia: Wm. E. & H.V. Baist, 1903.

Boyd's City Directory. Washington, D.C., 1850–1923.

Hopkins, G.M. *Atlas of Fifteen Miles Around Washington Including the County of Prince George Maryland, 1878*. Riverdale, MD: Prince George's County Historical Society, 1996.

Maryland Land Records, Maryland Archives. www.Mdlandrec.net. Anne Arundel, Calvert, Charles, Prince George's and St. Mary's Counties.

Sanborn Insurance Maps.

U.S. Federal Census, 1870–1940.

INDEX

About the Author

*P*atsy Fletcher has always been fascinated by lost African American communities. A longtime resident of Washington, D.C., she has particularly enjoyed studying nineteenth-century settlements. Fletcher consults in the field of historic preservation and community development through her company, Training, Historical Research and Economic Development (THREAD, LLC). As a preservationist, she has assisted neighborhood organizations in documenting and publishing the history of their communities and has written heritage guides for selected wards of the District. As an independent historian, Fletcher has contributed to the documentary *Master Builders of the Nation's Capital* (Jones, 2011), *The Economics of Historic Preservation* (Rypkema, 1994, 2005) and the *Biographical Dictionary of African American Architects, 1865–1945* (Wilson 2004). She may be contacted at plmfletcher124@gmail.com.